THE ART of COLLECTING

Library of Congress Control Number: 2010907109
Printed in the United States of America

ISBN-13: 978-1-85149-642-6

Jensen Fine Arts
115 Sewall Avenue
Brookline, Massachusetts 02446
www.jensenfinearts.com

Published by
Antique Collectors' Club Ltd.
Sandy Lane, Old Martlesham
Woodbridge, Suffolk
IP12 4SD, United Kingdom
www.antiquecc.com

Printed by
Capital Offset Company, Inc., Concord, New Hampshire

THE ART *of* COLLECTING

AN INTIMATE TOUR INSIDE PRIVATE ART COLLECTIONS, WITH ADVICE ON STARTING YOUR OWN

Diane McManus Jensen

with
Foreword by Wendell Garrett

Photography by Ralph Toporoff
Edited by Valerie Ann Leeds

7/14/12

To Lindsay,
Happy Collecting!!
Diane McManus Jensen

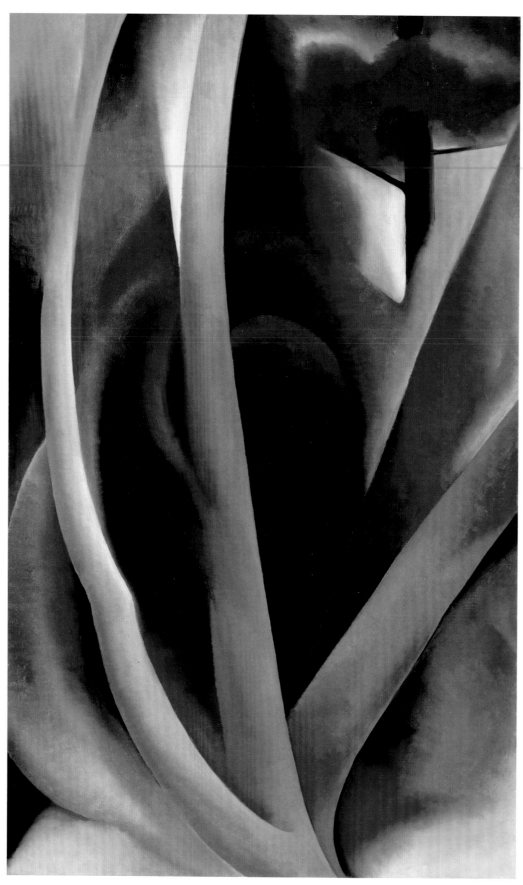

Georgia O'Keeffe (1887-1986), *Birch and Pine Trees-Pink*, 1925.
Paula and Peter Lunder Collection.

This book is dedicated to those who have a passionate love of life and the beauty of art, and to my husband, children, and grandchildren, who are my most treasured art, God's miracles, one and all.

"As you climb the stairs of quality, you'll meet individual works that you'll need for the rest of your life, works that will thrill you, energize you, lift your soul, soothe you, make you smile, make you think about the fate of mankind and the universe, make you have to see them again and again for the good of your psyche, state of mind, and strength of heart."

THOMAS HOVING (1931–2009)
Director, The Metropolitan Museum of Art, 1967 to 1977

CONTENTS

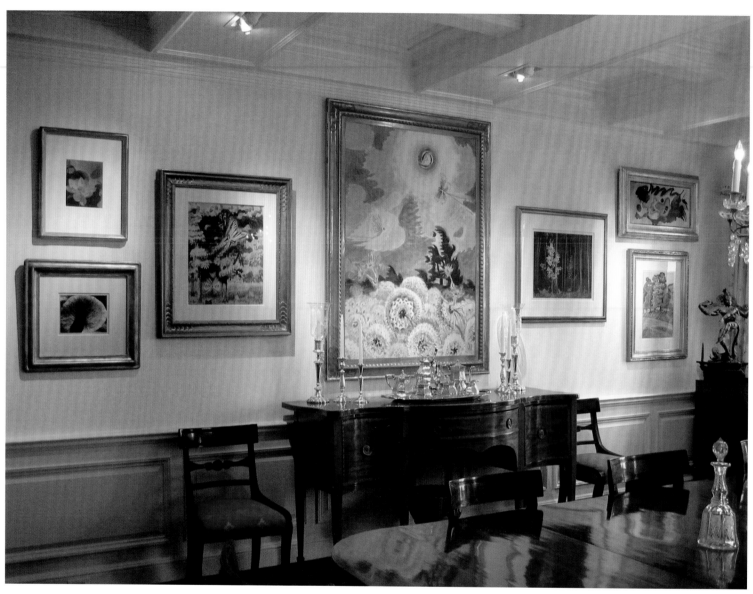

American modernist art featured on a dining room wall. Artists include Charles Burchfield, Edward Weston, Ansel Adams, Arthur Dove, and Edward Steichen. Framing by Eli Wilner & Company, New York City.

TOPICS IN COLLECTING

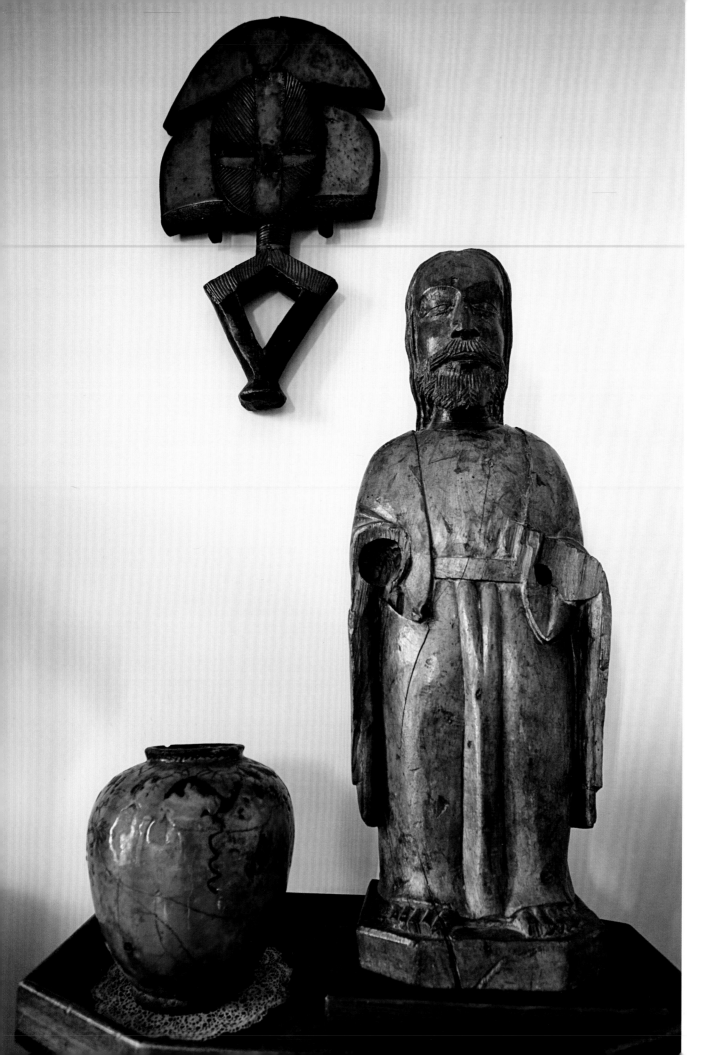

Foreword

WENDELL GARRETT

Editor-at-Large, The Magazine Antiques

The collector ... is soon overpowered by his habitual passion; he is attracted by rarity, seduced by example and inflamed by competition. While ... the novice is often surprised to see what minute and unimportant discriminations increase or diminish value.

—Samuel Johnson, *Idler*, May 12, 1759

The urge to collect has revealed itself throughout history as a fundamental human phenomenon. It is a curious activity that evades any precise definition. Millionaires, vagabonds, and children can be collectors, even without discretionary funds. Some collectors are rational and organized about their activity, while others are illogical and frantic. Stimulated by various motives, the collector's passion has taken many different forms, just as does the scale of gratification. The true collector is neither odd nor ordinary; his collecting is a response to impulses of great depth.

Collecting is not necessary to the human existence in the physical sense, but it is so widespread that it must satisfy some aspect of the human psyche. While some individuals collect discreetly, a few have been notorious, with activities entailing fraud, theft, and even murder. Some fortunes have been made by collecting, but an equal number of bankruptcies have also been caused by it. One constant among collectors is that few have regrets. One of the world's greatest and most unscrupulous collectors is said to have walked around his collection on the night before he died and declared with great anguish: "I must leave all this! What trouble I had to acquire these things! I shall never see them again where I am going." That man was Cardinal Mazarin, the leading statesman and minister of Louis XIV in March 1661. Few collectors can ever hope to emulate Cardinal Mazarin, but many have felt

Opposite page
Kota mask, Gabon; Persian vase; and medieval statue.
Catherine and Matt Mandel Collection.

as he did when faced with the prospect of parting from a beloved collection.*

The role of private collecting, which accompanies civilized society, is one of the most intriguing aspects of the history of collecting. There have been golden ages of collecting from the Hellenistic period forward, when large and varied collections were established, often with great flair and discrimination. Historically, there are many types of collectors and collections that have been built up over a long period of time, sometimes within a family, but without any particular notion of unity. These collections have been acquired over successive generations through marriages, bequests, fortunes of war, liberality of sovereigns, and political triumphs. Yet, the distinctive character of these collections is due to individual taste and fortunes. By contrast, some collectors are motivated by the true love of things artistic—these are individuals who carefully choose with discrimination the finest examples of the various schools or artists or craftsmen whom they most admire. Such individuals are inspired as collectors by aesthetic considerations and personal taste, and possess an intellect and eye schooled through contact with the fine or decorative arts of the past. Another type of collector is represented by an artist-historiographer who sets out to assemble a selection of art or artifacts that chronologically illustrates a stylistic evolution on a systematic basis. This is collecting as an organized obsession—an activity that is an outward expression of many kinds of motivation.

The Greek and Roman civilizations encouraged collecting, but the tradition essentially died out in the medieval world. Our modern tradition of collecting, like most of our artistic traditions, can be traced to the Renaissance. It is the free-thinking individual who stands at the heart of Renaissance art and civilization, and collecting was a means of asserting individuality. Although the outward forms of art and our conception of the universe have changed, this idea remains one of the main purposes in collecting at its best, and one of the keys to an individual's character can still be found in what art and objects he or she chooses to live with.

Collecting took on a different complexion in the eighteenth century: it became more orderly, and against a general intellectual background of scientific and phil-osophical discussion and investigation, works were collected because of their beauty, or their archaeological or scientific significance. By the middle of the eighteenth century collecting had reached the height of fashion. A connoisseur—in the eighteenth or the twenty-first century—can be literally defined as "one who knows" and who has a scholarly and aesthetic expertise in the arts. A true connoisseur can illuminate an object with a wide range of knowledge and critical judgments—about its authorship, date, the society in which it was produced, its use (especially if it is an object from the decorative arts), history of ownership, location of relative works, and an assessment of its quality, condition, and market value. Thus a good eye is one that is backed up by knowledge, supported by good visual memory, and independent enough to make individual judgments and fresh observations. An eye that has no scholarship to control its waywardness often makes careless errors of an elementary nature; and an eye that has its independent sensitivity smothered by too much undigested knowledge often fails to notice things that have been otherwise overlooked. Collecting and connoisseurship are discrete from one another but are a powerful combination if present together in a collector.

Connoisseurs and collectors of long standing usually develop a kind of sixth sense which, when coupled with enthusiasm, is baffling to the uninitiated. The layman may not understand how one knows what makes this thing old or valuable. Whereas the intuitive type of connoisseur may just simply know by instinct and from visual clues rather than as the result of long-reasoned judgment. The chief stock and trade of the dealer is just such an instinct, combined with a keen sense of the market value; of commonness and rarity, of the good, the better, and the best—and the requisite price that should be attached to each. Another type of connoisseur puts great emphasis on reason as well as instinct. Certainly he is more likely to be analytical in that he relies on careful study as well as on a calculating eye in amassing a group of works.

One of the first to address in writing the path to becoming a connoisseur was Jonathan Richardson the Elder in his *Two Discourses: An Essay on the Whole Art of Criticism as it Relates to Painting, and An Argument in Behalf of the Science of a Connoisseur* (1719). Although

* Cardinal Mazarin's collection was acquired by Louis XIV and is now part of the collection of the Musée du Louvre in Paris.

his observations pertain chiefly to prints, portraits, and drawings, and his language is now archaic, his comments are as valid today as when written. Many other volumes have been written since Richardson's time; but to date no one has tried and succeeded as well to delineate the various factors to be considered in arriving at an evaluation of craft-made objects in the fine and decorative arts.

At the beginning, the primary personal attribute for the connoisseur should be a good visual memory that stores and categorizes a near infinite number of images of ordinary, fine, and superior works of art. Anyone who aspires to become a connoisseur must first learn to see, and then look, and look, and look, and remember what he has seen.

During the first flush of excitement over a new discovery, as in the initial stages of love, is the time for the collector to rely on the spirit of inquiry and the reasoned mind as primary assets. The true connoisseur will cultivate habits of skepticism, humility, and objectivity. He will avoid avarice and flee from the desire for a bargain. Instead of leaping to conclusions, he will be skeptical. The humble collector will not, like a peacock, parade his knowledge before the seller and in so doing stop the flow of information that might be had for the asking. Finally, the quality of objectivity becomes all-important as the connoisseur attempts an evaluation of what appears to be a prize. To do this, he must establish the approximate date, country of origin, and hopefully the author, although this is not always possible. The excellence of workmanship, the condition, and the effect of wear are other important aspects that warrant careful consideration. To the objective collector, historical evidence will be less important than it is to the cultural historian, although he may be captivated by the appeal of the object as a work of art.

With the dawn of the nineteenth century, there came a new philosophy and a new point of view toward art patronage and collecting. By the American and French Revolutions and by the subsequent Industrial Revolution and the growing cultural aspirations of the *bourgeoisie* and the workingman, democracy now claimed the art for its own. The concept of the royal collection was a thing of the past; art was emancipated from the palace and the country house. No phase of our past heritage has undergone more radical changes in the last two hundred years than patronage of the contemporary artist and that accompanying sense of possession which has goaded many a man of wealth into becoming a collector.

Here in the new republic of the United States of America a new spirit regarding art and culture abounded. The democracy of Thomas Jefferson and the enlightened cynicism of Benjamin Franklin created a new and precious pattern in this country: it was to be the pattern of the great democratic museums filled with objects privately donated by capitalists and supported by taxation and popular subscription.

It is axiomatic that the appreciating of art both for its intrinsic worth and for its value as an expression of the human spirit appears to be common to almost every age. The form that this expression takes varies as greatly as does the climate, the language, and the social customs of every people. But what so often escapes the visitor to a museum or the reader of the literature of the past is the homogeneity, the organic character of artistic tradition. The private collections that grew up here show much more than the relation of art to wealth; it is the relation of the precious object to the idea. And these works of art have in many cases been preserved and handed down from one generation to the next because the ideas that lie behind them are, and have always been, considered vital to the abundant life. They are the very things that distinguish the adolescence of one nation from the intellectual maturity of another.

These works of art are merely the timeless pieces of currency for which ideas, ideals, and aspirations have been exchanged for centuries. For this reason they have been treasured, often beyond price; they never have been static; like gold coins they have moved from one century to another as the economy or cultural stature of each people has required. It remains for our generation to decide whether we shall guarantee the ebb and flow of these spiritual values, or, whether the temporary custodians of artistic works shall bear the responsibility of debasing the one remaining currency of civilized man.

Preface

Through a series of revealing and intimate interviews with twenty-three selected collectors, *The Art of Collecting* unveils the passion behind the pursuit of art objects, and at the same time offers an accessible approach and a realistic view into forming a collection. While attempting to de-mystify the process of collecting, the book offers the reader a rare glimpse inside a varied selection of notable American collections.

Collectors from diverse backgrounds and circumstances tell the stories of how they became involved with collecting art and what motivates their acquisitions. Thus the reader is afforded entrée into a very private endeavor, and an array of intriguing personalities is revealed. These interviews are complemented by insights from experts on various topics that relate to collecting. Within these pages lie a trove of tips and insights that relate to collecting from individuals with a wealth of knowledge about caring for artwork: conservation, installation, shipping, framing, storage, lighting, and more. This practical advice is invaluable to anyone who collects, or wishes to begin collecting.

The Art of Collecting has evolved from my early experience growing up in Detroit, where my mother and father frequently took my sister Jeannie and me to visit the Detroit Institute of Arts. Exposure to one of the finest institutional collections in the country greatly informed my ideas about collecting. My fascination with art continued, and even as I pursued an entirely different career path, I studied art history at the University of Michigan for my own enjoyment. On visits to New York, my oldest sister Pat introduced me to all of the incredible museums there, including the Museum of Modern Art, where works such as Picasso's *Guernica* further inspired my growing interest in the arts. Several years later, a friend who owned an art gallery in Grosse Pointe, Michigan, enlisted me for a presentation for a corporate art collection, which marked my formal entry into the art world. From there, I began my own art advisory business, working with corporate and private collectors. Later in Boston, where I relocated my growing business, I completed my degree in art history.

I was also involved with the Archives of American Art of the Smithsonian Institution, and served as chairman of the Committee of the New England Region, which gave me an opportunity to meet a wide variety of collectors, many of whom shared their stories. Meanwhile, my own passion for art deepened, and I opened a gallery in New York, and then one on Martha's Vineyard. As I worked with an increasing number of collectors, I discovered there was a real need for a practical guide to collecting, for those who are starting to acquire artworks, those who already have a collection, and even for the broader audience of art lovers who might one day consider collecting. This book is a response to that need, and is inspired by these diverse experiences in the art world.

Over the years, I have had the privilege of seeing some of the finest art collections in the country. Since not all of them could be included in this book, a cross-section of traditional areas of painting, sculpture, and an outstanding array of folk art, along with works from burgeoning collections of photography and video art, is represented.

An art collection can reveal much about the character of the owner and bring a sense of originality to any living space. In these times, the home may be particularly treasured as a sanctuary from the outside world. Having one's retreat filled with treasured objects that give pleasure and enhance one's daily life has become increasingly important.

I have consistently found it fascinating and challenging to discover what sparks an individual's interest and propels them down a path toward a certain type of collection. The reader is invited to explore a wide range of collections and points of view in the hope that the intriguing stories told by the collectors in these pages will inspire them to pursue this avocation on whatever scale suits their objective.

Collecting is an enduring pleasure. I invite those who find beauty and inspiration in art to look within these pages.

DIANE MCMANUS JENSEN

Diane McManus Jensen with *Ladies on Beach*, c. 1915, by Mabel Woodward (1877-1945). The work is in the Cecilia and Richard Canning Collection.

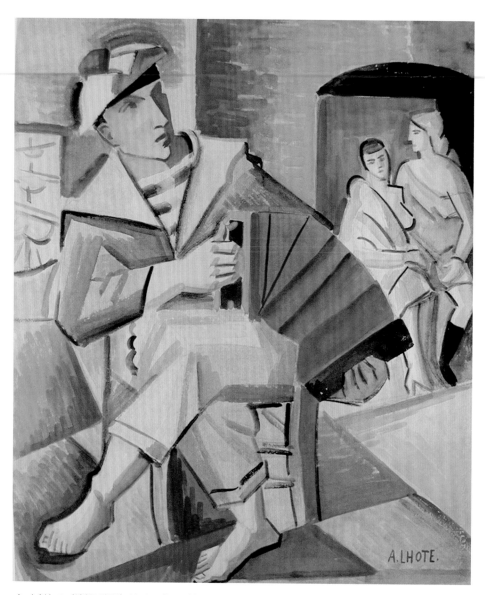

André Lhote (1885–1962), *Marin a l'accordéon*, c. 1920. Nancy and Charles Parrish Collection.

Acknowledgments

This book would not have been possible without the faith and generosity of the collectors and professionals who agreed to participate in this endeavor. To them, and to those who have participated anonymously, I am especially grateful. I would also like to extend my thanks to all of the clients who have given me the opportunity to work with them over the last thirty years, most recently Richard and Cecilia Canning and interior designer Maureen Griffin Balsbaugh.

In producing this book, I am indebted to the work and good counsel of many individuals, not all of whom can be thanked here. For his commitment and patience for "just one more photo shoot," a special note of gratitude is due Ralph Toporoff, whose talent and dedication to his craft informs the wonderful photography throughout this book. Thanks also to Carmel Brantley for her beautiful photographs of two of our Palm Beach collections.

My deep appreciation goes to editor Valerie Ann Leeds, art historian and curator, for listening, and for working so hard to produce the best book possible. Deborah Lyons also gave generously of her time and expertise as copy editor; both tackled this project with enthusiasm and professionalism.

Susan Swartz and Ray Ellis, Martha's Vineyard's own national treasure, have both been an inspiration to me. Of the many dealers and designers who I have been fortunate enough to know, I am especially appreciative of Heidi Lee, Robert A. Boyle, Connie Brown, Candy daRosa, Bill Fine, Kristina Hare Lyons, John Hagan, Sara Thurston, and Kathy Kendrick.

In launching this book, I have had the help of Beth and Peter Barker, Aaron Kennedi, John Aldrich, Loren Rees, Leah Laiman, Connie Procaccini, Diane Goshgarian Bourque, Barry Stein, and Donald H. Ratner, and the guidance and enthusiasm of Treesa Germany and Jan Pogue and her late husband, John. Thanks also to documentary filmmaker Arnie Reisman, and to Paula Lyons, whose coaching was so helpful. Richard Wattenmaker, Dr. Irving Burton, and Marilyn Schlain of the Archives of American Art have all offered invaluable insights.

I am grateful to Sister Ellen Marie Glavin and Sister Lillian Morris for teaching me invaluable lessons in art history and life. Elizabeth Shannon and Helen Rees gave me encouragement all through the years, as did my lifelong friend Jill Moran, who recently lost a long battle with breast cancer. Finally, I am fortunate to have supportive, loving family and friends who have listened to my ideas for this book over the years. Special thanks go to Danny, Peter, Kelli, Anna, William, John, Kate, Stella, Jake, and Rosie; Pat and Jeannie, Ernie, Judy and Jack, Kelly and David, Barbara and Bernie, and Ron and Diane. And to my husband David—grip, best boy, and confidant—thank you for accompanying me through the process of creating this book, every step of the way.

DIANE McMANUS JENSEN

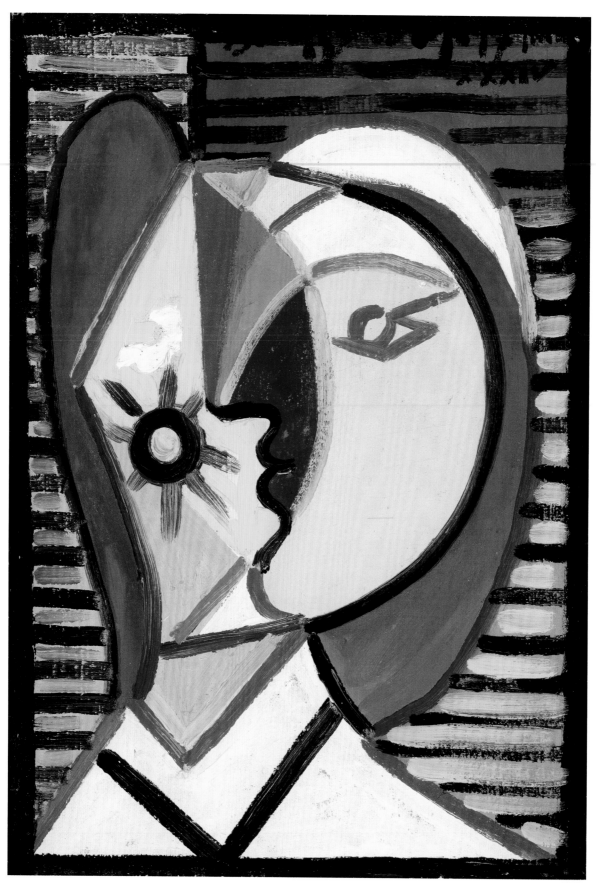

Pablo Picasso (1881–1973), *Head of a Woman, Portrait of Marie Thérèse Walter*, 1934. Scott M. Black Collection.

INTERVIEWS

Diane McManus Jensen

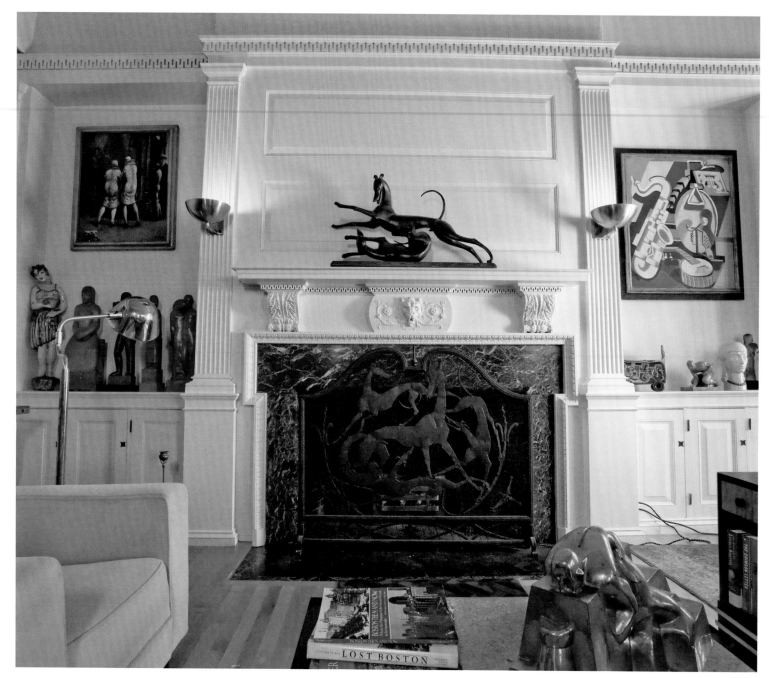

On mantle: William Hunt Diederich (1884–1953), *Playing Greyhounds.*

On wall, from left: Martin Lewis (1881–1962), *Leopard Skins* c. 1928; Jan Matulka (1890–1972), *Musical Instrument.*

Fire screen by William Hunt Diederich, *Fox and Hounds,* c. 1920.

End table by Paul Frankl (1886–1958), c. 1930.

Sculpture on table in foreground by Dudley V. Talcott (1899–1986), *Six Day Cyclist.*

JOHN AXELROD

African American and South American Art, Art Moderne, and Decorative Arts

DJ: *Let us talk about your collection and how you started. You have a great collection of mid-twentieth-century art, and it flows so well in your Victorian home.*

JA: It has taken forty years of collecting, editing, and arranging. I always have had an acquisitive nature, in fact, I am a compulsive collector. Like many kids, I collected rocks, salamanders, and stamps. When I was sixteen, I bought my first painting. We had a house in Gloucester, Massachusetts, and went to Rocky Neck, which was known as an artist colony, where I aquired that first painting of Gloucester trawlers sitting in port, which I still have. It cost me about sixty dollars, and it is probably worth about the same thing today.

In 1968, I started going to flea markets and began collecting objects that were of interest to me. I always tell people you should buy what you love. You cannot have decorators pick out art or objects for you, because you are not committed to those objects and you will not have a relationship to them. If you do not love the work then who cares what the price is, or if that work is not what that the artist is known for? If you love that painting, get it. It is as simple as that.

The first objects I collected were the kind of ceramics that used to be made for refrigerators. Another early purchase was a coffee set with a fitted tray, which reminded me of a skyline. I had no idea who the designer was, but I have always liked urban art forms. I paid very little for it, but it has since become an icon

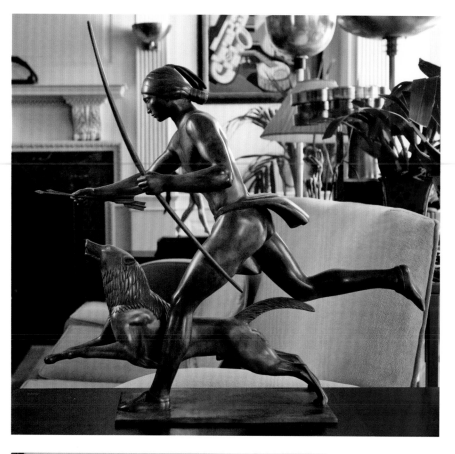

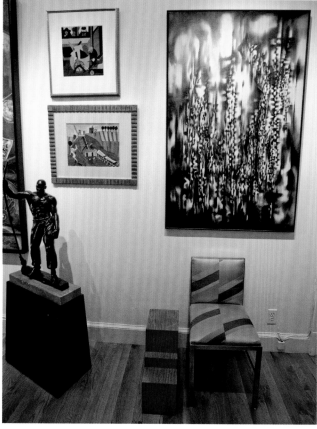

Top
Paul Manship (1885–1966), *Indian Hunter and Dog*, 1926.

Left
On wall, clockwise from left: Jacob Lawrence (1917–2000), *Harlem Junk Man*; Norman Lewis (1909–1979), *Every Atom Glows*; William H. Johnson (1901–1970), *Lunch Time Rest*.

Sculpture by Richmond Barthé (1901–1989), *Stevedore*.

of American modern design and is worth many times the price now.

DJ: *What was your next major step in collecting?*

JA: In a word, New York City. I remember going to New York because I found they had auctions of European Art Deco. This took my collecting of furniture and other decorative arts to a new level. Once in New York, I discovered dealers that fed into my compulsive collecting fever.

DJ: *What about the paintings and other fine art currently in your home?*

JA: Prior to the New York experience I had reproduction posters from the Harvard Coop, which I soon replaced with original poster art. In New York I attended a preview of an auction of American prints and fell in love with Martin Lewis. I collected Lewis prints and also those of Louis Lozowick and others, assembling a collection of American prints from 1900 to 1950 with skyscraper and urban themes.

After assembling a major collection of prints, I transitioned into collecting paintings and watercolors of similar themes by artists of the same period. As I collected more and more American paintings, I decided that I wanted to concentrate on American decorative arts as well. I was particularly interested in American design. It related more to skyscrapers, which were an American phenomenon, as well as to jazz, speed, and all things I found exciting. One difference from European design, however, is that most of the American furniture was designed to be mass-produced. I tried to find unique American pieces, which was very difficult. Most of these pieces were commissions.

DJ: *I understand that you have been a benefactor with regard to donating art to museums.*

JA: As my art collection veered more to paintings and watercolors, I donated the print collection to the Yale University Art Gallery. Likewise, my American decorative arts collection quickly overtook the available space in my house. I remember that when I was in Paris working, I felt that I could not go back home to the States to crowded conditions. I called the Museum of Fine Arts, Boston, and told them that they could have anything in my house that was not American, as long as it was removed within two weeks of my return. The curator of European decorative arts arrived at the house with her staff, and packers and shippers, and forty cases of decorative art were packed up and donated to the museum. The only objects I held back were a small collection of French glass created by Maurice Marinot and his group, because I could not find the equivalent in American design. Many objects not selected were not of museum quality, so I consigned them to dealers for sale, and the mistakes were packed in banana boxes to go to a local flea market.

DJ: *And can you talk about the sculpture that you have in the house?*

JA: Sculpture is one of the hardest things to buy, and unlike paintings and watercolors, cannot be easily stored. Furthermore, it is usually very heavy, and therefore requires a higher level of commitment. An exciting part of my collecting was getting to know the sculptors Donald De Lue, Walker Hancock, and Albert Wein. I partnered with a friend, D. Roger Howlett, to help finance these sculptors to cast various plasters into bronze, which otherwise might not have ever been cast. As part of this process, I not only learned how sculpture was created, but also learned about the foundry process.

DJ: *I see that you have Latin American art in the house. Can you tell me about that?*

JA: The only contact that I had early on with Latin culture was from visits to Puerto Rico. When American Airlines bought out the South American routes of Eastern Airlines, I received a pair of free tickets to fly anywhere in South America. I flew to Buenos Aires, where I had a friend from school. He had an art gallery where I fell in love with Argentine art. On that visit I felt those inner compulsions to buy, but was able to stave them off. Unfortunately, he gave me a drawing on my departure, which caused me to visit Argentina fourteen more times and build a collection of Latin American art of the period 1920 to 1940, concentrating on works of art from Argentina and Uruguay. I now have one of the major collections of art of the Rio de la Plata region.

DJ: *What about African American art, which is also a major interest of yours?*

JA: About fifteen years ago, when I was making a tour of the New York art galleries, I saw an exhibition that I felt was really compelling and I really fell for the work I saw. It was American art from a period I collected, but it was totally unfamiliar to me. It turned out it was this dealer's first exhibition of paintings by African American artists. I bought many paintings from that show and continued to do so at his annual shows. I have now assembled a major collection of art by African American artists, from the same time period, focusing on the 1920s to the 1950s but also including several nineteenth-century pieces by major artists such as Henry O. Tanner, Robert Scott Duncanson, and Edward Bannister. The collection has expanded considerably and has depth. I purchased this art because I felt that it was necessary to have these artists represented in order to have a great collection of American art.

During several trips to Buenos Aires, I visited other parts of South America. In Brazil, I became very excited by the art created by Afro-Brazilians. Both Brazil and the United States had a history of slavery, yet the art created by the descendants of slaves in the two countries is very different. I now have a significant collection of this art.

DJ: *I understand that when you turned sixty, there was a major shift in your collecting?*

JA: All of these collections grew and grew and so I felt I had to make some decisions. When I turned sixty, I wanted to keep only the best art in my collection, pieces that I wanted to live with. The parameters I established were that my art should be from the United States, and be created from 1915 to 1946.

My Latin American collection went into a warehouse and I am now trying to sell it all, except for one piece that I want to keep. I would like to sell it as a collection because when I collect, I start with a group of important pieces and then I expand outward. I try to get examples of the influential figures and of other artists in the particular movement.

As to other parts of the collection, I worked with the dealers who could help me make decisions about which pieces should go to auction and which should be consigned to dealers.

DJ: *Have you gifted additional works to the Museum of Fine Arts, Boston?*

JA: Even after the process of winnowing the collection to the most important pieces, I felt that my house still was too crowded, and I wanted to edit down the collection even further so that I could have more living space. I surprised the museum with the gift of anything in the house, except for paintings and sculpture. Again, the curators came and selected almost all of the furniture, silver, glass, ceramics,

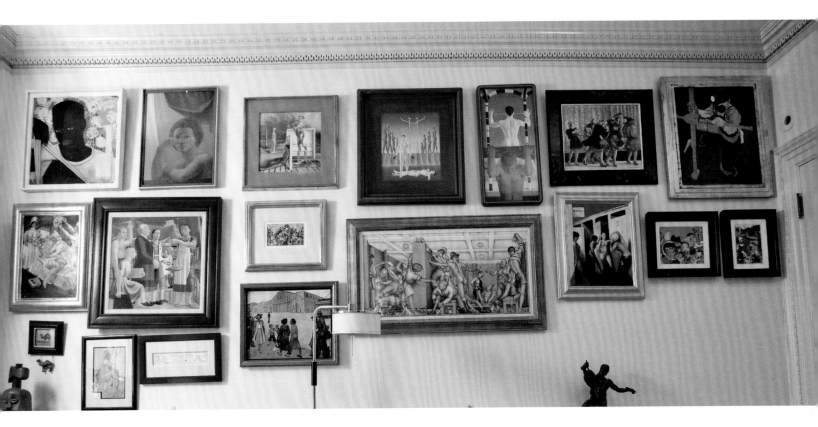

Top row, from left: Kerry James Marshall (b. 1955), *Supermodel;* George Tooker (b. 1920), *Girl in the Window;* Paul Cadmus (1904–1999), *The Shower;* Jared French (1905–1987), *Murder;* Jared French, *Division;* Reginald Marsh (1898–1954), *Girls on a Windy Day;* Robert Lepper (1906–1991), *Miner.*

Second row, from left: Philip Evergood (1901–1973), *The Works;* George Tooker, *Market;* Paul Cadmus, *Regatta;* Paul Cadmus, *YMCA Locker Room;* Guy Pène du Bois (1884–1958), *Coney Island;* Romare Bearden (1911–1988), *Untitled;* Romare Bearden, *Ritual: Conjure Woman as an Angel.*

Bottom row, from left: Lucy MacKenzie (b. 1952), *Camel;* Joe Shuster (1914–1992), *Superman;* Fortunato Depero (1892–1960), *Coney Island Roller Coaster;* Alan Rohm Crite (1910–2007), *Tremont Street Barns.*

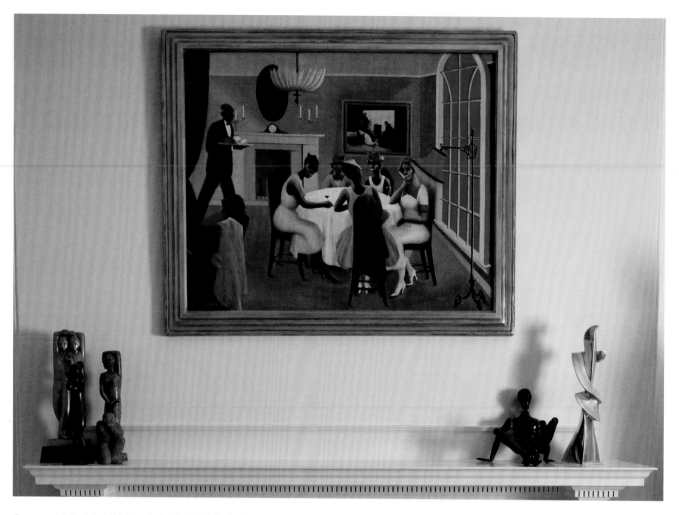

Over mantel: Archibald Motley, Jr. (1891–1981), *Cocktails.*

On mantel, from left: Jaques Schnier (1898–1988), *Couple* and *Dancers;* Brent Carlton (1903–1988), *Nude;*
George Stanley (1903–1973), *Artist's Figure;* Alexander Archipenko (1887–1964), *Silhouette.*

and other decorative arts to be a promised gift. In fact, 90 percent of it has been removed. This is a perfect fit, because prior to this gift, the museum had few items for display in their new gallery of decorative art from the 1920s and 1930s. I now have room to breathe in my house and can better appreciate the paintings and sculpture.

Equally important, I will get great pleasure in seeing my decorative arts beautifully displayed in the new galleries, rather than being crammed into my cupboards and closets.

DJ: *What are some of your favorite pieces?*

JA: That really depends on many things, including my mood. I often give my stock answer, which is that it is the last piece I acquired.

DJ: *Are you continuing to collect?*

JA: Nowadays, it is hard for me to find art that I want to add to the collection and even more difficult to pay the current prices. The discipline that I have adopted, however, is that when I do find something to purchase, I need to give up something already in the collection.

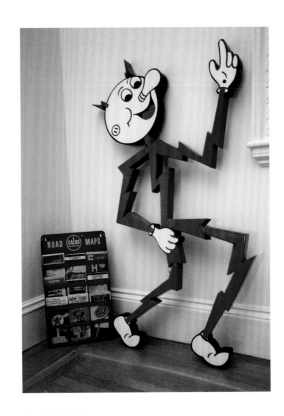

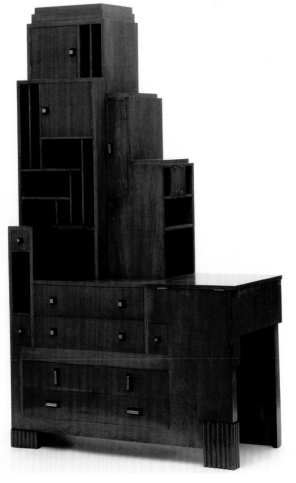

Above
On wall: Rubem Valentim (1922–1992), *Pintura #1*.

Sculpture by Agnaldo Manoel dos Santos (1926–1962), *Xango*.

Telephone table by Hammond Kroll, 1935.

Top right
Advertising memorabilia: Calso Gasoline Road Map Stand and Maps; Cutout of Reddy Kilowatt, advertising personification for the electrical industry.

Bottom right
Paul Frankl (1886–1958), Skyscraper desk and bookcase, 1928.

David Bakalar. *Shoah*, 1994.

SANDRA AND DAVID BAKALAR

Modern and Contemporary Sculpture

DJ: *David, what inspired you to begin to collect art?*

DB: It really happened by chance. Many years ago when I was in my mid-thirties, I rented a house in Wellesley, Massachusetts, that belonged to a professor. He had a marvelous library, which was full of art books with photographs of various paintings. I would come home and relax by looking at these photographs. I found them very intriguing and beautiful. Then I began going to galleries and eventually started collecting.

I started with paintings. I recall the first painting I bought was a Marc Chagall, which I thought was quite lovely. And I gradually shifted to sculpture and one thing led to another.

DJ: *And did you stay within a focus in your collecting, a particular period, a style or artist?*

DB: No, I am very eclectic. I really respond to objects that I find intriguing, beautiful, and provocative. And so I have bought art that ranges from Chinese and Indian to modern art, Impressionism, and so forth.

I have never bought works of art because I thought that they would change in value. I have acquired them for enjoyment and to have them around so I could look at them.

I think the main thing is not to collect something because someone tells you that it is worth collecting. You should collect something that you are intrigued by, something that adds to your life. And my experience is

Above
Sandra and David Bakalar, with *Sculpture of Sandy and David,* 1985, by George Segal (1924–2000).

that by doing that, I have enhanced my surroundings, and my own life as well as the lives of those around me.

My sculptures are around the house; paintings and other objects are inside the house. Henry Moore is one of my favorite sculptors and I have a lovely example of his work. I bought the Henry Moore when I did not have a garden, as I lived in an apartment. I had no room for it, but I just liked it a lot, so I stored it for a few years.

I do not care who the artist is—some are absolutely wonderful and others are good—one has to use judgment in terms of how you understand the piece and whether you want to own the piece. One should not buy something just because of the name attached to it.

Near the Moore there are other sculptures, which I think are very interesting from an historical point of view. There is a Renoir and an Archipenko, both of which were done in 1915, but which are very different. One is classical, and the other begins to develop negative space, punching a hole through the face, for example. And it is remarkable that these two sculptors, living and working at the same time, were working so differently. The Archipenko ultimately leads to Moore, in that Moore has holes or negative spaces in his sculptures. It also leads to Barbara Hepworth, whose sculpture is more geometric, as opposed to the organic interpretation of Moore.

DJ: *Would you explain this Barbara Hepworth sculpture to me?*

DB: It is called *Ancestor II*, though I am not sure why. It consists of three modified, box-like elements piled on top of a base. And each of the elements has pierced holes. I could give you boxes and punch holes through them and no one would give it a second glance. But this is just beautifully assembled. The patination is complex and changeable, and the holes change shape and seem to become a solid form, so it is a very interesting sculpture.

DJ: *And what about the George Segal sculpture with four figures?*

DB: I had seen photographs of George Segal's work at different galleries, but I had never thought of owning one because the ones I saw were made of plaster and they were too big to put in the house. I was more interested in large outdoor pieces. And then on a trip to Washington, I happened to go into the National Gallery and they had a cast of the four-figure Segal, *The Dancers*, which I learned was bronze, but was coated with a compound called Incralac that gave you the white ghost-like feeling. And so then I bought my piece.

DJ: *Would you tell me about this sculpture of you and your wife, Sandy, done by George Segal?*

DB: In a way, that particular sculpture is responsible for my becoming a sculptor myself. I had just purchased the large Segal and I wanted to have something done of Sandy and myself. I had seen a Segal that had figures on a bench, but the figures were not relating to each other. I called Segal and found him to be very open, so I explained that I really wanted Sandy and myself on opposite sides of benches with our bodies twisted towards each other, and that I wanted to create the feeling of rapport and empathy between two people, which is something that is counter to the feelings of isolation that Segal sculptures often elicit.

God bless George, he liked the idea and we visited him in his studio. He made the sculpture, which I think was very successful, and we became good friends. I think Segal is probably the most important American contemporary sculptor.

DJ: *David, tell us about your own sculpture.*

DB: Well, after I had Segal make the sculpture, I felt that if I could tell George Segal how to work on a sculpture, maybe I could do my own. I turned to him and said, "George, you're terrific, but I don't need you anymore, I'm going to try to do my own sculpting." Basically, my own sculpture has been tied in with my background, with my training in science. I've tried to have an approach that utilizes scientific things, which are happening, without making them obvious. In other words, I do not believe a piece of sculpture should try to teach you anything. What it should try to do is engage you so that you are not quite sure what it says, but you want to know and you start thinking about it in spite

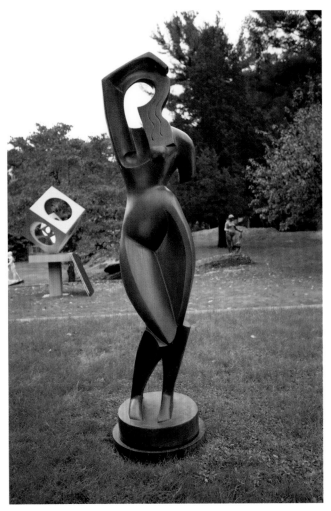

Pierre-Auguste Renoir (1841–1919), *Femme*, 1915.

Alexander Archipenko (1887–1964), *Woman*, 1915;
David Bakalar, *Motherhood* (in background).

of yourself. So my objective has always been to try to hook the viewer and have him thinking he knows what the work is about, and then later on maybe change his mind and think it is about something else. If I can do that with someone, then I feel I've succeeded.

DJ: *What materials do you use to compose your sculpture?*

DB: I have used granite and bronze, but lately I have been working with stainless steel because I like the idea that I can get stainless steel mirrors, and to me the mirror gives me another component in addition to form or a lack of form; in other words, positive and negative space. So I have also what I call reflective space, which I think makes the sculpture more interesting.

I wanted to have a sculpture which represented creativity. In my mind, the most creative thing in the world is a woman giving birth, because without that, none of us would be here to even talk about art. And so I thought I would create a so-called pregnant cube, where I combined positive/negative reflective surfaces.

I have also done several sculptures influenced by what happened in the Holocaust. My favorite, which is in my back yard, is a nine-foot iconic figure. The problem that I saw in making a Holocaust figure is that those that I have seen are quite representational. I just felt that they have no resonance with a young person who

knows nothing about what happened decades before they were born. The task, as I saw it, was to hook and intrigue a young person so he would want to know more about this. The device I used was a stainless steel mirror surface with saw-like edges so that a person looking at it and moving sees his image cut up, and then would want to know, "What is the meaning of this?" At that point I think you've got them in terms of understanding—the beginning of understanding the Holocaust.

DJ: *What type of work are you doing now?*

DB: More recently, I've focused on digital photographic images which I'm quite intrigued with, because I find I can create things that I undoubtedly could not do if I didn't have the advantages of the software and the digital power. It begins with taking a photograph, or sometimes finding a photograph. The interesting thing for me is to go beyond that. For example, the recent series I've been doing has been one where I've been photographing rooms with mirrors and then treating the image in the mirror differently from what is in the room. And so you come up with statements that have a lot to do with the transient nature of time. At the same time, I want these images to be intriguing and beautiful, and so there are the challenges of developing a wonderful palette of colors that resonate with people.

Opposite page
David Bakalar, *Life Force,* 1986.

Below
George Segal (1924–2000), *The Dancers,* 1971.

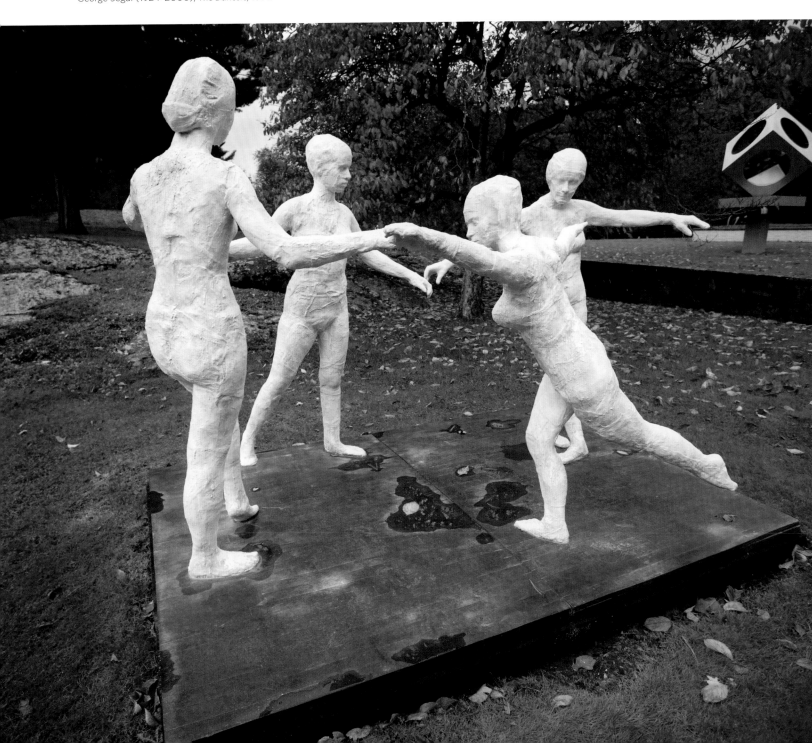

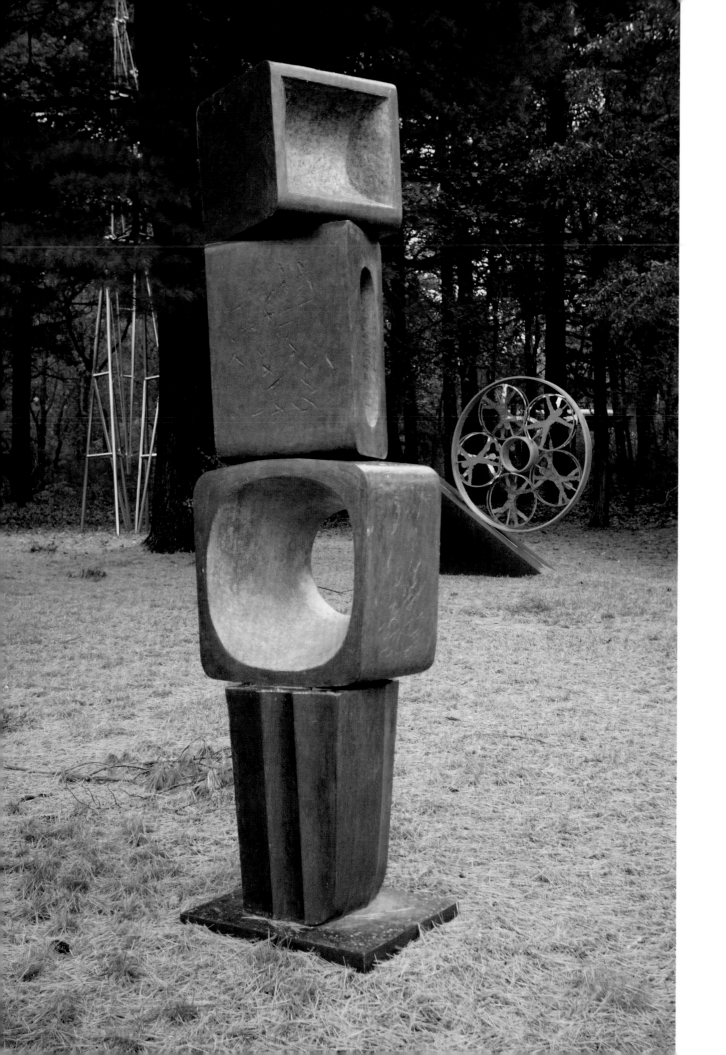

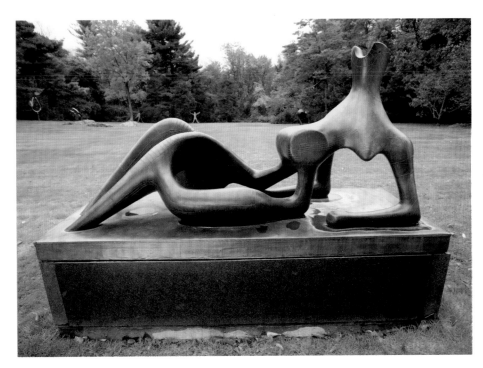

Opposite page
Barbara Hepworth (1903–1975), *Ancestor II.*

Left
Henry Moore (1898–1986), *Reclining Nude.*

Below
George Segal (1924–2000), *Sculpture of Sandy and David,* 1985.

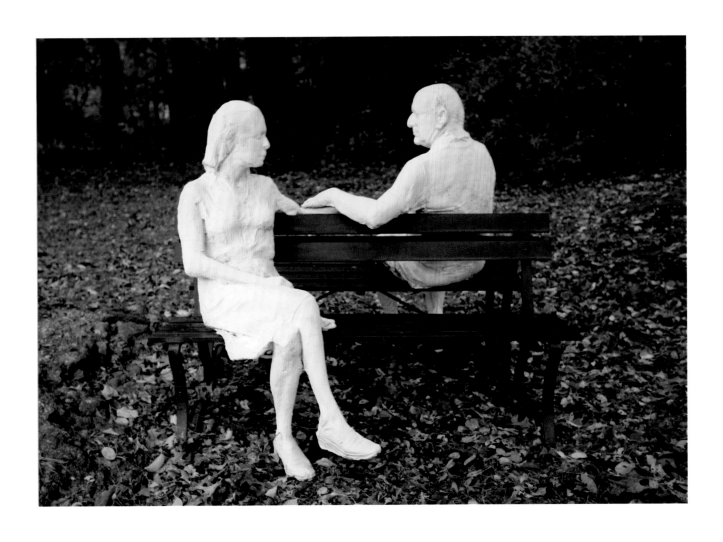

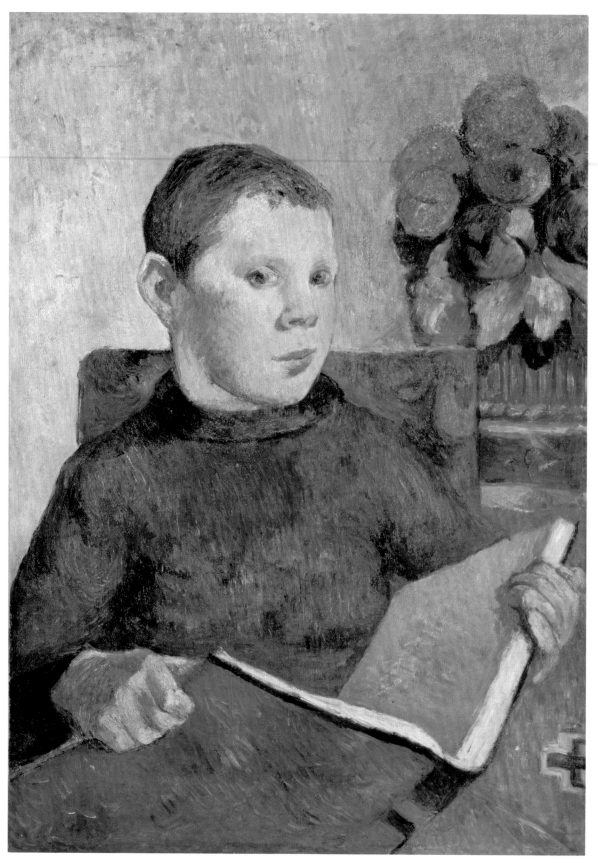

Paul Gauguin (1848–1903), *Portrait of the Artist's Son, Clovis.*

ISABELLE AND SCOTT M. BLACK

Impressionism, Post-Impressionism, Cubism, and Surrealism

DJ: *Scott, tell us when you started collecting and how your interest in art began.*

SB: I was born in Portland, Maine, but we lived in Newton, Massachusetts, from 1950 to 1955. My mother had reproductions on the wall. *Madame Charpentier and her Children* by Pierre-Auguste Renoir was one of her favorite paintings, and there were also Pablo Picasso's *Lovers*; the *Japanese Bridge* by Claude Monet; the boaters, *Déjeuner des canotiers*, by Renoir; and an Edgar Degas ballerina. So I was familiar with these reproductions from the time I was very young because they were all over the house. My mom also often brought me to the Museum of Fine Arts, Boston. In the 1950s, Monet's *Grainstack (Sunset)* and the *Rouen Cathedral* were always on exhibition there, so early on, I was familiar with Monet's art. I also had a

favorite painting by Renoir, *Children on the Seashore at Guernsey.*

I never expected to do this well in life where I could afford to own such works of art, but from an early age, I was visually attuned to the work of these artists. It was part of my everyday experience, seeing them on the wall and going to museums.

I attended Johns Hopkins University, which was close to the Baltimore Museum of Art, which has one of the finest collections in the world. Many of the most important works were collected and gifted by the Cone sisters. The collection includes a number of works by Henri Matisse, and masterpieces by Paul Cézanne, including *Mont Sainte-Victoire*, and Paul Gauguin, such as *Woman with Mango*, so I was further exposed to great art. After I graduated from Harvard Business School,

Above

Scott Black with *Pagans and Degas' Father*, c. 1895, by Edgar Degas (1834–1917).

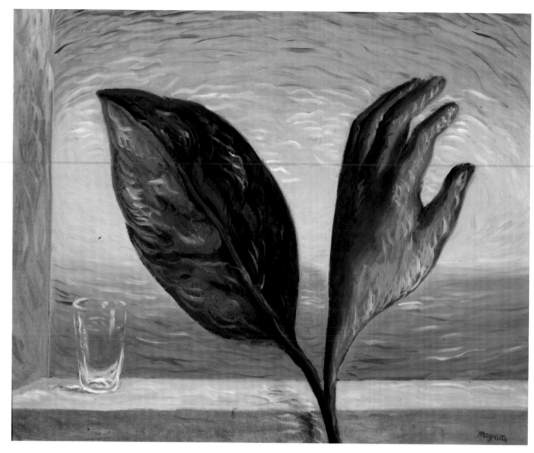

Left
René Magritte (1898–1967),
The Tempest, c. 1944.

Below
Fernand Léger (1881–1955),
La grappe de raisins, 1928.

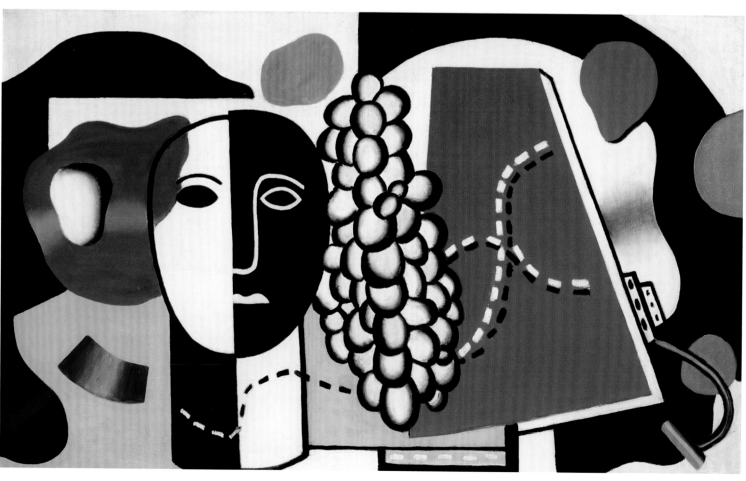

I moved to New York and often visited MoMA and The Metropolitan Museum of Art. And later, as I was able, I traveled all over the world and always visited the major museums to study the art in their collections. In London, there is the National Gallery; and in Paris, the Musée d'Orsay and the Louvre. It is very important for people who are serious about collecting to be exposed to the finest examples of work by the great artists.

As a collector, I believe it is better to have fewer objects that are museum quality than to spend a lot of money buying junk and just filling space with objects. Now, I cannot speak for other people, but that is the rule I have followed.

When there are museum retrospectives of the artists I collect, there are mostly museums lending, but I am one of the few individual lenders. I try to buy really good examples of the major artists, whether it is Monet, Renoir, Camille Pissarro, or Fernand Léger. The loan requests mean that I have bought well. I am not saying I have the greatest examples in the world—I don't—but I have very good examples of all of these artists. Many of the paintings I have are among the best within their category; a great Paul Delvaux, Giorgio de Chirico, Emile Bernard, a Fauve Raoul Dufy, and a Theo van Rysselberghe. For example, van Rysselberghe was not a great painter, but I have perhaps one of his best examples.

I have some things that are really iconic, such as a 1908 Braque that reflects the beginning of Cubism. Of course, I would like to own a 1908 Horta de Ebro Picasso, but I cannot afford that, so I have the Georges Braque. But I think Braque is the equal of Picasso in many ways.

The key is that I did not collect these paintings for investment. Yes, the better part of my net worth is in paintings, but ultimately they will be donated as a collection.

DJ: *What is the time span of your collection?*

SB: It starts in 1869 with Renoir. When I first started collecting, I was buying in the Impressionist area since I did not have much interest in the twentieth century. It is a shame because I missed some things along the way, by artists such as Picasso, René Magritte, and Yves Tanguy; there were wonderful paintings available at the time that were very affordable. Now I do collect these artists and have strong examples of them, but in the early years, I wanted to buy works by Monet, Renoir, Degas, and Pissarro.

But, in the 1990s as the market adjusted, I was able to acquire a number of major works—including works by Monet, Degas, Marc Chagall, Pissarro, Magritte, Paul Signac, Braque, and Léger. My favorite painter of the nineteenth century is Monet; and my favorite painter of the twentieth century is Picasso. I am not saying they are the best, but visually and viscerally—that is what I like. I also have a large sculpture collection as well, which started with my first acquisition of a Rodin in 1984.

At this point with my collection, I am just filling in with things that I think add something. What I have consistently tried to do is to buy the best examples of what I can afford. I would rather not buy something for a while, then eventually buy something really good.

DJ: *How has the collection evolved over time? What were some of the considerations that influenced acquisitions?*

SB: A couple of things were bought for my mom. She particularly liked Renoir and I acquired the *Tête de femme* of 1886 with her in mind, and also the *Head of the Jester*, by Picasso. My father, who was not as attuned to art as my mother, liked Henri de Toulouse Lautrec, and I acquired a 1892 Lautrec of two women making a bed.

Over time, I have filled in many niches and I have groupings. So I have many Impressionist paintings: I have three Monets and four Pissarros, two of which are landscapes. I have a beautiful scene looking down the Seine from 1901. I now own three works by Degas; and one Mary Cassatt—an American—*Simone in Plumed Hat*, which is similar to a work in the Clark Art Institute. I have one Cézanne, which I feel grateful that I was able to acquire. In the area of Neo-Impressionism—Signac, van Rysselberghe, Henri-Edmond Cross, and Maximilian Luce, are represented.

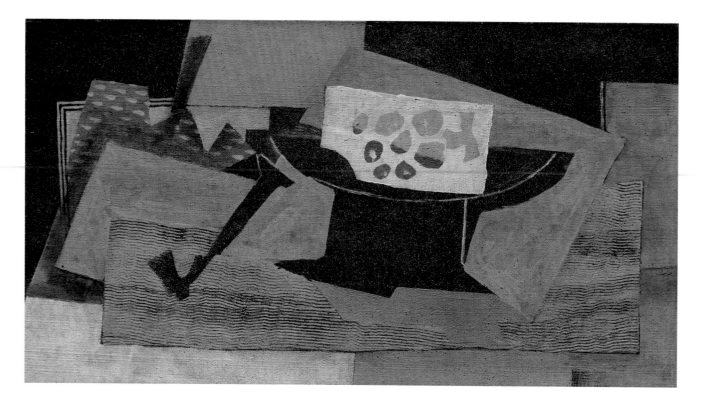

The next grouping is the Pont-Aven school. I recently acquired a Gauguin portrait of his son Clovis; the grouping is completed by a Bernard and a Maurice Denis.

Then there are the Cubists. In my opinion, the two most underappreciated artists of the twentieth century are Léger and Braque, especially Braque, who was very intellectual. Many times Braque is better than Picasso, however, Matisse and Picasso are obviously at the top. I have two Picassos—one from 1914 and another from 1934 that is a double image of his lover, Marie-Thérèse. And I have three Légers—one Cubist work with mechanical elements from 1917 called *The Wounded Soldier*, and two others from 1928 and 1929, both larger scale, *La grappe de raisins* and a still life.

Another grouping is Surrealism. My mother always liked Magritte. She always thought he was whimsical and he made her laugh. Later in life, I started to have a fascination for Joan Miró, and acquired two of his paintings. I was not as knowledgeable about Miró as other artists, but I have started studying his work. I was the underbidder on two more paintings recently in London.

As I said, I have learned through study, although I majored in math and economics and did not take art history. I have also spent much hard-earned money pursuing my passion and I really think you have an obligation to care for the paintings you own for posterity. The other thing I have tried to do has been to be public spirited. I have given money to the Museum of Fine Arts for programming, and not just in my own area. I have underwritten the last fourteen summer exhibitions at the Portland Museum of Art.

In my opinion, the best period in painting was in Italy from 1450 to 1550. These were the best painters. As good as Degas, Monet, and Picasso are, they are not Titian or Raphael. I believe that Raphael is the single greatest painter in history; he is to painting what Mozart is to music. Ironically, both died young—at the young age of thirty-seven.

If I could buy another Braque or Picasso, if the price were right, would I do it? Absolutely, because they are great painters. It is the same with the Degas—I was not particularly in the market for another Degas, but a beautiful one became available this past summer and I was fortunate to buy it. At this point, because prices are so high, the only things at this level worth buying are the top tier. Sometimes, I have gone above the high estimate, and when I have, I have been glad I did; you have to do that to get an exceptional work.

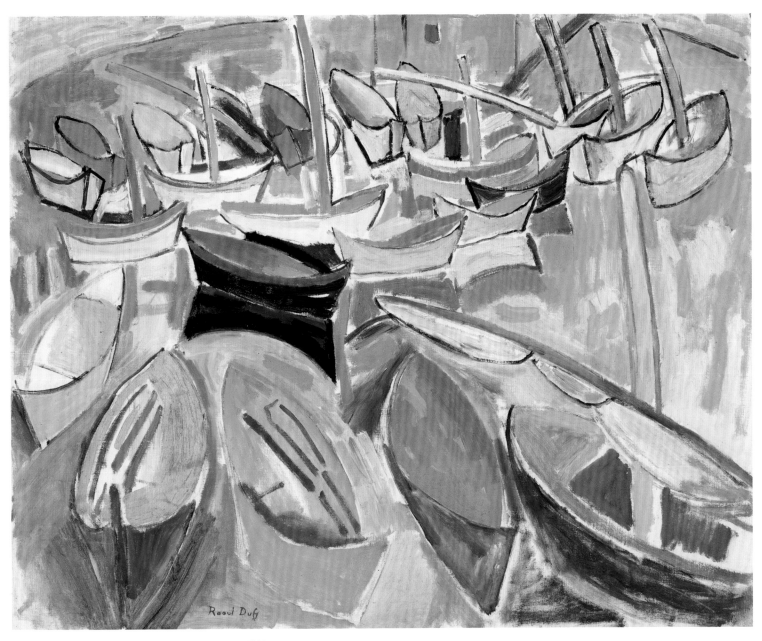

Raoul Dufy (1877–1953), *Boats at Martigues,* 1907.

Opposite page
Georges Braque (1882–1963), *Pipe and Compote*, 1919.

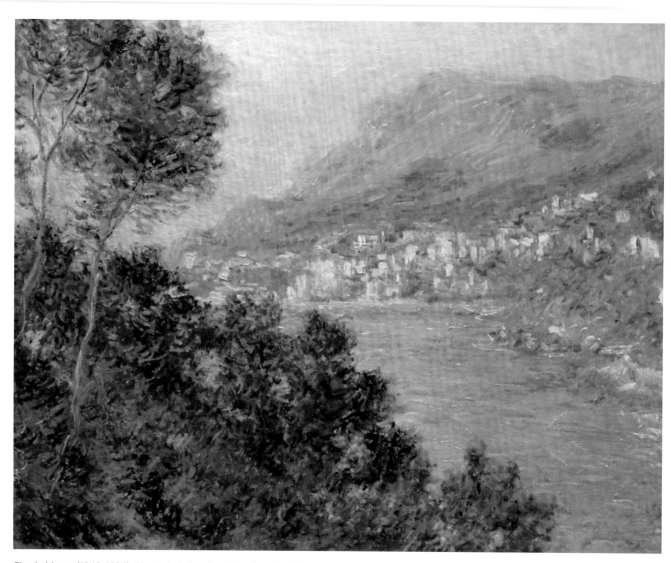

Claude Monet (1840–1926), *Monte Carlo Seen from Roquebrune*, 1884.

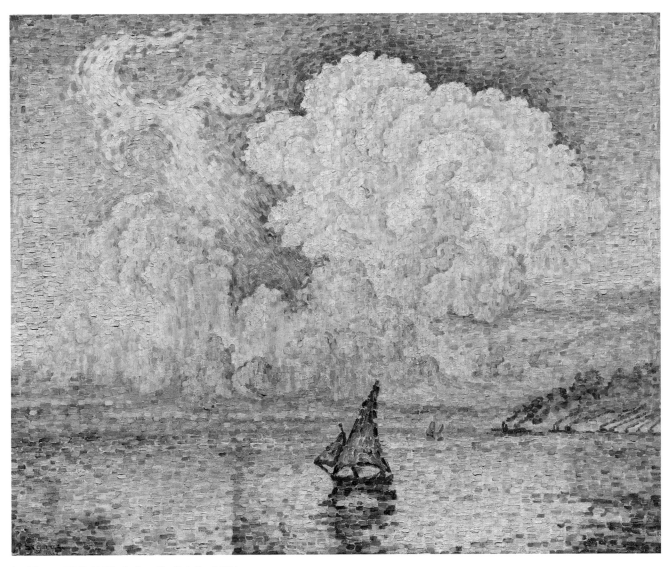

Paul Signac (1863-1935), *Antibes, The Pink Cloud*, 1916.

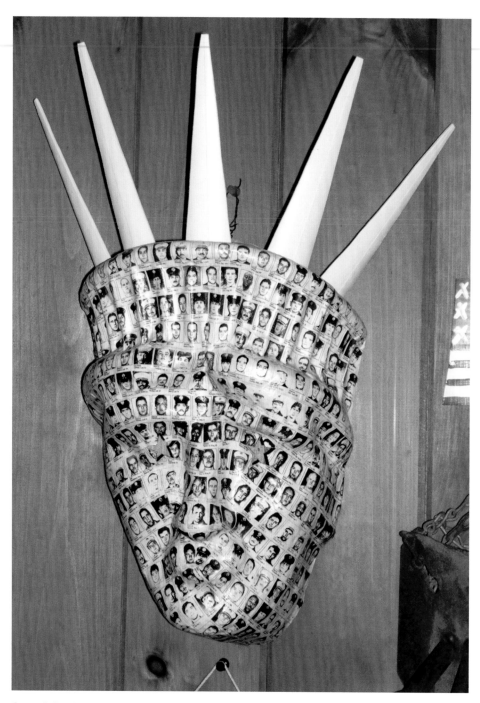

Georgi Dukv, aka, Liberty George, *Lady Liberty's Firemen, 9/11.*

PAULETTE AND LARRY BRILL

Outsider and Found Art

DJ: *How did you begin collecting art?*

LB: I guess it started with traveling with my parents, roaming around barns in upstate New York—I got to look around and amuse myself that way. And I also got to learn—to see the curve of a bowl, the shape of a frame.

Well, the very first thing I ever purchased, just for the graphics of it, was an old American/Polish insurance policy. It had the American flag and the Polish flag, and it was written in Polish and English. It had rubber stamps, signatures, and dates, along with a beautiful reindeer with antlers on it—that is still floating around somewhere.

DJ: *How old were you when you collected that? And how did you progress from there?*

LB: Probably between eight and ten, because I do know that I paid a dime for the American/Polish insurance policy. Prices have gone up a bit over the years.

As a kid, I collected baseball cards and also those tiny gum cards with graphics that were an inch by three-quarters with photos of baseball, airplanes, wrestling, boxing, and many other subjects. And I would just collect things, including comic books. Later on, I had the opportunity to re-experience that time and get all the missing number one comics that I never had, such as *The Amazing Spiderman* and *The Incredible Hulk.*

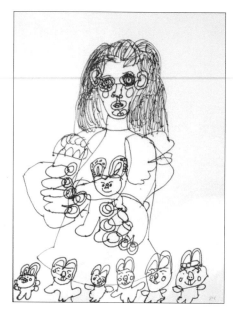

Top left
Dwight Mackintosh (1906–1999), *Untitled.*

Bottom left
Dr. Chill, *Jesus Held a Dead Man's Hand.*

Bottom right
John Mansfield, *Untitled* (*Self Portrait*).

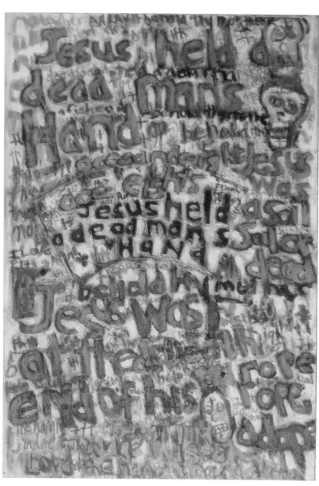

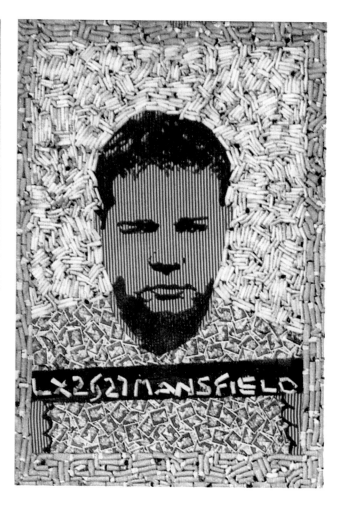

DJ: *I understand you have many collections. How did you come to collect Outsider art?*

LB: Being a designer and a trained artist myself (I studied painting), when I attended Sanford Smith's first Outsider Art Fair, I really thought that anybody could do it. There were things that I liked about it right away—like flash art, including the original signs from which people make tattoos. I particularly liked those from the 1920s, 1930s, and 1940s, with battleships, anchors, and, of course, sexy ladies.

That might have been in 1992, though I do not know what it was that made me first really see Outsider art— it might have been an S.L. Jones drawing. I did not have any education in it and you cannot fake knowing about it. One by one, and day by day, I started collecting and buying, and buying. But I would also just find things— I am always picking up something from the street and creating a collection of it.

DJ: *You have also collected artwork by homeless people.*

LB: Yes. The signs of homeless people can be truly powerful and moving images—desperate at times. I noticed them all over the city and became interested in them and the handwriting on them.

DJ: *Do you consider Outsider art part of modern or contemporary art, or in a category of its own?*

LB: I think it is universal and without any timeframe. These works are by untrained artists putting an idea that comes from within down on paper or wood or with whatever materials are available. Something is making them do it.

But some people, like Mose Tolliver, come to it for other reasons. He was hurt in an accident, and had no other means of supporting himself. He would make signs, drawings, and paintings on pieces of wood, cabinet doors, or pieces of plywood, and sell them on the sidewalk in front of his house for a dollar a piece.

His work ended up in exhibitions of Outsider art, which became an identified genre. He raised his prices and started to mass-produce pieces and had his whole family help. Now, even though Mose's signature might be on something, I can tell if it is his watermelon painting or one done by his daughter, because the pits of the watermelon slice are painted differently. I like his watermelon paintings—I have a wall of them in our kitchen in our upstate house.

DJ: *Where do you see in the future for Outsider art?*

LB: It is becoming a business now—it is highly commercialized. Mose got his first dollar, and then after a while somebody offered him one hundred dollars. That changes the artist's perception of what he is doing.

On my own, I have found people who are doing this just to earn a living, picking up things, and selling them to others. There are new people popping up, and even though they are called Outsider artists, they are not really Outsiders. They use the Internet as their gallery and sell anything they can for a few dollars.

But there are still real Outsiders. I remember buying one or two pieces for six to eight dollars from Steven Chandler and then we started keeping in touch. I encouraged him to keep working. Now galleries and dealers come after him, but he is still having a good

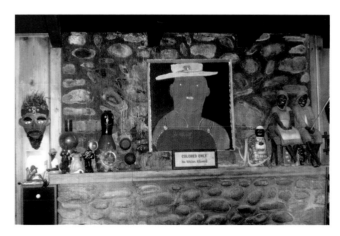

Over mantel: Jimmy Lee Sudduth (1910–2007), *Mr. Imagination.*

Inez Nathaniel Walker (1911–1990), *Untitled.*

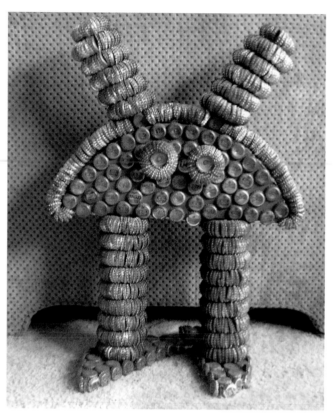

Clarence Woolsey (d. 1987) and Grace Woolsey (d. 1992), *Untitled.*

time and still doing the same level of work. He works with a mixture of paint and red Georgia mud. He loves Bill Traylor's work, and incorporates silhouettes as Bill does into his own images. We talked about him doing a portrait of my wife and myself and my son, but he indicated that he could not paint portraits because he does not do features; every figure is flat and black.

DJ: *How do you decide when to go on to the next collection?*

LB: I collect something until I cannot afford to any more, and then I have to find something else. I do not choose to find it, but somehow, something else pops up and catches my eye. Something will grab me—an image, a shape—and that is all it takes.

I was at a flea market and there were some garden hose nozzles on a table. There were three of them. I looked at them, and I thought they were great small

sculptures, and now there are over two hundred of them lining my window sills.

For me, more is better. Also, I do not like even numbers or two things side by side; three is much better.

DJ: *So do you have a plan for future collecting?*

LB: I do not have any conscious plan for collecting, but there is something I always do. I always educate myself in the thing that I am currently interested in. For instance, for the longest time, I collected old wristwatches. I studied many watches, examined pictures of them, and got books about them and how to repair them. I actually started to tinker with them, but it ended up being too technical and hard on the eyes. I do the same thing with anything I become interested in. If I care about something, I want to know everything about it.

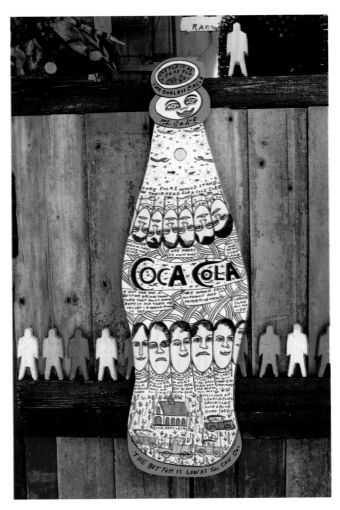

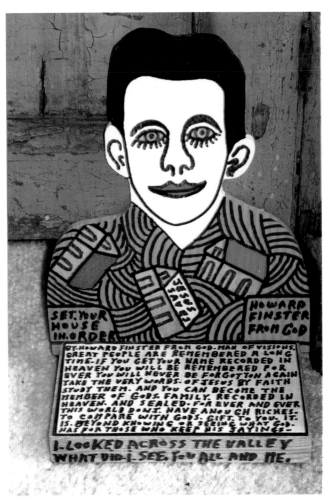

Howard Finster (1916–2001), *Coca Cola.*

Howard Finster, *Self Portrait.*

Lee Godie (1908–1994), *Prince of the City.*

Clockwise, from top left
Lorenzo Scott (b. 1934), *Adam & Eve*

Mose Tolliver (1919–2006), *3 Watermelons*

Palm reader's sign, recto and verso

Mary Klein, *Two Dogs with Red Ball*.

Clockwise, from top left

Philadelphia Wire Man, *Untitled* sculpture.

R. A. Miller (1913–2005), *I Love My Wife.*

Purvis Young (1943–2010), *Dancers.*

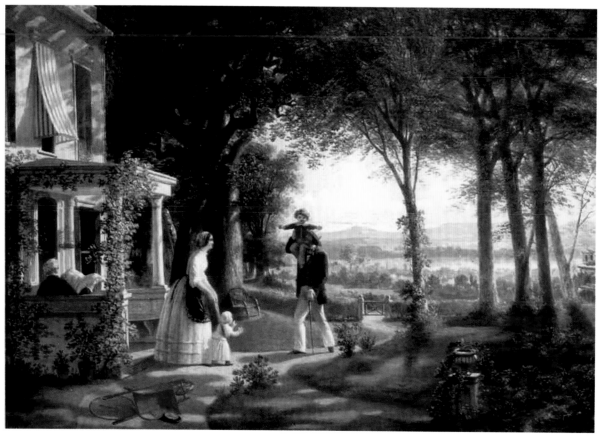

Thomas Prichard Rossiter (1818–1871), *House on the Hudson*, 1852.

Penny and Logan Delany

Nineteenth-Century American and Hudson River School Paintings

DJ: *I would love to know how you started collecting.*

LD: Well, I liked the Hudson River School, but never really thought I would be able to acquire museum quality paintings.

PD: We had young children and animals and we did not want our house to be like a museum. I loved antiques but did not want to have to worry about damaging something.

LD: After our kids had grown we thought about starting to collect. At the time I served as chairman of the Hudson River Museum in Yonkers, New York, and I talked to the director of the museum, who recommended we work with a consultant. So we hired a consultant and started going to auctions and to galleries.

We started collecting in 2000 and acquired a handful of paintings at that time. I found I really enjoyed the whole process—learning about the paintings, going to galleries and auctions. Since then I have been to just about every major American art auction.

I spent a lot of time learning about the art, acquiring art books, and eventually, after a couple of years with the consultant, I decided to do it on my own. I have always loved art, but initially I was too intimidated to walk into galleries, because I did not know what I was looking for, and what was good and what was not. I also did not know whether the prices were appropriate. There was no clear information about that; the Internet has made it much easier to find out about pricing and to research the history and provenance of artwork.

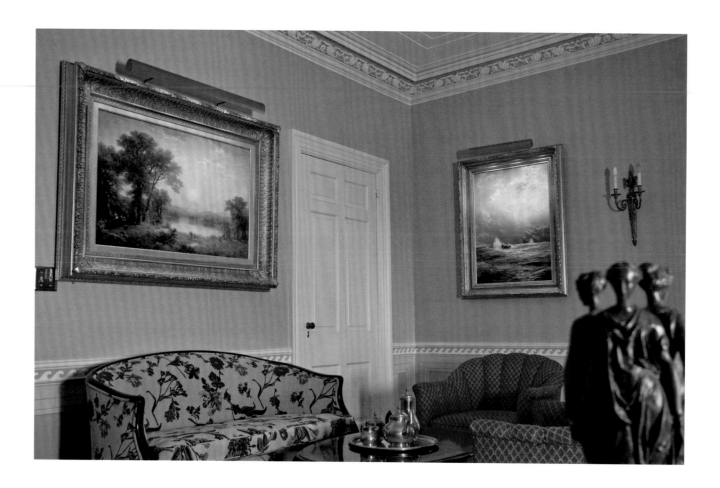

Above

On wall, from left: Asher B. Durand (1796–1886), *The Picnic, Bolton, New York*, 1863; William Trost Richards (1833–1905), *Kettle Cove, Narragansett Bay, Rhode Island*, 1889.

Left

George Inness (1824–1894), *The Passing Shower*, 1865.

PD: The pricing of art is really important to Logan because he is a businessman and for him it was more than just the painting and the painter; it is about where an acquisition fits in the market.

He spends hours and hours researching that for any work he is interested in. He will compare it to all the other paintings by the same artist that have been sold, as well as to similar paintings by other artists. He studies the art, the genre, the artist, and the pricing.

LD: I have a database of about 16,000 images of American art, from the nineteenth to the early twentieth century that I have seen either in person, on the Internet, or in magazines, so that I can review the works and see where they fit in.

It is amazing how many times I come across the same paintings again and again. The database has been helpful in this respect so I do not have to rely on memory. I know exactly where I saw it and how much the dealer was asking for it, so it makes me feel more comfortable about knowing the value of what I buy.

DJ: *And Penny, how does collecting fit in with your own work as an artist?*

PD: Well the paintings that we started collecting aesthetically fit into what I am attracted to as a painter. I studied art history in college and I paint botanicals. Contemporary and modern art do not appeal to me particularly, but I am drawn to nature and landscape subjects, so nineteenth-century painting was the perfect place to start collecting.

That is the other thing, I have always been drawn to classicism and that was really what attracted me to the aesthetics of the art that we started collecting.

LD: We are also moving into the early modern era—toward Impressionist works and the Ashcan School. We have also considered works by George Bellows and his mentor, Robert Henri—both subjects from Monhegan Island in Maine. The Bellows is from 1913 and the Henri is from 1903. But we live in the Hudson Valley, so there is a real connection with the Hudson River School painters and the paintings of the region.

PD: We have been traveling to see some of the places where artists actually painted. We went to see Kaaterskill Falls and some of the other places that are the subjects of Hudson River School paintings.

My favorite artist is William Trost Richards. I just love the way he captures detail and the essence of the ocean in his seascapes.

DJ: *Do you have a favorite painting?*

LD: It has changed. The Thomas Rossiter—if I had to say one painting is our favorite—would probably be it. What would you say?

PD: It evokes feelings that I really love. He is not the most famous artist and it may not be the best picture that we have, but it is a homecoming scene and is just lovely. The light in the painting, the sun—the late afternoon or early evening sun is dappled; it is a wonderful genre scene of everyday life.

DJ: *Are there any stories that come to mind, like the painting that got away?*

LD: There was a painting that was traded away. We had a beautiful William Trost Richards seascape, which I traded for a Sanford Gifford Kaaterskill Falls painting. The Richards was a beautiful painting, there is no doubt about it, but I thought the Gifford was a more important and rare effort that fit more within our collection.

PD: Well, Logan has a method to his collecting, and he wants to have one of everything. He wants to get the major artists, so when the opportunity for a Gifford came up, he thought that since we already had another Richards, we could spare that one. We have four Richards right now.

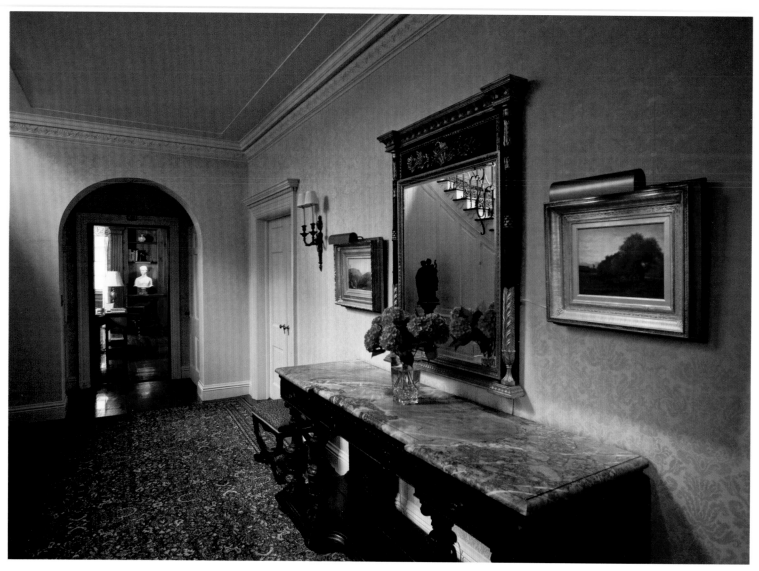

Above
Through doorway: Hiram Powers (1805–1873), *Prosperpine*, c. 1849, marble.
On wall in foyer, from left: Sanford R. Gifford (1823–1880), *Twilight Park*, c. 1860;
George Inness (1824–1894), *Sunset*, 1866.

Opposite page
Martin Johnson Heade (1819–1904), *Roses in a Vase*, c. 1883.

In terms of a painting that got away, when we were first collecting, there was a Francis Silva that I liked very much. There also happened to be a Samuel Coleman, almost identical to the Coleman we have right now, that was up for bid at the same time. The Silva was a Hudson River painting with a sailboat. At the time I felt very uncomfortable bidding over $100,000 since we had just started collecting and this was only our second or third auction.

But I also saw a very similar Silva with a dealer right before the auction, so I did not aggressively go after the one at the auction, because I knew I could get the other one. However, I think some collector in Boston outbid me.

PD: There are a couple that I wish that you had gone for; one was a painting of crab apple blossoms by Martin Johnson Heade.

LD: There are things that we have not gotten because when you walk into an auction, I believe you must have a maximum price, and you do not go above that price. What I do is pick a number that I think is a fair price for me, and if somebody gets there before I do, I will go one tick above it, and then stop. However, there are special paintings that will never come up again, and if you want it, you may have to pay an inflated price or lose the painting. Personally, I have never put myself in that position. There is always another great painting coming up for sale that I will enjoy at the right price.

Now what is true and what I think is very difficult for a novice collector to figure out is whether the pricing on paintings is an exponential function of quality. So something that is A- quality is two or three times the price of a B quality painting; and something that is an A+ may be ten times that of a B quality painting. But you still want to be on that value curve and you do not want to overpay for the quality. There is a value ratio for a particular quality and that is what you want to pay. I do not believe that you should overpay for anything. You pay what you need to pay to get a particular painting and if you do not get it there will always be another one coming around.

PD: See what I mean about the more business-like approach? Not everybody approaches it that way.

I wanted to add one thing. Our collecting style revolves around all the work that Logan does; he does all of the background work and research. He looks at the works—goes to the galleries or auction previews— and shows me what he likes; then I am the veto person. And I go and look.

LD: My interest is in the history—where the artist fits in, and where the particular painting fits in his genre or his oeuvre. Penny is more inclined towards the aesthetics.

For the most part, we buy paintings or sculpture and then worry about where we are going to put it. We do not do it the other way around. And that is the story of our collecting.

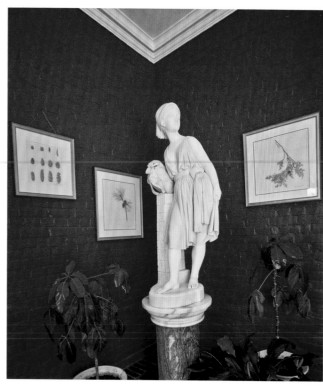

Left
Penny Delany, *Botanicals*; Greek statue.

Below
John F. Francis (1808–1886), *Still Life with Apples,
a Basket, and Chestnuts*, 1854.

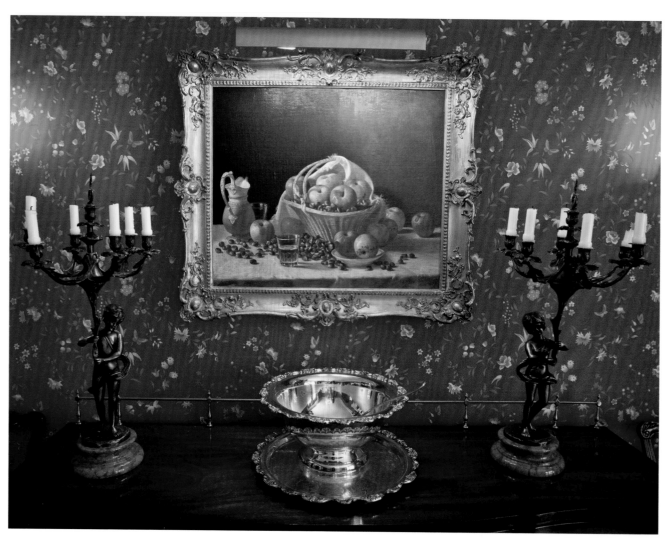

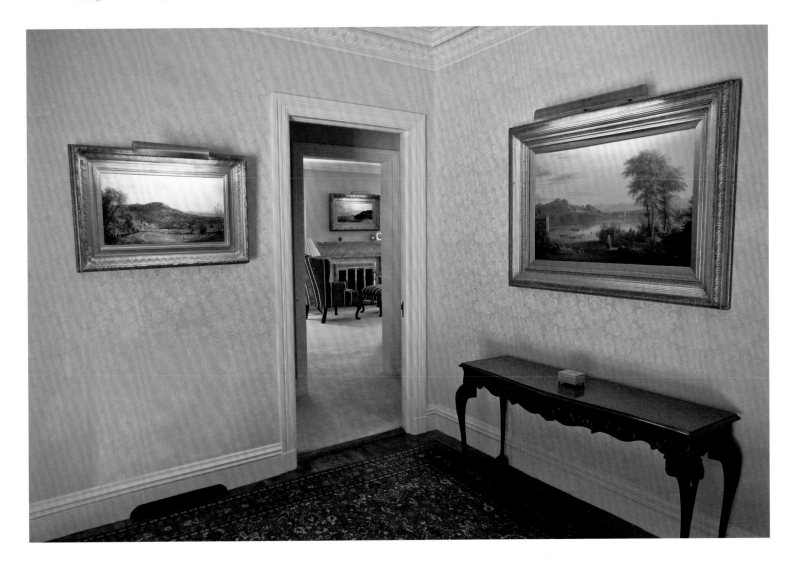

Left
William Mason Brown (1828–1898), *Still Life with Watermelon, Grapes, Peaches, and Plums,* c. 1870.

Below
From left: Jasper F. Cropsey (1823–1900), *Autumn Landscape,* 1879; Henry Ary (1807–1859), *View of Mt. Merino from Hudson, New York,* 1851.

Through doorway: Alfred T. Bricher (1837–1908), *The Coast, Beverly, Massachusetts,* c. 1885.

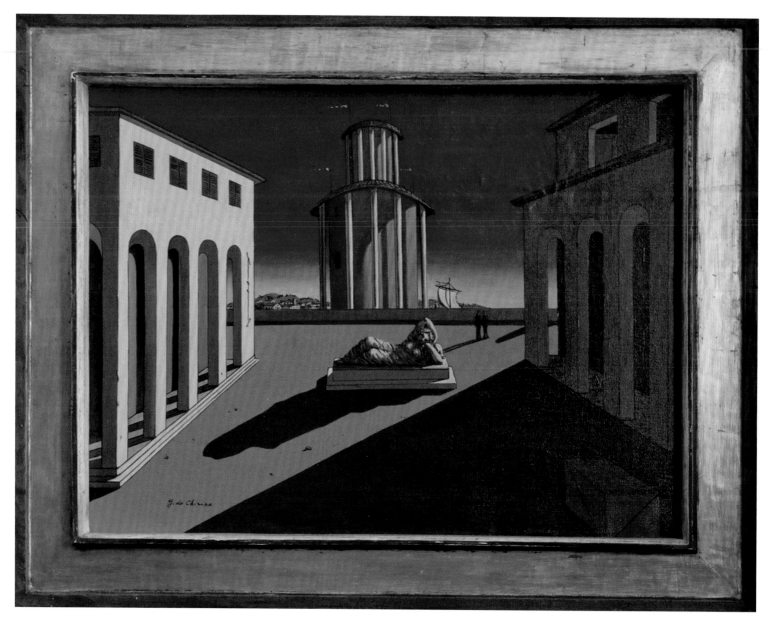

Giorgio de Chirico (1888–1978), *Piazza d'Italia.*

CAROLYN COHEN AND ALAN DERSHOWITZ

Modern Masters and Judaica

DJ: *So let us talk about your collection. What inspired you to begin?*

AD: It was just a natural extension of my desire to be surrounded by beauty. I love to sit in a room with beautiful art, whether it is in a museum or, even better, in our own home.

DJ: *Did you always have this passion for art, even growing up?*

AD: I have always loved art and have always gone to museums. I went to a high school in Brooklyn near the Brooklyn Museum. It was a terrible high school and I got a poor education. I got suspended with frequency and the first place I would go was to the museum. I would go from room to room, and got to know the museum very well.

When I was a law clerk in Washington, D.C., my job in the Court was across the street from the National Gallery, and every day I would spend my lunch break in the museum. I would pick one painting and I would sit in front of it and just closely look at the painting and get to know it intimately. And so, I have always had this passion for art.

CC: I spent all my time at the Museum of Modern Art—I loved MoMA.

AD: We still do. Our best dates in New York are at MoMA.

The great thing about MoMA is that there is always

Opposite page

On wall: Hunt Slonem (b. 1951), *Dr. Gregorio*; Persian prayer rug; Albert Alcalay (b. 1917), *The Cove*; Joan Miró (1893-1983), *Couple d'oiseaux*; Menashe Kadishman (b. 1932), *Head*; Ossip Zadkine (1890-1967), *Intimate or Narcisse*.

Sculpture by Diane Feldman, *Tumbling Figure*; Leo Sewell (b. 1945), *Dachshund*; Artist unknown, *Contemplation*.

something new, but then you go back to the old. You see *Picasso's Girl Before a Mirror* and the *Demoiselles d'Avignon*. And it is like going home again—it is such familiar art.

I have so missed the Picasso painting *Guernica*, which was sent back to Spain. I grew up seeing it in MoMA. The first thing I did when I went to Spain a couple years ago was to visit the painting there.

We find art in the oddest places. We have found art in flea markets in Paris, Poland, on Martha's Vineyard, and in the auction houses of Sotheby's and Christie's.

We do not have exactly the same criteria. There are ten pieces of art that we have very strong differences about, but I think that on most of the art there is a consensus between us.

CC: Alan and I overlap on almost everything. We like playful things mixed in with the serious. Neither of us takes it so seriously that it has to be pristine.

AD: My criteria is that I do not care how important the piece of art is, it has to be beautiful, and that is true not only of paintings, but of Judaica or Americana. And then it has to have a special significance to me, and to us. It has to resonate in some way. We love transitional art—work by artists who are in transition. We have a beautiful Picasso watercolor from 1907 in which the artist is moving toward the Blue period. I love that piece.

We also have transitional works by Joan Miró, Chaim Soutine, and Marc Chagall. It is always nice to see an artist in process, rather than doing the same thing over and over and over again. We have a very conventional Chagall, but another work that is not conventional at all.

We have an eclectic range of artists, including Andy Warhol, René Magritte, and Egon Schiele. I also love faces and heads, whether on a piece of scrimshaw by a sailor five thousand miles away from his loved one, who takes a whale tooth and a piece of whale bone and ink, and draws, or by Picasso, or a Roman artist.

CC: We used to like to collect portraits a lot. I remember thinking that this house was not a good place for a paranoid person, because everywhere there was a face or head looking at you, but they have been dispersed a bit.

DJ: *Do you bargain with dealers, even for works you really want?*

AD: For me, bargaining is part of the whole process, although I feel badly about it sometimes. On the Vineyard, I do not bargain with people at the flea market, particularly with people I know, because it means so much more to them. I feel bad since I do not really want to take a hundred dollars from someone who really needs it. But everywhere else, I bargain.

DJ: *Did either of you grow up with art?*

CC: I grew up with art in my house. I grew up in Charleston, South Carolina, which has wonderful historic things.

So I certainly grew up with an appreciation of art. It was a matter of affording it. When I married Alan, I had a collection of masks and some pieces that I really loved. I was a graduate student and could not afford anything else.

AD: I did not grow up with art. There was nothing hanging on the wall of my home and there were no books. And then my mother, for a short period of time, got a subscription to the *Reader's Digest Condensed Books*. So I had about ten volumes of that in the house. When I got into high school, I went down to the local bookstore and I bought an old, used set of the *Encyclopedia Americana*. And having the *Encyclopedia Americana* and being able to read about things was eye-opening.

And also the *Americana* had beautiful art pictures. So if you opened up to Picasso, they had just gorgeous paintings by Picasso, and gorgeous paintings by Henri Matisse. And of course, I grew up when all these

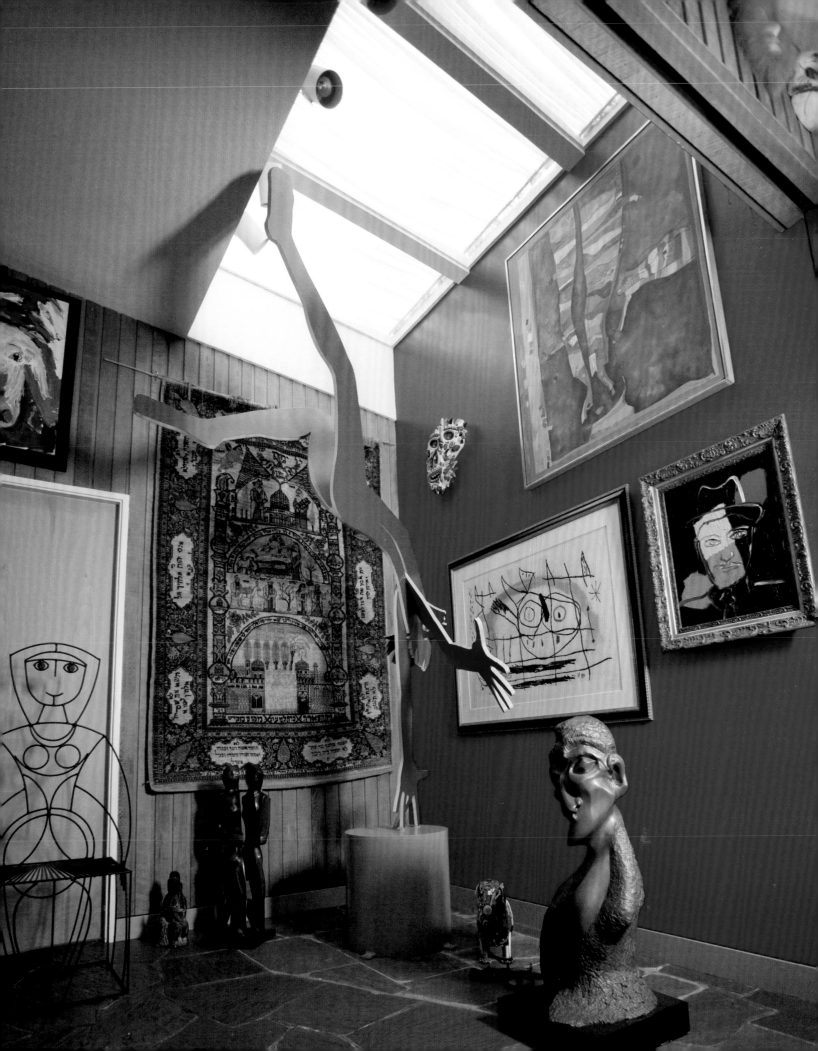

Below
Among the works in the entrance hall are a Xian warrior; David Hockney (b. 1937), *Joe with Green Window*;
Andy Warhol (1928–1987), *Black Rhinoceros*; Fernand Léger (1881–1955), *Profile et peroquet*; Marc Chagall
(1887–1985), *Le martyr*; Marc Chagall, *Cirque au clown jaune*; Andy Warhol, *Howdy Doody*; Amedeo Modigliani
(1884–1920), *Soutine*; Jean Cocteau (1889–1963), *Untitled*; Jakob Steinhardt (1887–1969), *Der Sabbathabend in
Der Stadt*; Bela Kadar (1877–1955), *Two Figures with Horse*.

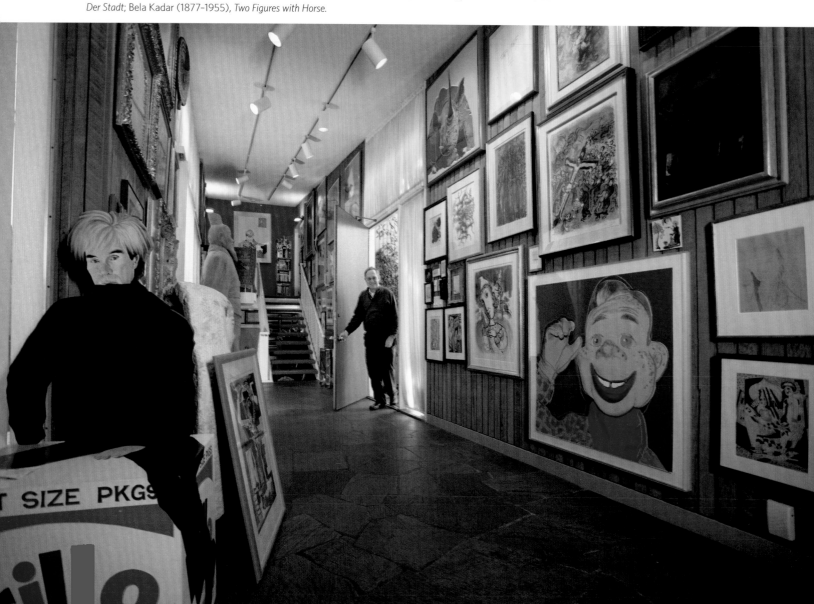

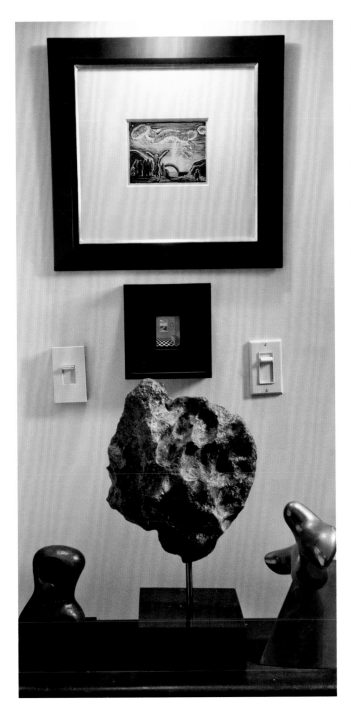

On wall, from top: Rockwell Kent (1882–1971), *Untitled*; Loretta Cuda (20th century), *Red Chest*.

On table, from left: Henry Moore (1898–1986), *Cyclops*; a meteorite; Jean Arp (1886–1986), *Geometrique–Ageometrique*.

people were still alive. So I remember the day Picasso died. I remember the day Matisse died. I remember reading in the newspapers about the death of all these people who are now regarded as icons of twentieth-century art.

I went to Brooklyn College, which had a phenomenal, innovative art department. It may have been one of the best art departments in the world. Among the professors was Ad Reinhardt. Jackson Pollock was a visiting artist there and also Jimmy Ernst, the son of Max Ernst, as was Mark Rothko and Louise Nevelson. Many of the great artists of the period passed through there. And I went to every single art lecture I could and I met some of these people. So I really began to love art.

DJ: *Alan, was your first purchase of art made when you were at Harvard?*

AD: When I was on the faculty at Harvard University, the dean sent me to Paris and London to give me some culture. I was the only Harvard professor who had never had the opportunity to travel abroad, so he figured out an excuse to send me there, claiming I should look at some criminology institute.

I spent my time there in the museums and the galleries. I did not have much money, but I acquired a Kandinsky lithograph, a few Daumier prints, and a painting—the first I ever owned—by a Lithuanian artist named Kaziulis, which I still like to this day. Carolyn does not like it and so it is relegated to my office with the other works that Carolyn does not like. And my judgment on Kaziulis in terms of value was not particularly rewarded by history, but my judgment on Kandinsky was.

I actually looked at a Chagall in those days, and I could have had it for about two thousand dollars. It would be worth considerably more now, but I just did not have the money. But I loved it—it was a small circus painting.

DJ: *Do you have favorite works in your collections?*

At right

Wassily Kandinsky (1866-1944), *Kleine Welten II.*

Below

Works on rear walls include: Mane-Katz (1894-1962), *Portrait of a Young Man*; Jean Dubuffet (1901-1985), *Amoncellement a la corne*; Franz Kline (1910-1962), *La terre bleue*; Fredrick Prescott (b. 1961), *Kong Time*; Moise Kisling (1891-1953), *Saint-Tropez*; Moise Kisling, *Landscape*; Samuel Bak (b. 1933), *In Line*; Maurice de Vlaminck (1876-1958), *Fermiere dans sa cour*; Greek or Roman mosaic depicting the north wind.

To left of fireplace: Jacques Lipchitz (1891-1973), *Miracle II;* an Egyptian sarcophagus.

On right wall: Keith Haring (1958-1990), *Totem.*

The rug was designed by Carolyn Cohen and Karyn Mendelson.

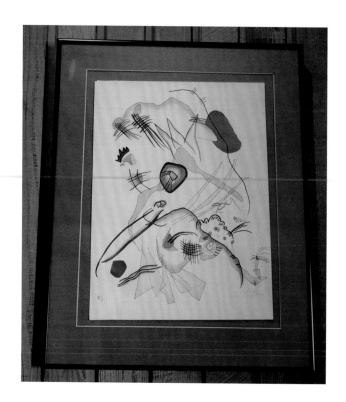

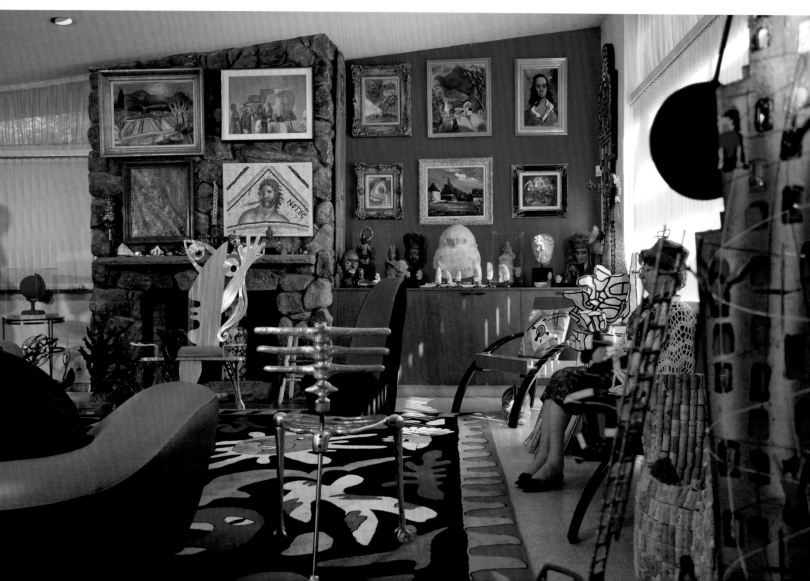

CC: Oh yes, I love the de Chirico.

AD: I think we both would say that that would be our favorite.

That was an interesting thing. We saw it in a catalogue and we both immediately fell for it. I rarely do the bidding in person at auction. This time I decided we wanted it so much that, although we had a limit, I went there and as soon as they announced that painting, I stood up with my paddle and did not sit down. I was going to get that painting no matter what the bid was. I apparently scared off other bidders and I got it at a reasonable price.

DJ: *Do you ever sell any art?*

AD: We have never sold a piece of art, though there are a few we could. But out of the two hundred or more works, we love most everything.

DJ: *Do you just buy what you see and love?*

AD: I would never do what some collectors do—hire somebody to find art for me. The collection has grown organically and by circumstance.

For example, we have the Soutine, an Ossip Zadkine, a few drawings by Amedeo Modigliani, and a painting by Moise Kisling now. It turns out that these were four artists who happened to be Jewish. And the four of them lived in the same house at the same time in Paris. And we accidentally had art by all four of them.

One difference between us is that I like to put things in some relevant order though Carolyn does not like that. She much prefers just to have the art arranged more aesthetically, so we compromise.

DJ: *What other ideas would you offer to new collectors?*

AD: I would recommend starting with museums, obviously, and then I would go to a lot of auctions. I think that auctions do a few things. First, it gives you a much

better sense of the market—galleries do not give you a sense of the market, because the art in galleries is more a function of where the gallery is. But the true market is determined by auction, for the most part. Auctions are also fun to go to and you meet interesting people. You see how people bid and it is entertaining. Any event in which you are looking at art close up is very important in educating and forming taste.

And then there is the prospect of finding a work of art that you just cannot do without. Of course, you do have to set limits for yourself. Only once or twice have I violated my own internal rule of what I was prepared to bid. Three or four times I have regretted not bidding more, since I felt terrible that I had missed a piece.

DJ: *The one that got away?*

AD: You never know if you could have gotten it, because if you had gone higher, the next guy might have gone up astronomically. However, I think I do have good judgment about the value of things, which is something you develop when you follow the market.

One way to get a bargain is to find a work that has little to do with the category of work being auctioned. A number of times in Judaica sales, for example, I have found pieces that have nothing to do with Judaica; they just happened to be by an artist who was Jewish. For example, I got a terrific bargain on a Chagall because it has a crucifixion scene. And it was at a Jewish auction.

DJ: *So you live with your art and enjoy it?*

CC: I love this great Pharaoh's sarcophagus head, because I think, "did this guy ever dream he was going to be in this modern house in Cambridge?" I love the continuity of the centuries. You don't know where things will end up thousands of years from now.

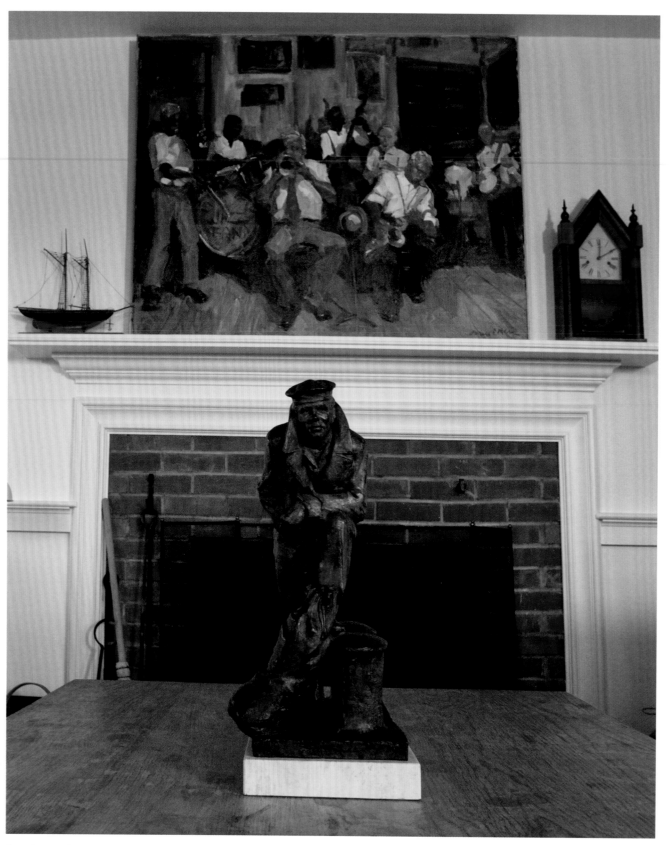

Over the mantle: James Kerr (b. 1953), *Preservation Hall, New Orleans Jazz Band.*

On table: Stanley Bleifeld (b. 1924), *Liberty Hound.*

ANNE GALLAGHER

Contemporary Regional Painting

Above
Anne Gallagher with *Abstraction* by E. Hunt.

DJ: *Would you share some of your ideas about collecting?*

AG: The desire to surround myself with art was an instinct that came to me naturally. I collect it for the pleasure of living with art. I bought my first original oil painting when I was in sixth grade. My family had driven from Illinois to a family reunion on Cape Cod, Massachusetts. In one of the gift shops and galleries that lined the streets was a very small oil painting (about one-and-a-half square inches) by a Cuban artist, which depicted a tropical scene in bright colors, with tiny details. I remember being fascinated with how it could have been possible for someone to render a scene in such small and precise detail. My mother advanced me the $3.25 it cost to own the painting and I paid her back over time from my weekly allowance.

My formal art education began at twelve years old when I attended art classes at the Art Institute in Chicago. It came as no surprise that after high school, I majored in art at Bennington College. Newly married and living in Lincoln, Massachusetts, I studied art history and took courses at Harvard and at the DeCordova Museum in Lincoln.

Gradually, my perception of art went beyond the immediate response to the various creative interpretations of feelings and objects. As I gained experience, art became more fully integrated into the larger context of history and culture, and I began to acquire artwork.

I joined the education department of the Boston Museum of Fine Arts, and became a lecturer on topics in European, contemporary, French, Middle Eastern and Asian art. I continued to lecture for twenty years, and

the exposure informed, expanded, and seasoned my artistic appreciation. Visual arts became an essential part of my life.

I am drawn to contemporary art and I collect art of new and developing artists, especially those in New England, where I live. I acquired some early works—in some cases the first pieces of their art that were sold—of landscape impressionist Allan Whiting; architecturally influenced paintings by Paul Arsenault; and works with subtle colors and flat figurative designs by Betsy Podlach.

I have watched as the work and reputations of various artists have grown, sometimes even being involved in the process. Being able to meet and talk to the artists further animates their work for me. Knowing the artist makes their work even more affecting and personal. I perceive it as an extension of them, their unique talents, viewpoints, and personalities.

Traveling has also created opportunities to add to my collection. At the Martha's Vineyard Agricultural Fair I was stopped in my tracks by Deborah O'Farrell Donnelly's *The Prize Winner*, a thickly painted, wildly colored portrait of a blue ribbon bull. She is an artist from Lowell, Massachusetts. In a small upstairs gallery on Block Island, Rhode Island, I found a small bronze sculpture by Stanley Bleifeld, *Liberty Hound*, a maquette of a piece that became part of a World War II memorial commissioned by the U.S. Navy Department. A sketch by Tom Maley for one of his sculptures was in a thrift store art show; and on a trip to Doha, Qatar, I discovered an expressionist painting of women in burkas by Salmon Al-Malik.

Responding to art is for me a visceral thing—immediate and spontaneous. In addition to the transitory impression, a work of art enhances and enlarges the experience for me. I take great pleasure in the act of discovering a piece of art that excites me. The fun of collecting is just getting involved with the work itself and getting in tune with what the artist created. I am not in a position to spend extravagant amounts on artwork (were I able to, I would certainly choose a Vermeer), but I am not intimidated by either the anonymity or recognition of an artist. What affects me and what speaks to me is the work of art itself.

I never consciously thought of myself as an art collector. I do not acquire as an investment. I have no intention of selling my art, but I will happily pass it along to my children, who have begun acquiring art on their own.

My advice to those who would like to begin collecting is to get your feet wet by visiting art shows, museums, and galleries. Artists and gallery owners are usually happy to discuss their work with someone who is sincerely interested. And read as many art publications as possible.

Begin what will become a lifelong love affair. Open your eyes and mind in order to respond to new and different approaches. Make decisions about what you want to own based on an educated eye, informed reaction, and personal response. You might have to pay for a piece in installments, but you will wind up keeping it much longer than other household acquisitions.

If you are affected by original creative work enough to own it, jump in. If you see something you love, if you are drawn to it, informed by it, educated by it, and really want to live with it—take the plunge. It is a joyful process.

Allen Whiting (b. 1946), *Scalloping.*

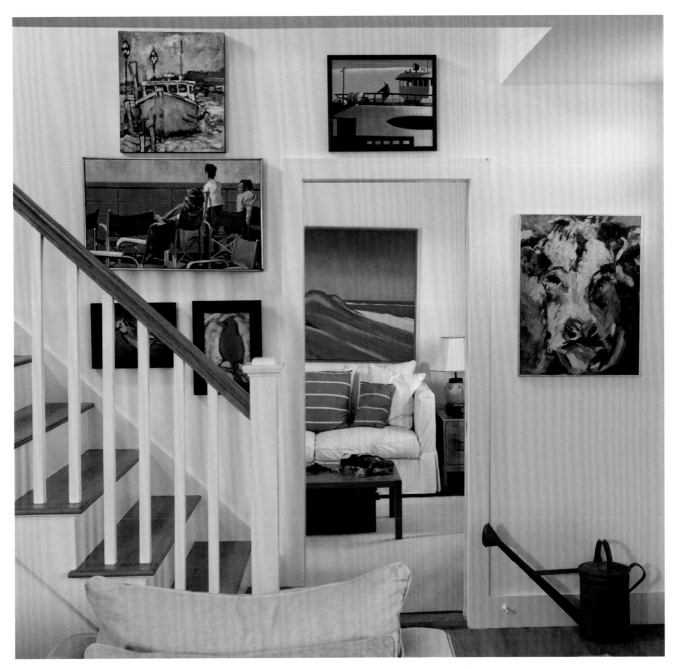

On wall, left of doorway (from top): Traeger DiPietro, *Menemsha Harbor*; Earle Radford, *Vineyard Sound*; Jacqui Mendez-Diez, two paintings of birds.

Over doorway: Ken Vincent, *Last Call*.

Through doorway: Allen Whiting, *Black Point Pond*.

To right of doorway: Deborah O'Farrell Donnelly (b. 1978), *The Prize Winner*.

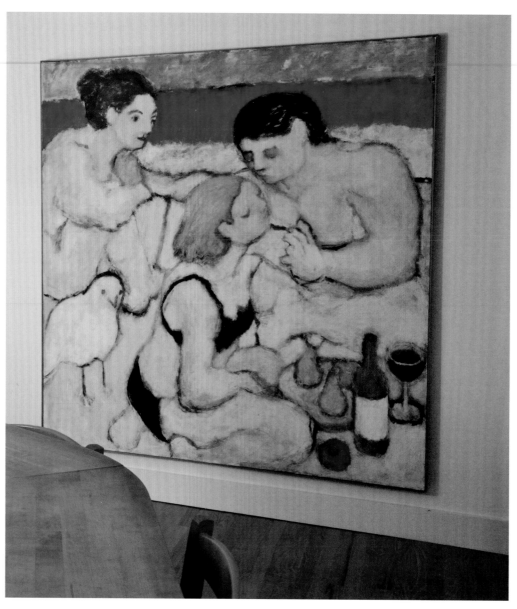

Betsy Podlach, *The Beach*, 1998.

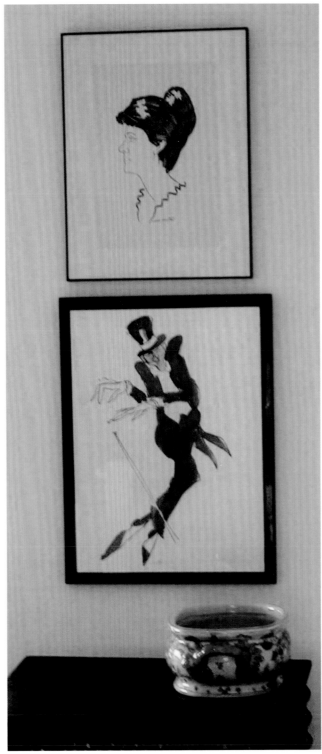

Above
Salmon Al-Malik, *Women in Burkas.*

At right
Abel Chretien, *Olga Hirshhorn (Mrs. Joseph H. Hirshhorn).*

Jules Feiffer (b. 1929), *Top Hat of Fred Astaire.*

Works in the living room include: Dan Tribe, *African Dan Mask*; Christine Sefolosha, *Birth Giving*; two paintings by Sava Sekulic, *Hiroyuki Doi*; five paintings by Bill Traylor, *Black Dog, Blue Pig, Blue Cat, Man and Woman Pointing, Man with Checked Shirt and Cane*; Scottie Wilson, *Autobiography*.

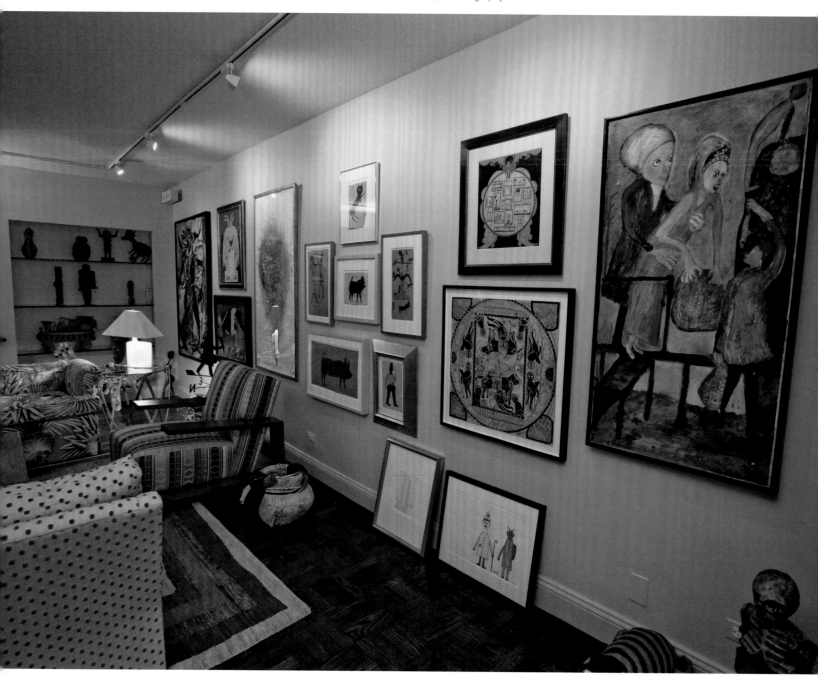

AUDREY HECKLER

Outsider Art

DJ: *What originally inspired you to collect art?*

AH: I always liked art, and growing up in New York City, I had a lot of exposure to it. I used to go to the museums on the weekends and I developed a real passion for it. When I first married, an uncle of mine gave us some money. We spent our honeymoon in Europe and I bought a piece of art. Then whenever I got extra money or wanted a present, I would buy a painting. It was not Outsider art, but the things I selected had a little something that was different. And so that is how I started.

Eventually, my personal circumstances changed and I moved back to the city. On one occasion, possibly in 1992, I happened to see a sign for the Outsider Art Fair, and I decided to attend. I was overwhelmed by the art I saw there and I bought a piece. And I went back the next day, and I bought another piece by the same artist. I saw all this wonderful art that I could afford, and that was how I got hooked.

At the fair, I joined the American Folk Art Museum. They organized a trip to Alabama and we went to see Thornton Dial, Lonnie Holley, and Charlie Lucas, and some of the galleries down South, and I started to buy pieces. During the early years, I stayed with Southern art. I had an upper amount of what I would spend, and it just became a continual pursuit, and I never stopped.

Above
Audrey Heckler in the foyer. On the wall are six paintings by Carlo Zinelli (1916–1974).

On table: James Castle (1899–1977), *Construction (Pink Bird)*; James Castle, *Silver Bowl and Black Rooster*; David Butler (1898–1997), *Whirligig.*

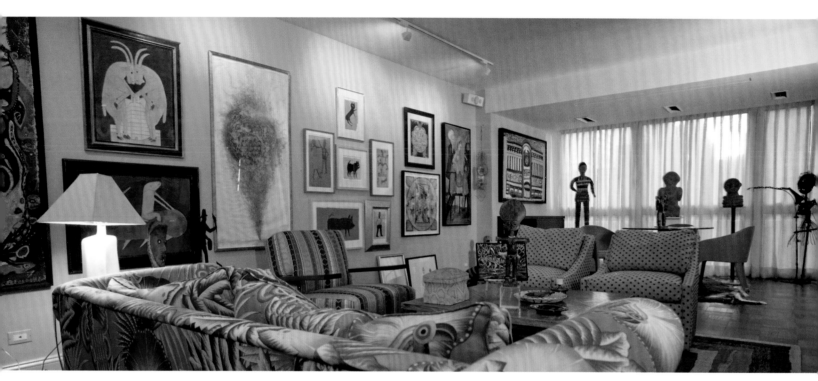

Sculpture in front of windows, from left: Nik Chand, *Sculpture of Glass Bracelets*; Sam Doyle, *Angel*; Barbara Muller, *Face*; Charlie Lucas, *Music Changed My Life But I Put on My Little Grass Skirt and Danced.*

DJ: *Where do you find Outsider art?*

AH: I acquire from dealers. They have the best pieces. I was not a party to the early days, when people went to the artist and bought directly for very little money.

DJ: *Where do you house your collection?*

AH: I have some things in my house in Katonah, New York. I really hate to store art, because then what is the point of having it? I love to see everything. I am getting to the point where the house is pretty filled up now and I do not know how I will handle it when I run out of space. But I want to live with these works on the walls—these are my friends. They do not talk back to me, but I see them every day and they are part of my life.

DJ: *Do you consider Outsider art a form of its own or is it part of modern and contemporary art?*

AH: I consider Outsider art to be a form of its own. It originally started in France with Jean Dubuffet, who became disillusioned with the Academy and the discipline of art. He decided he wanted to find something real and began looking around Europe in unconventional places such as mental institutions. He became so excited by what he saw. He labeled it Art Brut—because he saw it as very real and uncontaminated art.

DJ: *Is Outsider art defined by the personal history of the artists rather than by the professional art world?*

AH: Yes. This art comes from the person who has a need to create, and it often starts later in life. Even though these people might have doodled or drawn when they were younger, they did not come to it fully until some sort of transcendent experience occurred. I just have such a connection to the raw and real emotion of the expression. It means something to me, and to me, it is real art.

DJ: *What do you see as the future of Outsider art? Do you see more museums showing it?*

AH: There are not that many museums that exhibit Outsider art. And as I understand, the curators of mainstream art museums are educated according to European academic methodologies of art and they do not know where to place this genre within the traditional historical canon. In some cases institutions like the Studio Museum in Harlem have reclassified artists like William Edmondson and Bill Traylor as part of the beginning of modernism—something to which they were really unconnected. Gradually, you see some museums, like the Museum of Modern Art in New York, including Outsider artists in theme shows, but not too often. The galleries do not show it, except dealers that have been showing it for ages, and even they have had a tough time, but they stuck to it since it is their passion. So the public has not been exposed to very much of it. I do open up my house and feel I have to share this collection. I have a wide range of artists' work represented, so people can see the variety of expression in Outsider art here, since I have more of it than do most museums.

I think the dealers that devoted themselves to Outsider art should really be credited. There are a number of them around the country—basically in Chicago, Philadelphia, California, and New York, besides dealers in the South.

They remained very committed to showing this type of art. There was a time when they could not give much of this wonderful art away. It was a real struggle. Even now, it has not reached the mass popularity that hyped contemporary art has.

DJ: *And would you have words of wisdom or advice to people that want to collect this? How would they go about it? Or what would you tell them?*

AH: I would tell them they should attend the Outsider Art Fair in New York to start, because a lot of dealers are represented, and you see different types of art. And then visit the dealers and galleries, look around, and get acquainted. That is not hard, since there are so few galleries that specialize in Outsider art. You have to love it—I am enamored of the passion behind it, and it is also affordable.

Martin Ramirez (1895–1963), *Landscape*, c. 1948–63.

DJ: *What is it that distinguishes Outsider art from other mainstream genres?*

AH: Well, what makes the art Outsider is the fact that these artists are self-taught. And as I said, for most of them it came later on in life, and it came just from within themselves. Nellie Mae Rowe lived down South and wanted to decorate her yard. For David Butler, with his whirligigs and little tin figures, it was a way he could decorate his house and yard.

Without the means to obtain good tools and materials, Outsider artists worked with whatever was available. They just made art out of whatever they had at hand or could find. Much of it is obsessive, but most of it is also colorful and cheerful—and it is all intriguing. What they create is a phenomenon to me—the colors, spaces, and design of their art. I never get tired of looking at these works, and I always find something in them that I did not see before. It is hard to create Outsider art today, because we are living in a different world, with television and an infusion of information and technology bombarding these individuals with a diverse range of outside influences. It is difficult not to be attuned to modern culture and to remain uncontaminated from it. But there are still new artists being discovered.

DJ: *Do you have favorites?*

AH: It is hard to say, because I really love it all. I love the historical artists like Traylor and Edmondson, but also some of the contemporary artists, like Timothy Wehrle, Christine Sefolosha, and Chris Hipkiss. I do not respond immediately to some artists' work— some things take a little longer. Art is such a very individual thing, but as a collector, you should really love a piece, it should speak to you, and you should feel a visceral reaction to it. I have been very fortunate to be able to buy what I like.

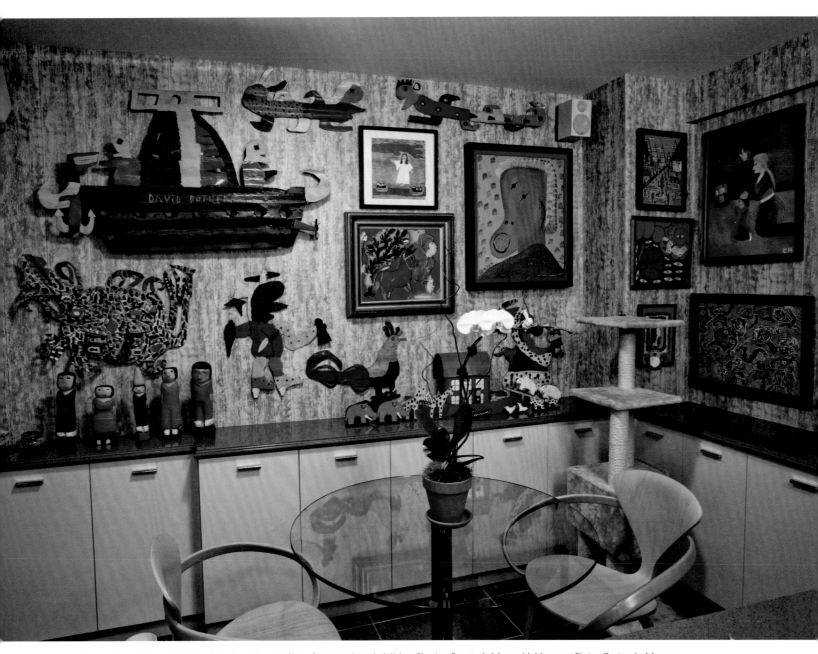

On back wall, from left: David Butler, *Monster Ship, Creature, Untitled (Man Chasing Rooster), Mermaid, Merman*; Sister Gertrude Morgan (1900–1980), *Angel Called Joseph*; Nellie Mae Rowe (1900–1982), *Untitled* (below); Mose Tolliver (1919–2006), *Untitled (Face)*; David Butler, *Untitled*; Rutherford Tubby Brown (1929–2003), *Noah's Ark* (on cabinet).

On smaller back wall, from top: Howard Finster (1916–2001), *The Gap Road*; Leroy Altman, *Angel & the Devil*, 1988; Lonnie B. Holley (b. 1950), *Don't Let Your Child Be a Target*.

Wall at right, from top: Charles Hudson, *Prayer Lesson*; Riet Van Halder, *Untitled*.

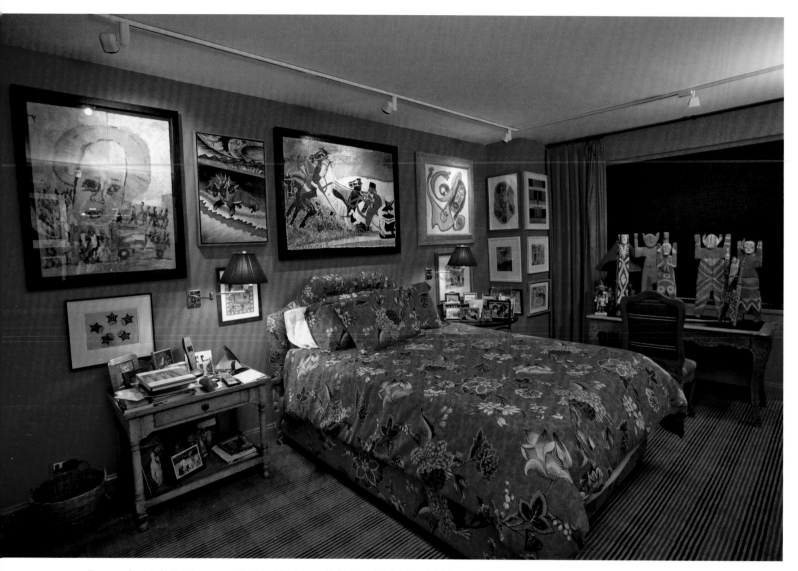

Top row, from left: Purvis Young (1943–2010), *Man with Halo and Yellow Truck*; William Blaney, *Red Beast*; William Hawkins (1895–1989), *Winter Sleigh #1*; Thornton Dial (b. 1928), *Dressing the Window Dummy*.

Bottom row, from left: James Castle (1899–1977), *Untitled*; Adolf Wolfli (1864–1930), *Untitled*; Minnie Jones Evans (1892–1987), *Untitled*.

Untitled sculptures on desk by Charles Willeto: Black-and-white figure with diamond pattern, Pair of Navajo male figures, Navajo male hunter, Navajo female weaver.

On wall at left: Christine Sefolosha, *Tree of Skulls*.

On right wall: Justin McCarthy (1891–1977), *Society Lady* (top); Johann Hauser (1926–1996), *Untitled.*

On table: Pre-Columbian sculpture.

Cynthia Packard (b. 1927), *Memories.*

Rosabeth Moss Kanter

Contemporary Art

DJ: *What would you like to share about how you began collecting?*

RMK: The first thing is that I really do not think of us as collectors. I think of us as appreciating certain kinds of art that we want to surround ourselves with when we come home. In my case, although my husband and I often look at art together, I select a lot of it, and I want artwork that is colorful, powerful, and will make me smile. There is great art in museums that makes me think or stirs up emotions of other kinds, but at home, I want things that bring in warmth and color.

When I was in college I bought my first set of prints at an art show, since prints were all that I could afford. I still like a few of the things that I found in the early days before meeting my husband. Practically everything was bought on the street or out of the artist's home. I would go to street fairs and meet young artists, intrigued by imaginative work with color, warmth, vibrancy, and texture. I particularly like oil paintings, but I started with prints, because they were affordable. After we got married, street fairs were a wonderful leisure activity.

For us, the opportunity to meet an artist, not even necessarily one who is well-known, and to visit his or her studio, can initiate a relationship. This sort of interaction was a turning point that helped us acquire a lot of things, especially in the early years when we were just starting out. Also, for me, knowing the story behind the work and where it came from enhances my experience of the paintings.

We would also visit galleries, though not the high end ones, and certainly not those in New York. We used to go to antique shows, as we were interested in antiques during a period in our life. My husband knows much more about history than I do. We bought a few antiques from Europe at one point, but that was when the dollar was very strong.

I am not concerned about the name of the artist; instead I focus on the feeling I have for a painting and how it would look on our walls and in our living space. This is not a matter of decorating in the narrow sense of matching things and making them look good; it is a matter of what you see when you look at a painting.

I realized that what I liked about landscapes is what I like about the Cape Cod region in Massachusetts, that is, open spaces and seeing vistas. So I want to see vistas inside too. I do not like to be closed in—I flourish in light, so all of these paintings bring in color and warmth, and often light and sky, which allows the eye to travel.

I do not like dark palettes because at home, I want light, air, and joy. A work might look fantastic on a totally empty white wall, in a museum, a modern house, or in a corporate building. But I live in a home where there are a lot of things around, and I want to notice the paintings. I also want paintings to harmonize and not be jarring or out of place, since it is our home where we live with these works.

We liked browsing at galleries, and we would sometimes acquire things there, but most places seemed too expensive, especially when I was accustomed to buying from artists we knew.

Now we have pieces in Boston that come from many parts of the world, some of them reminding us of the joys of traveling together. We also love our summer place; there we have some works that local artists on the Vineyard painted for us. So overall, the art in our lives has much to do with feelings, memories, and with creating a warm environment in our home.

One more thing about the early years: those acquisitions were very often expense-driven, and we were limited by prices. Early on, we happened on a print by the artist Thomas McKnight. Later on, as we could afford them, we acquired two of his oils. By now many of these works probably have gained in value, given what we paid for them, but that is not why we bought them, and it was never because of any idea that they would appreciate.

We could have gotten a lot of work by Wolf Kahn, but we could only afford one large oil. And I now think that we should have bought more, because what felt like a lot of money then would be a bargain now. But as the artists whose work we found intriguing caught on with other people, their prices went up and we stopped buying. So we have early works by three artists that have now emerged.

DJ: *You and your husband Barry share this passion. Do you have to agree on every work you acquire?*

RMK: I would say that we love to explore this together, but I am the driving force behind most acquisitions. I have the overall sensibility, which he defers to, and an interest in whimsy. But we sometimes have bought a certain number of things at craft shows that Barry has at first declared terrible. But they come home and they really look good, or they are very funny, so he supports my decisions and taste. These are works that are not meant to be serious, and they go in places that are appropriate for that. These are not like the high American crafts that people are now collecting.

We have pieces of glass and lamps—some that have come from antique shops are not really antiques, nor are they objects with provenance. If you know what you want the look of a room to be, it is the combination of things, the feeling you get and not how much these things cost or even whether they are fine art. It is the combination of pieces that speaks, and it is hard to tell

Wolf Kahn (b. 1927), *New England Landscape.*

Clockwise, from left: Rez Williams, *Under the Green Car*; Allen Whiting (b. 1946), *Fisherman*; Allen Whiting, *Boat in the Cove.*

On back wall: Artist unknown, *In the Woods*.
In foreground: Artist unknown, *Prowling Leopard*.

which is the important piece of old majolica or the dollar piece of old china from a yard sale.

Barry and I often look together, and we enjoy this as a weekend activity. I do rely on him to steer me toward or away from things, and his opinion matters. Sometimes he will urge me to go ahead, but sometimes I am reluctant on the basis of price or other reasons, such as we have too many similar things already.

Just looking has been meaningful and valuable, whether or not we bring anything home. By going to shows with multiple artists, ranging from street shows to art fairs, you begin to see a range of works that hone your own tastes and educate you about value.

DJ: *Was there ever a work that got away?*

RMK: I remember it well, though it was nearly twenty years ago. There was an exhibition of an artist whose work I really liked. There was a softness to the figures and landscapes, so it had a soothing feeling like that of the Cape Cod area. We did buy one painting by that artist, but there was this second painting that I have never forgotten because we did not buy it, possibly for budget reasons or a reluctance to plunge in too much. A number of years later, we asked the gallery owner if we could contact the artist, because we were really interested in that painting, but we learned that the artist had died. And I thought that I should not have let it get away, because when it is an original, there may not be another one, and it is often gone for good. These are not interchangeable objects, which is why we buy the things we do when we do. We buy them because they are unique.

DJ: *Do you display your works in both your primary home and summer place?*

RMK: Yes. We move things around and Barry often rehangs, sometimes behind my back, since I do not like change as much as he does. When I have said that we do not have any more room, he will find space; he is really good at that, very creative, though we have

Over stairwall, from left: Laura Anderson (b. 1943), *Three Boats;* Albert Alcalay (b. 1917), *The Village;* Susan DeMichele (1946–2002), *Near the Bridge.*

Under the stairs: Jeffrey Hessing, *Landscape.*

To right of door: Meg Mercier (b. 1964), *The Tractor.*

some spaces that are overfilled. But I love the fresh look that happens when things move to new spots.

DJ: *What suggestions would you offer to new collectors?*

RMK: I think a great deal depends on individual goals, such as whether one is trying to surround oneself with creativity or whether the goal is to build a more formal collection. Also of importance is whether acquisitions will appreciate in value. Those are all very different motivations, and you would go about things differently depending on the motivation.

People in the art world can be very elitist, and you have to not be cowed by the judgments of others. It is freeing if you are doing it for yourself, because it is the way you want to live. Then you can spend within your budget and get things that you happen to like.

So you have to have the courage of your budget and also of your own taste. We have ended up with various works of art, which could be called a collection—in the sense that they are in the same place, and were acquired by the same person—but we do not think of it in that way.

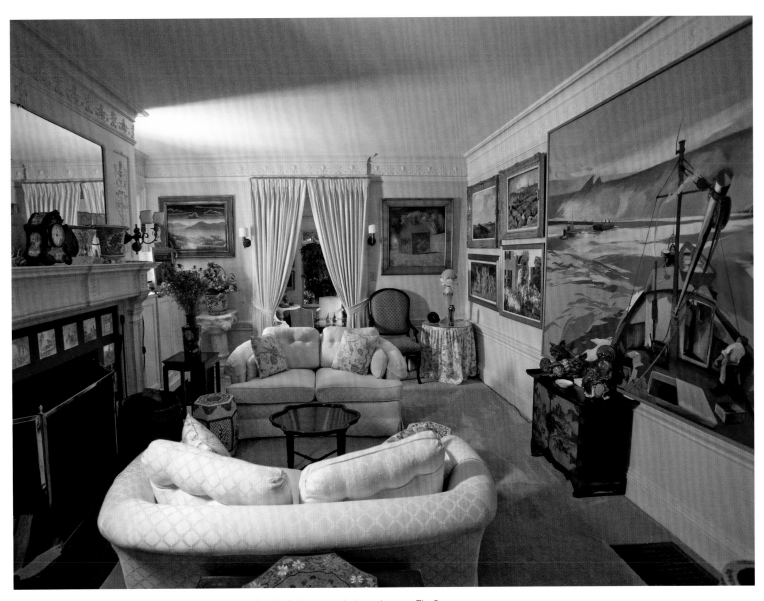

On back wall, from left: Thomas McKnight (b. 1941), *Seacoast*; Artist unknown, *The Barn*.

On wall at far right: Rez Williams, *Out to Sea*.

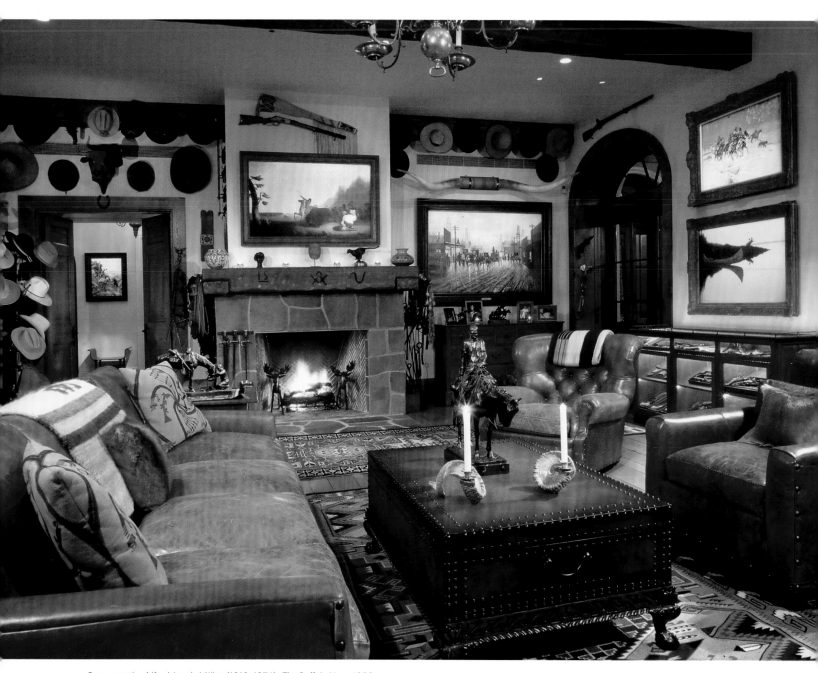

Over mantle: Alfred Jacob Miller (1810–1874), *The Buffalo Hunt*, 1850.

To right of mantle: Gerald Harvey (b. 1933), *Oil Patch*, 1981.

On right wall: Charles Marion Russell (1864–1926), *The Whoop-Up Trail*, 1899 (top); Frederic Remington (1861–1909), *Coming to the Call*, 1905.

William I. Koch

Impressionist, Western, Marine, and Contemporary Art

DJ: *Who inspired you to begin collecting?*

WK: I guess my parents did. My mother and father had a small collection of paintings and my dad traveled all over the world, and he would go to a place and buy things like swords and guns, or Moroccan furniture.

DJ: *Did you accompany him on these trips?*

WK: No. I was too young when he did it. Well, later on, I went to Africa with him where we bought some African carvings. My father actually collected ranches, which he loved.

My mother was an artist and she got me interested in the arts. And my father had a couple of Monets and a Thomas Hart Benton. I loved those paintings. Then

when I worked on my father's ranch in Montana for five summers, my mother had placemats with Charles Russell paintings on them. I began to develop a real taste for Russell and Frederic Remington and some of the other Western artists. I loved the West.

Then I got into sailing and I thought that since I love art, I might as well pursue sailing art. I went from sailing art, to sailing folklore, and then to carvings and scrimshaw. My interests, unfortunately, just keep expanding.

DJ: *Of all your collecting, do you have favorites?*

WK: It depends upon my mood. If I need some peace and quiet, I will look at a Monet landscape or a Monet water lily painting. If it is before bed, I will look at the

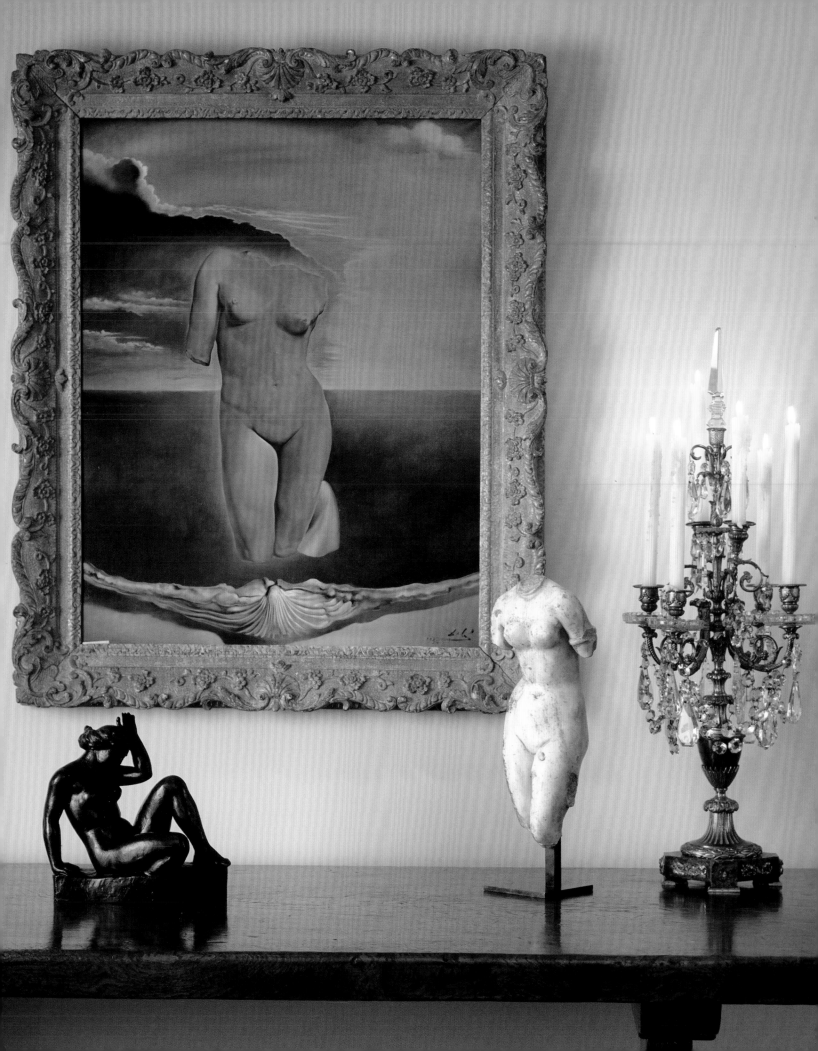

Modigliani. If I miss the West, I will look at some of my Western paintings.

Obviously, there are paintings that I like better than others, that have more emotional meaning to me. Artwork makes me feel good. When I look at it for a period of time, it calms me down, settles my nerves, and changes my thought patterns. Maybe I am an art junkie, because I love it and need it. Art is a great pacifier for me.

DJ: *Are there any stories that come to mind about your collecting over the years?*

WK: There are many stories. Nelson Rockefeller had a Modigliani, and a woman came to his house and saw the painting and asked him how much he would take for it. He said that he did not want to sell it. She pressed him to name a price and said she would get him a check the next day. He named a really high price and she told him that her driver would come in the morning with a check and would pick up the painting. She followed through on her promise and afterwards Nelson looked at the blank space on his wall and was sorry he had sold the painting. He missed it. He had more money than she did and wondered why he had sold it.

For me, each painting has personal meaning. For example, the painting of poppy fields by Monet surprisingly reminds me of a field at my father's ranch in Kansas, where he used to take us for picnics. Even though the poppy fields are in France, and totally different from fields in Kansas, the tree line and the wildflowers in the grass all remind me of that.

DJ: *Do you loan your paintings to exhibitions?*

WK: I have, but I received so many requests that it became difficult, and many institutions do not even bother writing you a thank you letter after you have loaned a work. I had an art foundation once where I bought paintings and loaned them to smaller museums. I once offered to lend paintings to The Metropolitan Museum of Art and they wrote me a letter indicating that they do not hang paintings from private collections unless they will be gifted to the institution. Now my policy with the large institutions is that I will only lend

when a work of comparable value and quality is lent in return. If there is no reciprocal arrangement, then there is no loan. I am often urged to share my collection, but my paintings have gotten enough exposure.

In fact, I do have a policy. I loan my collection to small museums around the country that do not have a chance to exhibit these kind of works.

DJ: *What plans do you have for the disposition of your collection? Are your children interested in art or collecting?*

WK: They are not very interested in collecting at this point, though my twenty-two-year-old son has started to develop an interest in art. I have six children ranging in age from twenty-two to two years old. I do try to get them interested and I offer to have their schools visit the collection at the house. I do that for about six to eight other schools around here in an attempt to stimulate interest in art in the young. I am generous to people who appreciate the opportunity; however I am not generous to people who are arrogant about it.

DJ: *It is a marvelous educational opportunity for those children to see the art that you have in your holdings.*

WK: I have been doing this for close to ten years now. Most of the schools are extremely appreciative. It is interesting to see the attitudes of the children. I am fascinated by how people relate to art and what kind of emotions they get out of it, particularly kids, because they are so honest.

DJ: *You have talked about your passion and your love for all the artwork that you collect. What would you tell people who want to begin collecting? How do you think they should go about it?*

WK: Well, I would say that it is very individualistic. When I first started collecting, I made some mistakes. I found things that after a while I no longer liked and I got rid of them. I found I paid too high a price. So what I did was try to get an education. I made an arrangement with the Museum of Fine Arts, Boston, that John Walsh would be a curator of my art foundation. I went around with him to visit dealers. He taught me

Opposite page: On wall: Salvadore Dali (1904-1989), *Rhinocerontic Gooseflesh*, 1956.

On table, from left: Aristide Maillol (1861-1944), *The Mountain*; Roman, after a Greek original, *Torso of Aphrodite*, 1st–2nd century A.D.

In the 1970s, I came across a late Inness at one of the galleries. I looked at it from a distance and thought that it had the same feeling as a Rothko painting, and that directed my interest toward Inness, whom I found to be complicated and extremely intriguing. He was an avid abolitionist, non-conformist, and Swedenborgian; in his day, he was considered to be very progressive and modern in his ideas and outlook and it was reflected in his canvases.

KM: Frank became very drawn to Inness and I think the connection he felt was that there was more to Inness's work than just the paint that he would put on the canvas. There is a deep expression about God and nature without the use of overt symbols.

FM: Through my readings I have found a lot of parallels between Inness and Ralph Waldo Emerson's ideas about the oversoul. Emerson regards the oversoul as the intuitive spirit that we all have. You can be Chinese, American, English, Indian, or anyone—but we all have this thread—this intuitive thread.

In the paintings of Inness, it was the light, this unique light that comes out from his canvases. It is a spiritual and unifying light, which connects all organisms. Inness was a metaphysical painter. And by metaphysical I mean an artist who paints the natural world, and its corresponding relationship with everything in the spiritual world. And that to me was a captivating idea, that God is not somewhere up there, but is everywhere and is a force within all of us. This was the type of nineteenth-century philosophy with which I was intrigued.

DJ: *How many years have you been collecting Inness's work?*

FM: I guess it has been over twenty years.

DJ: *What have you done to ensure the legacy of Inness?*

KM: Frank has been working on the George Inness catalogue raisonné with the scholar Michael Quick for over fifteen years. It has been a monumental undertaking, resulting in a two-volume work published in 2008. This says it all for the legacy of George Inness. It has been a labor of love for both Frank and Michael and they are extremely proud of the outcome.

DJ: *What is your involvement with Inness' works and museums?*

FM: One time I was on my way to Trenton to visit my mother and someone had told me that the Montclair Art Museum had about eighteen Inness paintings in the collection. I could not resist the urge to visit the gallery. They had one or two later Inness paintings, from the 1880s, on view. I soon embarked on a project with the Montclair Art Museum that resulted in the exhibition *George Inness: The Presence of the Unseen*, that was presented in 1994.

Another outcome was the Inness Gallery at the Montclair Art Museum. Richard Blinder, a well-known architect from New York City, designed it. It has a chapel-like feel and is a beautiful and quiet space. It is there for visitors to just sit and contemplate the many fine Inness paintings.

We participated in a show at the National Academy of Design Museum in New York—*George Inness and the Visionary Landscape*; it was held in 2003. We also supported a Whistler/Inness exhibition at the Clark Art Institute in 2008, titled *Like Breath on Glass: Whistler, Inness, and the Art of Painting Softly.*

DJ: *Is your entire collection in your home?*

FM: The paintings are in our home, but we often lend them. I am more interested in the idea of why Inness painted, which is more important to me than the actual art itself. And what he was trying to teach

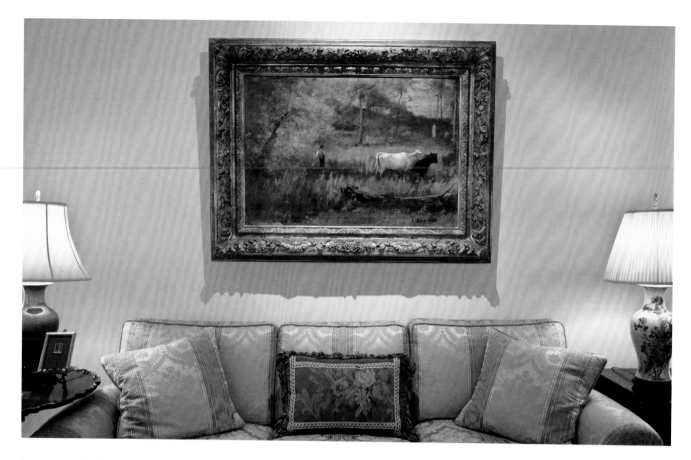

is extremely important to me. I see it as a wonderful Platonic expression of spiritual optimism.

KM: We collect his later works and I feel our collection has a certain sense of unity because of this focus. We would love to keep our collection together, but no course has been determined as of yet. We do look to find other Inness paintings, but any addition to the collection would have to speak to us in the way these paintings have. It would need to be a painting that would relate to the other works in the collection.

DJ: *This has been your passion, your journey through collecting. What would you say to new collectors?*

FM: I would suggest that there is more than one way to see. That we do not just see optically, that we see through our feelings. And maybe even more importantly, we see through our intuition. This is what Inness was getting at. It is easy for artists to paint detail, but to paint an expression of such a high quality is just quite amazing. I have learned that detail does not necessarily make a great artist. It is the

empowering feeling of that impression you get after you look at art.

It can be an impression of a momentary time and place, which is similar to what the Hudson River School and the Impressionists painted; or it can be something that takes you to another world mentally and metaphysically.

There is the art of the mind and I would suggest that people look for that in a work of an art. Let your mind and feelings about a painting speak to you. You may find that hidden expression that Inness talks about, the Swedenborgian connection, which makes us all part of the whole process.

DJ: *Is there anything else that you would like to add?*

FM: A reaffirmation that "knowledge must bow to spirit," as Inness said. Part of the reason why I left Wall Street was to try to articulate that idea. Through my studies in philosophy at Fordham University I was able to get a better understanding of what Inness was after in his paintings, painting the "reality of the unseen."

Opposite page
George Inness, *Edge of the Woods*, 1882.

Below
Granite sculpture by William Crovello.

Kelly and Scott Miller

Contemporary and Emerging Artists

DJ: *Who inspired you to start collecting art?*

SM: Well, I was actually an art student from around the time of junior high school, and that continued all through college. At the University of Alabama, graphic design was my major and photography and art history were minors. I went on for a master's degree in visual communications at Virginia Commonwealth University. The emphasis of my education at Virginia Commonwealth University was on visual communications and graphic design.

So because of my background in art, it is possible I look at the art a bit differently than other collectors. Although I pursued marketing and advertising in business, I did feel like I was still drawn to fine art.

I had always thought that it would be interesting to meet young artists at the start of their careers. I followed how collectors assembled collections and how their efforts were viewed years later, and that continues to interest me.

I began buying art on a local level when I was in college and continued in that way. Later as I traveled, I would acquire things here and there. And then I met David Moos, a curator at the Birmingham Museum of Art. He had an incredible passion for and knowledge of contemporary art, and he got me involved with the museum's contemporary collectors group, which further spurred my interest in art and collecting. He also got me interested in travel and really looking at acquisitions, and what I would call museum quality works by young artists that we could afford.

I did not grow up in a family of avid collectors, although I had an uncle who was a collector at heart; he had one of

Opposite page
Agathe Snow (b. 1976), *Seventeen* (*Snake with Metal Sculpture*), 2007.

Kelley Walker (b. 1969), *Black Star Press*, 2006.

Opposite page
Ryan Johnson (b. 1978), *Sentinel (Dead Hand)*, 2008.

the world's largest cash register collections and one of the world's largest carousel horse collections. Perhaps I got a bit of the collecting bug from him. It was when I met David and we started traveling together that I got focused.

He opened a lot of doors for me to meet dealers, museum professionals, and other collectors, and that opened up a whole new world. The thought of actually acquiring a work of art that one day could be loaned, gifted, or shown in an institution inspired me.

DJ: *How do you acquire art?*

SM: I was never the type to be intimidated by the art world, so I would just walk into galleries, introduce myself, and ask to see work by particular artists in which I was interested.

There were some dealers who would open their galleries and spend time with me when they saw that I was interested in learning about the work and the artist. Of course, there were others who were not responsive to my overtures.

It has been my intent to find these artists early on, not only for budgetary reasons, but it is what really interests me—trying to find the artists who will be talked about fifty years from now.

DJ: *Do you have a favorite object or painting in your collection?*

SM: Yes. We have a great painting by a Japanese artist, Takashi Murakami, who is, I think, one of the three most important artists working today, besides Jeff Koons and Damien Hirst. His influence is so widespread on an international level that I think he will be viewed fifty years from now in a way that Warhol is seen today. His work transcends generations through fashion, music, and design, and appeals to all age groups.

DJ: *How do you care for your collections? Do you have a curator?*

SM: No. It is definitely a passion and nearly an addiction of mine. When I am not working at my full-time job, I am spending most of my time on the computer, talking with galleries, reading magazines, and doing research on art, and that is what I most enjoy.

DJ: *Where is your collection housed?*

SM: It is housed in our home; we have two buildings on the property, and one is our living space, and that is full. Then we have a building out back that was my office, but is now just a gallery space; and some of the art is also exhibited at our current office space.

DJ: *What are you currently collecting?*

SM: Well, we collect some younger artists, including the work of Terence Koh, who shows at Peres Projects in Los Angeles, and museums all over the world; and also Sean Raspet and Kelley Walker. What interested us about Kelley's work is the way he appropriates images. He did a series of paintings based on the 1960s race riots at Kelly Ingram Park in Birmingham, which he painted with dark and white chocolate. So Kelley was an artist that we had been watching for a while and felt, in terms of content, was appropriate and important to have here in Birmingham.

DJ: *You have mentioned the future. Where do you see your collection heading?*

SM: Well, growing up in Birmingham, there was not the possibility of seeing this type of artwork here. Later, I would travel to New York, Los Angeles, and other larger cities with art communities to pursue my own interests. What I would love to be able to do is to open up a public or semi-public space where this art can be seen here in this area. For the last five years, we have been trying to make that happen for students and regional residents so that they do not have to travel to New York or other large urban areas to see such work.

Above
Sean Raspet (b. 1981), *Torment*, 2008.

Right
Heather Bennett, *Guess*, 2001.

Clockwise, from top

Radcliffe Bailey (b. 1968), *Black Diamond*, 2007.

Tim Lee (b. 1975), *Untitled*, 1970.

Takashi Murakami (b. 1962), *Eye Ball Pink*, 2001.

Amy Pleasant (b. 1972), *Sleeping Head*, 2008.

I have also gotten involved with college students, modeling a program on what we did with the museum's collector's circle. I take them to certain cities and arrange for visits to private collections, museums, and galleries; so far, we have visited Houston, Atlanta, and New Orleans. It has opened my eyes as well as theirs, seeing new things—and that is truly an amazing thing.

DJ: *Is your wife involved in collecting?*

SM: Yes, Kelly has also been involved with making our choices. It has to be something that we both agree to live with, and Kelly has been very patient in the expansion of our collection as it has taken over our living space.

DJ: *Do you have any ideas or advice that you would offer to people who want to begin the journey of collecting?*

SM: That is difficult because I think it is such a personal journey. As a collector, you really have to find your own way, although it is great to be able to meet other people in the art world who collect.

But when you acquire an actual work, it is what comes with that work of art that you buy that is really what is exciting. It is not just about the artwork that will be hung on the wall. There is much more to it. There are so many people to meet and things to learn about. It is great to be a part of that circle.

DJ: *What developments have you seen over the course of your collecting?*

SM: Well, over the last ten years, we have watched the careers of artists like Murakami, whose reputation and desirability has increased dramatically. It is interesting to experience, not just our own journey as collectors, but also the journey that these artists take in their careers. As you know, some of them just fade into the background while others become superstars. We love the work equally well in either case, but it is fun watching them and being a part of that as well.

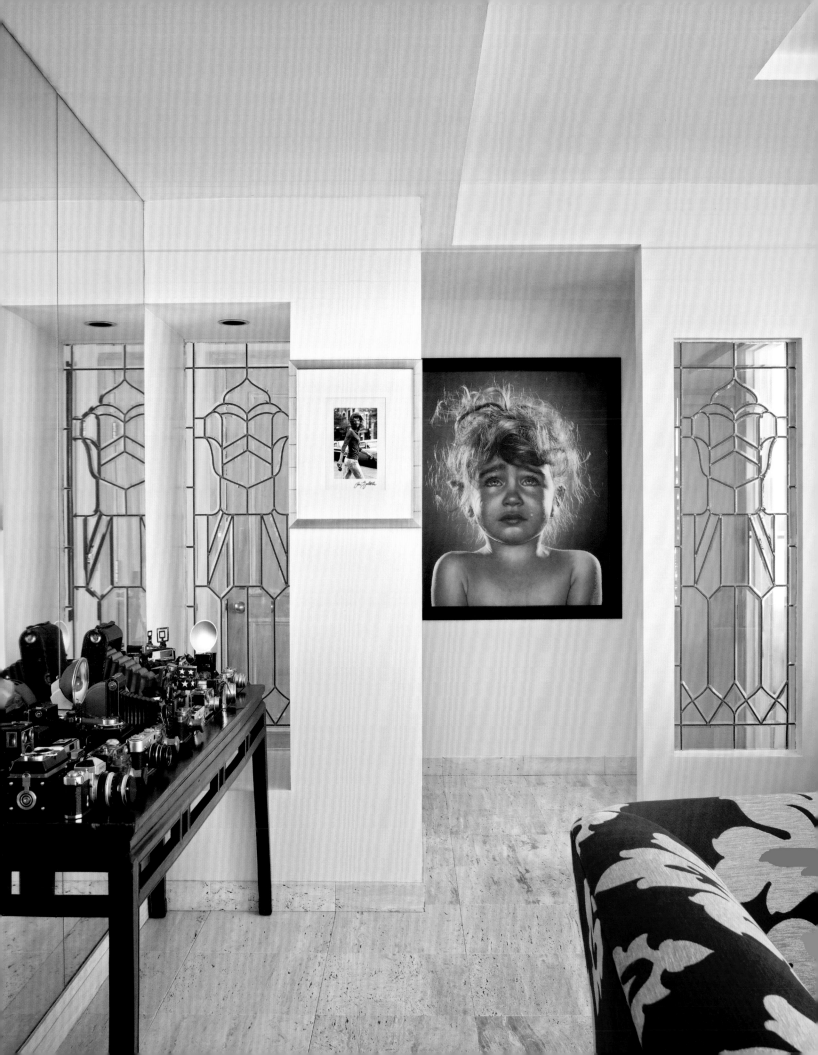

TOMMY MORRISON

Photography

DJ: *How did you become interested in collecting photography?*

TM: Beginning when I was about six years old, I would spend Saturdays and Sundays in New York at the Met, the Frick, Sotheby's, and Christie's, looking at furniture and Old Master paintings with my parents. I got comfortable going to galleries and museums. Then in high school, I developed a strong interest in photography and wanted to become a photographer. I studied under a local photojournalist in Salisbury, Connecticut, at the Salisbury School.

When it came time for college, I did not realize that you could study photography, but when I saw the equipment they had at Rochester Institute for Technology, in New York, I decided to go to school there. I really started getting into fashion photography and continued with it after graduation.

I then started taking pictures with fashion photographer Patrick Demarchelier of *Harper's Bazaar* when he was in his transition to *Vogue*. That was an incredible experience and I really wanted to become a photographer at that time, but circumstances changed. I got more involved in the family business and decided not to take pictures any more.

With my passion for photography, I just started acquiring small things. Then a major collection came up at auction and I acquired a photograph of bananas by Edward Weston that had been sold to The Metropolitan Museum by the Gilman Paper Corporation. My dad saw that I had interest in this work, so he went in on it with me. That was the first major work I bought.

Opposite page: On table: Collection of vintage cameras.
On wall, from left: Ron Galella (b. 1931), *Jackie Kennedy*, 1971; Jill Greenberg (b. 1967), *Unless*, 2006.

Right

Eugenio Merino (b. 1975), *For the Love of Gold* (life-size sculpture of Damien Hirst).

On wall, from top: two photographs by Jerry Uelsmann (b. 1934), *Untitled (Kudzu)* 1982; *Untitled (Floating Rock/Colorado)*,1991.

Below

Clockwise, from left: Gregory Crewdson (b. 1962), *Untitled,* 2001; Images from the *House Without Walls Portfolio of Photographers*; Mary Ellen Mark (b. 1940), *India*, 1989; Larry Clark (b. 1943), *Untitled*, 1991; Barbara Kasten (b. 1936), *Birth of the World*, 1991; Thomas Ruff (b. 1958), *Nudes KN 30*, 2000 (behind stair rail).

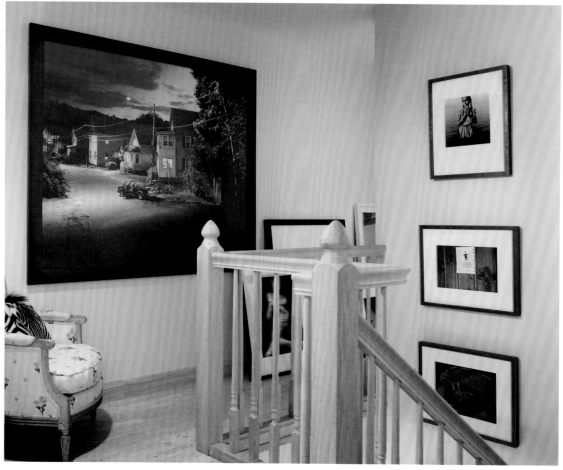

I began attending art fairs, like Art Basel, and also went to auctions and learned about the market, particularly for the work of young photographers. I kept myself on a budget and tried not to exceed it, buying things that I really liked, for example, images by Abe Morell, Gregory Crewdson, and Ryan McGinley.

I love these photographers: Ryan McGinley is my age and he had his first solo show at the Whitney Museum when he was twenty-six. I have one of the pieces from that series, *Ground Zero, 9/11*, which was shot on 9/12 or 9/13. I also have five or six others by him.

Through my dad and the collector Jane Holzer, I got entrée into galleries and boards and that continued to open more doors for me. Ray Merritt, a board member at the Norton Museum of Art, was very helpful as well. And I just fell in love with buying young people's artwork.

DJ: *How do you see your collection developing?*

TM: About two and a half years ago, I went to an art fair and was looking around and could not find one piece by any young photographer that I really liked that was in my price range, so I started collecting vintage black-and-white photography.

Now my focus is really on the American portrait. I am interested in the story and the expression behind the images, particularly as it relates to humanity and dignity. I have things that are just of ordinary life, but are images that you will remember when you walk away. Like a shot of Jackie O, which is one of the first paparazzi photographs, and is the image that is imprinted in everyone's mind when they think of her. It was not a very expensive photograph, but it was something that I had to have.

I also have work in depth by Helen Levitt, and by the Swiss-born Robert Frank, who is the most important portrait photographer of American culture in the 1970s. The last piece I bought shows him with the image of the American flag. When I find someone that I really like or who sparks my interest, I dive into that artist. I have two or three Edward Weston photographs, but now those prices are getting too high for me, so I will go on to someone else. Robert Frank is the new interest of mine right now. Then there are the younger photographers of today—Gregory Crewdson and Ryan McGinley. And this is the direction that I really want to follow.

DJ: *How large is your collection now?*

TM: I would say it is a little less than one hundred pieces right now. I am very picky about what I buy. I really do not just go out and buy; I do a lot of research, read a lot about the artist, and follow through. I find out their prices so that when I get to the gallery, I am informed.

DJ: *How do you find the work you acquire?*

TM: Now I am very focused on auctions; I got a bitter taste from some galleries. You have to determine whom you trust and only deal with people who have credibility. You really have to watch your back.

DJ: *Do you have a favorite photograph?*

TM: Yes. Robert Franks' *Marilyn Is Dead* and Helen Levitt's *New York*. Those are my two favorites and also two of my most recent purchases, too. I think my last purchase is always my favorite.

DJ: *Do you ever buy from private collectors?*

TM: No, I have never bought from a private collector. I have a lot of knowledge in the photography area, but I do not have access to many people who collect. Because of our age, many of my peers do not collect.

I use Ebay frequently as a source to look at different auctions and I watch as many Internet sites as I can. I read every photography blog and try to buy photography wherever I can.

I really do not have a lot of other people from whom I can get feedback. I am on the Photography Committee of the Norton Museum and am now starting to get more comfortable with the people there. But it is hard to relate to older collectors who have been collecting for so long.

DJ: *Do you ever sell anything out of your collection?*

TM: I have not sold anything, but I am thinking of selling a couple of pieces right now to buy something better. I do not want to keep some of these pieces forever; I like to change them on my walls. And if it is not on my wall, I would sell it.

DJ: *What type of images attract you?*

TM: I see my collection going to twentieth- and twenty-first-century black-and-white, American photographers, and portraiture. I love the portrait, particularly the candid portrait. I am more interested in the photo-journalistic approach to photography than in studio photography, for example, Helen Levitt, compared to Irving Penn. Levitt is on the street shooting a candid portrait, and Penn would not photograph on the street. I respect both of them, but I like Levitt's portraiture. And I am also developing more of an interest in landscapes—particularly large-format images about American culture.

DJ: *Your collecting process is very inspirational for other young collectors.*

TM: I do find that people are pretty inspired by my age and my knowledge. I try to go to as many gallery openings, museum shows, and art fairs as I can.

DJ: *Do you collect other things?*

TM: Yes, I bought my first sculpture at Pulse, in Madrid, recently. And, as a big photography buff, I also have over one hundred cameras, from Brownies to Leicas; there are a number of old ones, from World War II. My friends give them to me and scout them out, finding them at thrift shops and other places for very little money.

DJ: *What would you tell collectors of photography, specifically?*

TM: Do your research, because if you do not, you will be in trouble sooner or later. There are technical issues with prints and negatives in which a collector needs to be well versed. I think doing your research is the most important thing. You can never do too much.

Also, the collector must train his eye. The more experience that you have, the better. Look as long as you can before you buy. You are better off paying more down the line and buying right than rushing into something. Find things you treasure and do not spend on artists or photographers who are hyped.

The Internet is your best friend. It is worth putting the money into accessing websites, like Artnet or Art Price, and read all the blogs you can. I also read every article that I can in newspapers and art magazines just to know what is going on in the art market—what is going on today as compared to yesterday.

I am very passionate about all the photographers that I collect and I think one has to be. With regard to the photography that I have acquired, I realized I have learned from just looking at and studying the images.

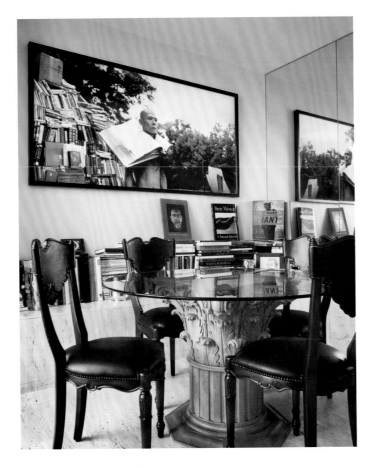

Above
On wall at center: Zhang Huan (b. 1965), *My Boston I*, 2005.

Right
Clockwise, from left: Zack Gold (b. 1972), *Stairs*, 2004; Helen Levitt (1913–2009), *New York*, 1938; Images from the *House without Walls Portfolio of Photographers*; Lewis Baltz (b. 1945), *Untitled*, 1991; Duane Michaels (b. 1932), *Untitled*, 1991.

Right
From left: Robert Frank (b. 1924), *Untitled*, 1951 (on floor);
Paul Strand (1890–1976), *South Street*, 1952; Brett Weston
(1911–1993), *Nude*, 1975.

Below
From left: Edward Weston (1886–1958), *Johnny the Cat*, 1944;
Alexander Rodchenko (1891–1956), *Portrait of Mayakovsky*, 1924;
Abelardo Morell (b. 1948), *El Vedado Camera Obscure*, 2002;
Edward Weston, *Bananas*, 1930; Robert Frank, *Marilyn Is Dead*, 1962.

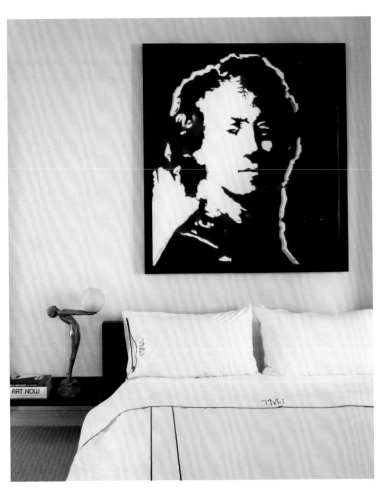

Left
Vik Muniz (b. 1961), *Self Portrait, after Rembrandt*, 2002.

Below
From left: Zhang Huan, *My Boston I*, 2005; Zack Gold (b. 1972), *Kurt*, 2004; Terry Richardson (b. 1965), *Untitled* (*Taxi*), 1999.

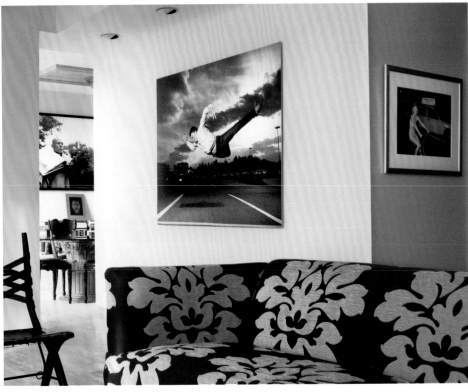

Nicole Cohen (b. 1970), *Going with Blue*.

ERINCH OZADA

Video Art

DJ: *You collect in an unusual area—tell me how you began collecting video art.*

EO: I started collecting art, meaning sculptures and paintings, in the 1990s. Then I bought my very first video piece at the inaugural exhibition of the LUX Gallery in London in 2002. The piece was by Marcia Lyons, who was the head of the new media lab at Cornell University at the time.

In this work Lyons scanned her taste buds and transformed the image into this incredible, moving painting. I was really impressed and smitten by it and within a week of seeing it, I called the gallery and bought my first video work.

In any event, when I took Marcia's video home, I realized how a video piece could really animate a space and make it breathe and move. And this led me to think that video art was an interesting medium with real possibilities. I started getting deeper into it, but as you hear from others, a collection does not evolve in a linear manner, but with each addition, the cumulative character of the collection changes.

I focus primarily on younger artists and my collection demonstrates many approaches to film and video that reflect themes and concerns of everyday life. I also have a fascination with boundaries of both a physical and metaphoric nature. What I am trying to say is that the video art that I have collected reflects the times in which we live.

DJ: *How do you make your choices about acquisitions and how do you acquire video art?*

Köken Ergun (b. 1976), *I, Soldier*.

Trine Lise Nedreaas (b. 1972), *It Takes Two To Tango*.

EO: I tend to gravitate toward artists and work I like, and my taste is eclectic, as is my collection. After Marcia Lyons, I drifted toward Bill Viola and started collecting his work; of course I did not know that Viola was to become one of the most important video artists.

I am also interested in the work of Nicole Cohen. Nicole has gotten a lot of attention through her work being shown at the Getty Museum in Los Angeles. She did a video installation called *Please Be Seated* that was installed from 2007 to 2009. I liked her work because she was beginning to incorporate backgrounds with light beams and it was the first time I had seen that—a moving, dancing, animated image reflected on a background. The background could change, which could radically alter the context, depending on her choices.

When I met her, I would have never thought that one day she would get such attention for her exhibition at the Getty. For *Please Be Seated*, Cohen selected sixteenth-century chairs from the museum's permanent collection, each representing a different style. She created a unique video for each chair by splicing footage filmed at the Musée National du Château de Versailles and other places.

The work is completed each time visitors take a physical seat in one of the six abstractive light reproductions of Getty chairs, and their images are projected by surveillance camera into the video footage playing on a television screen above. It is just incredible—you have to see it.

DJ: *Do you like to meet the artists whose work you are collecting?*

EO: I do. I like to meet them all, and in fact, I have become friends with some of them, including Trine Lise Nedreaas, who studied in Norway. She has shown her work in New York at MoMA, and in Paris, Milan, Berlin, and other venues. I have one of her works of an old man dancing the tango by himself—*It Takes Two To Tango*; she is a visionary and often uses humor in her work.

DJ: *When you say your video art collection is eclectic, what does that mean? What kinds of video art do you collect?*

EO: In video art, that means that you can have a pretty piece next to a disturbing piece, next to a funny piece, next to a terribly serious piece. For example, I have works by Ahmet Öğüt, who is originally from Turkey. He is a serious artist whose work is thought provoking. His videos, such as *Death Kit Train*, which is part of my collection, address social issues, historical processes, and their effects on society and politics. He is one of the artists I have been collecting over the years.

DJ: *Are there any other specific artists that you are collecting now?*

EO: I think I will add to my collection of Köken Ergun works. He has a theatrical background, which really captures my imagination. He filmed Turkish weddings in Germany. His videos capture different realities and pose questions about immigrants who never assimilate and who maintain their own traditions within German society. I have two of his previous works. One of them has something to do with the military, and the other one is called *The Flag*.

DJ: *Is there a lot of attention being paid now to video art, and the galleries that show it? Do you see that when you go to the art shows?*

EO: Yes. There are a number of up-and-coming artists winning competitions in film and video, including Ergun, who won the Short Film Award last year in Rotterdam.

Another artist is Ziad Antar, who lives in Lebanon and France. He has shown his work in Paris and Tokyo,

and at the film festival in Germany. I bought his piece called *La Marche Turque*.

DJ: *What do you see as the future for video art?*

EO: I think video art will assume an increasingly significant place in contemporary art, as it has now clearly become part of our lives and we are more comfortable with it. Video animates spaces and makes them more exciting.

I am pretty surprised by how quickly it is being accepted as an art form. All the art fairs are showing it more and more. It is also a great medium for artists, because many of them feel they can express more with it; as such, I think the importance of video art will only increase.

DJ: *What do you see are the possibilities for your own collection?*

EO: Well it is always nice to share what you like. Many of my friends have really begun to acknowledge it and have urged me to be more public with the collection. I think it is moving in that direction. Over the next two or three years, I could see doing more in this respect. Of course, eventually, it does belong in a museum and I will most likely donate the collection to an institution.

DJ: *What are some of the challenges and issues that relate to collecting video art?*

EO: One important issue has been ownership. It never really bothered me because I guess I liked it enough to not care about that. The copyright of a work is really intellectual property and belongs to the artist.

DJ: *What measures do artists take to protect their intellectual property?*

EO: Well, it is a contractual agreement as it is with the acquisition of any work of art. You have a contract in which the artist says that they have made a certain number of copies of this particular work, and that one belongs to you.

DJ: *Is the display of your art concentrated around your home? Are the videos shown constantly, or periodically?*

EO: I have it both at home and at work, but I do not have video art going constantly. I find it to be too stimulating to have it on all the time.

DJ: *What advice would you have for people who want to collect video art?*

EO: Really there is no right or wrong way to go about it. Video art is still in an embryonic stage. The quality of film is still being defined and most everyone is preoccupied with the message that is being delivered. Increasingly, as technical advances become more sophisticated, video art will gain in significance. The whole field continues to evolve and video art is more pervasive today than ever.

So my suggestion would be to buy work that you can relate to and enjoy, or that you can understand. If, over time, the work becomes more artistically important— that is wonderful. But it is very, very difficult, if not impossible, to just travel on that path alone.

I like to think that I have only acquired work that I like. I have tended to gravitate toward work that made me think and had a message. I am intrigued by video art that is engaging, serious, whimsical, or funny. My advice for others would be to buy work that keeps you excited and engaged. Maybe I was early, or just lucky, because many of the artists whose works I acquired ended up being masters in the field; but you just cannot forecast that ahead of time.

Marcia Lyons, *Skin Flick*.

Ahmet Öğüt (b. 1981), *The Death Kit Train*.

Köken Ergun, *The Flag*.

From left: Liam Gillick (b. 1964), *Weekday in Sochaux*, 2005; Thomas Struth (b. 1952), *Fei-Lai-Feng, Hangzhou*, 1999; Simon Patterson (b. 1967), *The Great Bear*, 1992.

ANNE AND WILLIAM PALMER

Emerging European and American Art

DJ: *Tell me about your art collection. When did your interest in art begin?*

WP: I have been interested in art for as long as I can remember. I could not help it; my father was an art dealer in Los Angeles. I just thought that everybody collected art.

There was always art around the house, and so it just seemed natural to continue to collect and to have art around me.

DJ: *What kind of art did your father collect?*

WP: My father had one of the first contemporary galleries in Los Angeles, the Herbert Palmer Gallery. He opened the gallery in the 1960s and was showing wild contemporary artists, many of whom are now

considered part of the contemporary establishment. It is so funny to have seen that happen, but at the time, the art he was showing was considered controversial.

DJ: *As you grew up and went out on your own, did you continue to collect the same type of work that your father had shown?*

WP: The path was generally the same, but I traveled down a different road. I started to get involved on my own at college, where I majored in art history. I was not prepared to focus solely on art so I also majored in mathematics. After college, I moved back to Los Angeles and joined several arts support groups. I joined the Contemporary Art Council at the Los Angeles County Museum of Art, where I met many great friends who

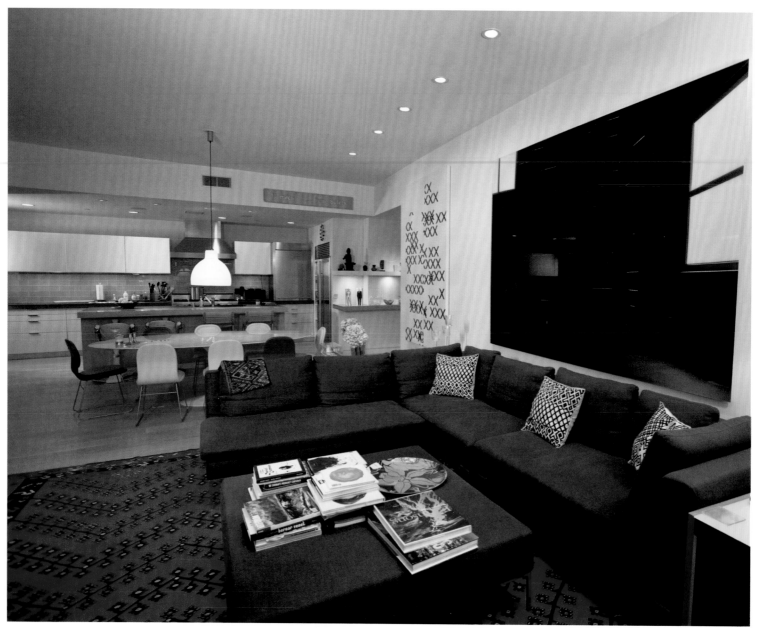

From left: Wade Guton (b. 1972), *Untitled*, 2006; Thomas Demand (b. 1964), *Scheune (Barn)*, 1997.

were also caught up in art. In the early 1980s, I joined a group that wanted to create a new contemporary art museum for Los Angeles. This became the Museum of Contemporary Art in downtown Los Angeles, designed by the Japanese architect Arata Isozaki. There were about ten of us at the time and together we raised the money that helped to launch the museum, which was very exciting.

In 1986 I moved to London. It was there that I really started to build a collection and to become more involved. At the time, the contemporary art scene was very small and it was easy to feel part of something. I joined the Patrons of New Art at the Tate and it was similar to the group in Los Angeles that I had previously joined. At the time, the Tate was a museum that was aiming to increase its focus on contemporary art. The patrons group visited galleries and located contemporary works that we felt should be acquired by the Tate. With our own funds, we would then buy those works and donate them to the Tate. At the time the bulk of the museum collection was in other areas, so we really helped the Tate build its contemporary collection. This was before the Tate Modern was built, which now houses a wonderful collection of contemporary art.

I was also asked to join the board of Artangel, a very small but unique art organization in London. I loved that the organization consisted of only a small team that devoted their time to raising money to enable artists to create temporary works in public spaces. In New York there are several groups that have similar missions; my favorite is Creative Time, and I have participated in their projects.

DJ: *What are you interested in collecting now?*

WP: Considering the current state of the economy, not much. We are looking a lot, but buying very carefully. I think that finding new art is a fascinating puzzle, a challenge, and an adventure. I have always looked for young, less recognized artists that have something different to say. This means going around to galleries and museums, talking to friends, and just going out and looking. I have been looking for a

long time and after a while you get a sense of how a new artist might fit into the continuum and what art might impact the future.

That does not mean that you cannot look backward as well. There are discoveries to be made there too. We have some early photography by Alfred Stieglitz and Edward Steichen, black-and-white images from the magazine *Camera Work*. These are still great images and just as powerful to me as some of the contemporary photographers.

For me, however, the real excitement is to collect and look at what is new. In looking around our apartment, there is a story that goes with every piece, and for me the story adds so much to the works—they really come alive. I think that this is true for many collectors.

Maurizio Cattelan (b. 1960), *Joseph Beuys' Suit*, 2000.

DJ: *Do you collect works together?*

AP: Well, we both have veto rights. William has been looking for a lot longer than I, so I put him in the lead, but I will always give my opinion. We do have several works that I discovered.

WP: Yes, I think that together we just have a sense of what we like and what makes sense to collect. It is not always easy to explain what attracts us to a work. I have been looking at art for over thirty years. Having looked so much, I can usually place a work somewhere in the historical chronology—and decide whether it has something new to say.

DJ: *What would you tell people who ask you how to go about collecting?*

AP: William's advice to people is that art has to be something you love and can live with. You should not think about art as an investment.

WP: That is true. I do say that. As you look at art with higher valuations, it is helpful to know something more about the artist, and other exhibitions he or she has been in, to see if there is a trajectory in the work, and then make a judgment as to value. There are many helpful resources today: online auction histories, knowledgeable curators at museums and universities, and some great dealers.

You used to be able to acquire good young artists for three to five thousand dollars per work. Today, or at least recently, young artists who had been exhibiting for a very short time had work for sale at twenty thousand dollars or more. For me, that is way too much. I think that one of the positive results of this global economic crisis will be that young artists' works will go back to more reasonable prices, in the three to five thousand dollar range.

DJ: *How would you suggest someone train their eye?*

WP: Well, I always recommend that new collectors join a museum group, in particular a collector's group in an area that seems interesting. I think sometimes someone new to the art world is worried that they have missed the boat or are too late. If you are interested in looking at new art, there will always be something new and there will always be opportunities. And it does not have to cost very much.

Typically, young collectors start with prints. You can always start there and obtain works from great artists at very good prices. You can also buy drawings instead of works on canvas, which are much less expensive. It is really important to learn something about the artist so you can recognize good work from bad. No one should ever feel that the best work is already gone; there will always be new artists to look at.

After a while, it is natural for a collector to be drawn to particular styles or periods. It does not have to be planned; it can just happen. Everyone has a different idea of how one builds a collection. Some people say to only buy drawings or to only buy nineteenth-century art. But I think that is too narrow a way to collect; I believe that one should find art that excites you and that you are passionate about. Later one can take a leisurely look back and notice if there is some connection. I do not agree with some advisors who direct collectors to focus their collections. It is better if it is unplanned.

AP: When we are asked what we collect, I do not honestly think that we have a clear set of criteria. In general, it is a more intuitive process, for William and for me too. Though since I have been looking with William, I can see what he sees. I can see it through his eyes and then make my own judgments.

WP: Well, I do think that we both have a pretty good eye now, but that does not mean that Anne and I are always right in terms of who will be remembered for the future. In today's world a lot of artist recognition has to do with being with the right gallery or having the right promotion. In the end, however, that does not really matter. For us, it is the process, and it is such an exciting moment when we find a thrilling new artist.

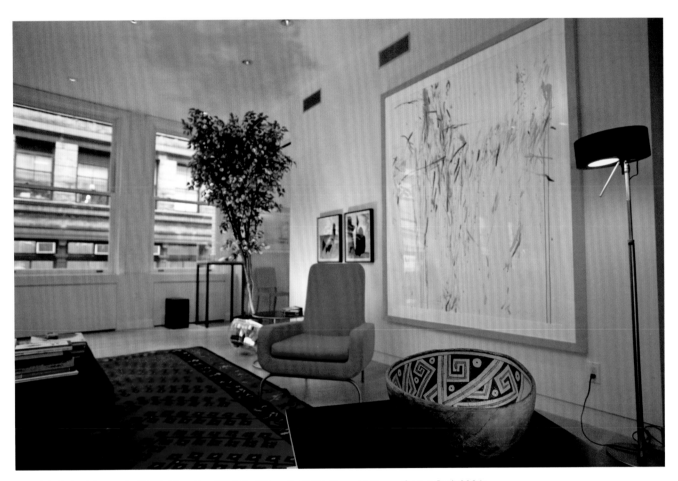

From left: Gabriel Orozco (b. 1962), *Moon Tree*, 1996; Paul Chan (b. 1975), *Opus at 7:15 p.m.*; *Opus at Dusk*, 2006;
Rebecca Horn (b. 1944), *Seelenzagen*, 2005.

Left
Ilya Bolotowsky (1907–1981), *Untitled*, 1913.

Below
M. P. Rosado and M. P. Rosado (b. 1971), *Sin Titulo*, 2004.

Opposite page, top
From left: Paul Graham (b. 1956), *Bogside, Ceasefire*, 1994.
Anish Kapoor (b. 1954), *Pigment Void*, 1998.

Opposite page, bottom
Marc Quinn (b. 1964), *Italian Landscape (12)*, 2000.

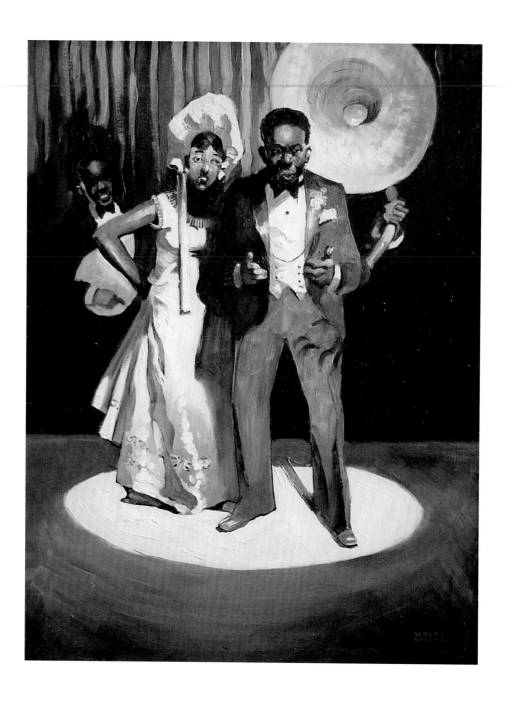

NANCY AND CHARLES PARRISH

School of Paris Painting and Southwestern Pottery

DJ: *Nancy and Chuck, I would like to hear some of your ideas and thoughts on collecting.*

NP: Chuck and I have both always been interested in early modernist and Post-Impressionist works, even as a young married couple. We used to buy Picasso, Modigliani, and Gauguin prints, which for years filled our house. In the 1980s and 1990s we traveled to Paris and went to the neighborhoods of Montparnasse and Montmartre and learned more about how these artists lived and worked. During the first half of the twentieth century, artists from around the world were drawn to Paris. In fact, the art produced during this period of time, which we are interested in, became known as the School of Paris. It was a really exciting time.

CP: We quickly learned that there are many unknown artists that painted alongside those who are considered the great masters; the "lesser-known artists" as we think of them. And many of them were women, and not unusual to this period of time, a lot of art by women and by African Americans remain undervalued. As the descendants of these lesser-known artists began to age, more of their art has made it into the marketplace and is seen at auction and in galleries. Also, many of these works of art become known by word of mouth. Over the years, we have become acquainted with dealers who have the same passion and love we do for that period, which has helped us acquire pieces we would have otherwise not had the opportunity to find.

DJ: *Do you find it advantageous to work through a dealer as compared to working on your own?*

Left: Albert Alexander Smith (1896-1940), *Cabaret*, 1932.

Above: Nancy and Chuck Parrish with *Nu devant le miroir*, c. 1940, by François Desnoyer (1894–1972).

Leopold Gottlieb (1883–1933), *Monsieur X*, c. 1920.

Jozsa Jaritz (1893–1986), *Femme dans le fond vert*, c. 1925.

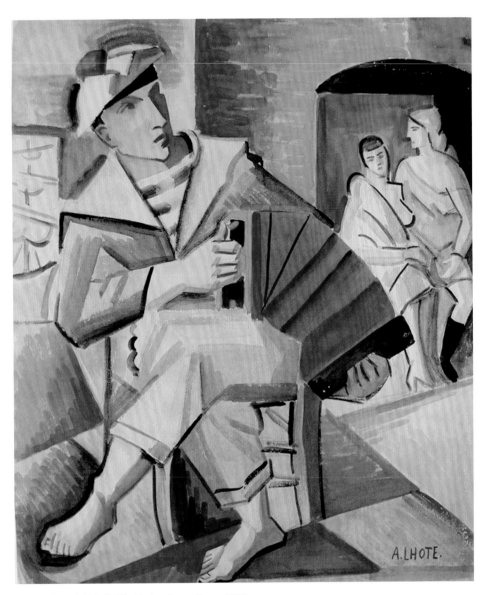

André Lhote (1885–1962), *Marin a l'accordéon*, c. 1920.

Edmond Vandercammen (1901–1980), *Danseuse noire*, c. 1920.

Marie Vassilieff (1884–1957), *Masques et poupees*, c. 1936.

Jozsa Jaritz (1893–1986), *Femme dans la robe de pokadot*, 1925.

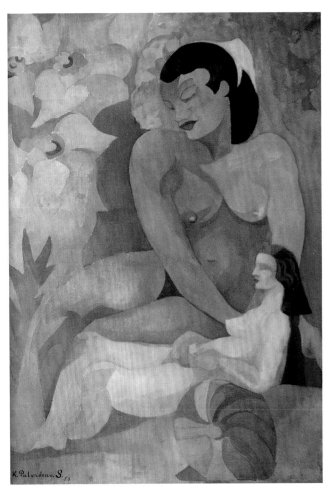

Katia Palvadeau (1903–1960), *Sur la plage*, 1952.

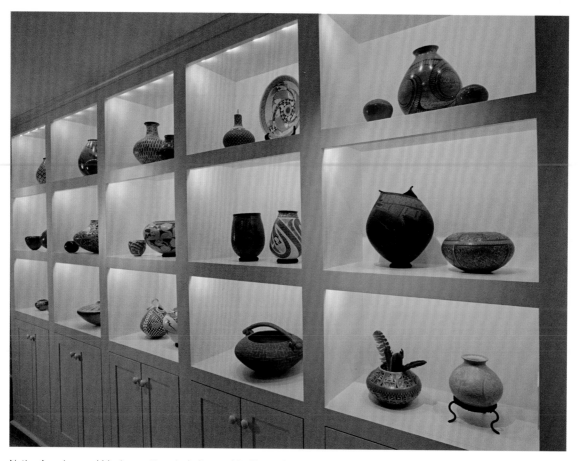

Native American and Mexican pottery, including work by Native American potters Rondina Huma (Hopi-Tewa); Steve Lucas, (Hopi); Nathan Youngblood, (Santa Clara); Tammy Bortz Garcia, (Santa Clara); Jody Naranjo, (Pueblo); and Alice Wiliam Cling, (Navajo). Casas Grandes potters include Juan Quezada; Hector Gallegos; Olga Quezada; Angela Lopez; Pilo Mora.

Nancy Parrish "shelling" a table. On wall, from left: Jules Tavernier (1844–1889), *Ile tropicale*, c. 1930; Colette Debat-Ponsan (1900–?), *Sur la plage*, c. 1935.

NP: We do. It is important to do your homework and take it slowly. Over time a relationship is built on confidence and trust. After all, they are professionals and have spent more time than we have learning about the market and finding interesting pieces of art. The dealers we know travel to Europe several times a year and over their careers have developed relationships with other dealers around the world as well as with descendents of artists, and some also come to be the exclusive representative of artists' estates. So it has been a great advantage for us to have a solid relationship with a small group of dealers. We appreciate their guidance and openness as we grow and our interests grow. Essentially, they have become our partners.

DJ: *How do you decide what to acquire?*

CP: One is always told to buy what you love. But when you begin to seriously collect, you want to not only buy what you love, but you want to make sure that it has value and will stand the test of time. We try to find out everything we can on any particular artist and learn how an individual work of art fits within their entire body of work.

DJ: *And as part of your education, you travel to the museums and shows?*

NP: Yes. Every chance we get. In every city we visit for any reason, we search out galleries and museums. Occasionally, we specifically travel to see a particular exhibition. It is like anything, the more art you see, the more you learn. Your eye becomes trained and you begin to build confidence in your ability, not only to choose art you will love for the long term, but also to learn about value and the market.

DJ: *Aside from collecting early twentieth-century School of Paris painting, what other collections have you developed?*

NP: Well, pottery has always been a passion of mine, and I particularly love the work of Native Americans and Mexican Casas Grandes artists. I appreciate the self-taught quality of their work. Knowing that an object that appears perfectly symmetrical and is paper thin was hand-coiled is extraordinary; and also that these objects are made from natural materials from the earth. For example, there are many different clay colors; there is a bead weed, like spinach, that produces dark colors. It is beautiful. Indian art reflects their culture, so pottery for me was an entrée into that world, and so I have focused on Hopi, Navajo, and Casas Grandes potters, and, as it turns out, many women potters.

DJ: *So there is a theme to your collecting, perhaps not by design, but that happened?*

NP: Yes, while it was not my intent, I was emotionally drawn to certain pieces of pottery. I began to discover many were by women artists and as is often the case in the art world, their pieces are generally undervalued compared to male artists. So I have, initially by accident, begun to collect more pieces by female potters.

I also search out pottery from a particular family from Casas Grandes, Mexico. It was Juan Quezada who brought his village back to life with income from sales of his pottery. And his work was so appreciated for its quality and uniqueness that for some period of time a Japanese patron agreed to buy everything he made. It became a fixation of mine to acquire a few pieces of his because his work was so extraordinary, as was the story of what he had accomplished for his village. I was fascinated by his life and appreciative of the opportunity to purchase a piece of his work.

DJ: *Do you also have other areas of collecting?*

NP: We collect local artists. Artists rarely seem to be appreciated during their lifetime. Art reflects a unique moment in historical time and is indicative of one's

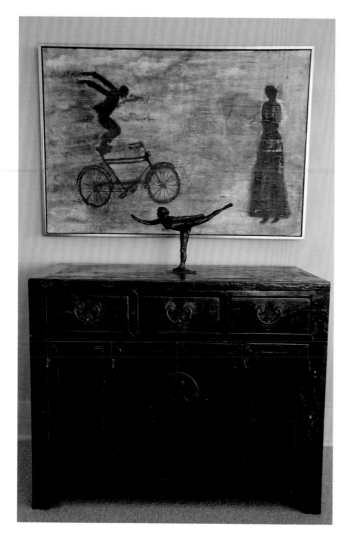

out there by producing a piece of art for the public and critics to either applaud or ridicule. Over the ages, some artists have even been jailed for speaking through their art, or governments who have felt threatened have destroyed their works.

NP: This appreciation has sometimes caused us to go off on tangents, as in the case of collecting the Latin American art we so admire. But we will likely continue to direct most of our attention to art from the period known as the School of Paris. I think we will continue to dig deeper into generally unknown artists of that time. It is often quite informative to see some of the early works of these lesser-known artists, who were contemporaries of Modigliani, Picasso, or Matisse, for example. Some of them were groundbreaking in their time, but just never became famous, possibly because they did not have a patron or the right gallery to represent them.

DJ: *Do you buy in depth with particular artists that you like?*

NP: Yes, because either we particularly like their work or we have stumbled upon an interesting story. For example, there was a woman named Kiki who was a well-known model in Paris in the early 1900s. She was a very modern woman in her day but like many women of her time she is remembered because of her relationships with many famous men. She was the lover of both Hemingway and Man Ray, and in fact the famous photographs of Man Ray with the woman with the long oval face are of Kiki. She was so admired that many artists began to paint images of her. Our interest was

culture. We often learn about others through time by the remnants of art they have left behind. I am always hunting through the local art galleries and studios for works. We have formed a modest collection of local artists from Martha's Vineyard and New England.

CP: We also have a small collection of contemporary Latin American art. We feel that, in terms of contemporary art, there are some wonderful, exciting artists coming out of Latin America that are reasonably priced. Sometimes we do not know where to put them, because they do not fit in with the work we have collected from the School of Paris era.

DJ: *Do you see your collection going in that direction?*

CP: Well, if only we knew. Our challenge is that we so admire artists and their abilities to put themselves

Opposite page, top
Guillermo Olguin (b. 1969), *Nadja*, 2005; Sculpture by Edgar Degas (1834–1917), *Arabesque—Bronze No. 3.*

Opposite page, bottom
Gen Paul (1895–1975), *Le guitariste, Andre Segovia*, c. 1928.

Sculpture at left: Edgar Degas (1834–1917), *Torso—Bronze No. 28*; at right: Nancy Parrish, *Vineyard Turkey*, 2004.

Charles Kvapil (1884–1957), *Kiki*, c. 1925.

piqued so we began to look for paintings or photographs of Kiki, and we also have a book with her diary. And that is really another fun aspect of collecting—to learn the human stories behind a piece of art or a person.

DJ: *How do you decide what to acquire?*

NP: Chuck and I generally agree on what to acquire. We do have a mutually agreed upon individual veto power, but we rarely exercise it. However, we only have so much wall space. So we have sold a lot, which is another advantage of working with dealers; therefore, the collection keeps evolving.

DJ: *What do you tell beginning collectors?*

NP: Well, I think it is really about emotion and passion first. So, very simply, it should be about what speaks to you within your budget. It is about what you love, but you should become as well informed as you can about a certain artist, period, or work. You can visit local galleries, artist studios, and museums or stop by your local library or simply sit in front of your computer.

As young people all we could afford were posters and prints. These copies of great works ultimately drove us to think more about art and to inquire more deeply about who these artists were, what and why they painted, and what their lives were about. It continues to be a wonderful journey.

An interior by Pierre Bonnard (1867–1947).

DAVID ROCKEFELLER
(with Bertha Saunders and Sandra Liotus)
Impressionism and Post-Impressionism

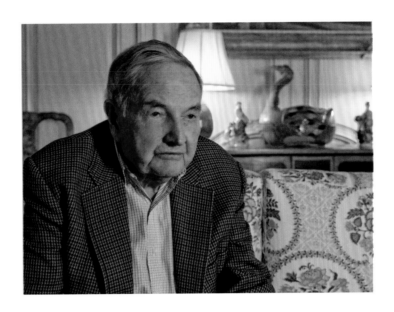

DJ: *I would love to know a little background on how you began collecting. Did your parents influence you?*

DR: Yes. I believe that my parents influenced my interest in art. I grew up in three different homes filled with the art collected by my parents. My mother, Abigail Aldrich Rockefeller, who was one of the founders of the Museum of Modern Art in 1929, of course had a particular interest in modern art. She was a noted collector of modern and folk art. Mother and father, John D. Rockefeller, Jr., were responsible for the living history museum, Colonial Williamsburg, which also includes the Abby Aldrich Rockefeller Folk Art Museum.

Mother's gallery was on the seventh floor at our house at 10 West 54th Street, where she showed her contemporary works. She changed the art on display from time to time as she acquired new works. Father was never very keen about what he called "modern art," and so the paintings in other parts of the house were more classical.

I became interested in both the more classical paintings collected by my father, and the more modern art favored by my mother. Right after World War II, my wife and I began to assemble our own collection. I succeeded my mother when she retired as a trustee of the Museum of Modern Art. I have been a trustee, and am now an honorary trustee, for more than sixty years. Thus, in many ways my whole life has been involved with art of all forms, and it continues to be.

DJ: *And so you discovered early on that you were a natural collector. Did you continue to collect what your parents collected?*

DR: Well, I have continued to collect. My wife of fifty-six years, Peggy, and I bought paintings together, and I have continued to do so. By and large, we acquired paintings for our homes. We bought them together, and almost always bought things that we both enjoyed, rather than just what one or the other liked. Sadly, she died several years ago, but I have continued to acquire art, although on a much reduced scale.

DJ: *Where do you find your works of art?*

DR: Wherever they are to be found—through galleries, and dealers bring them to me. Also, I hear about some from curators at the Museum of Modern Art. Occasionally, I spend an afternoon visiting galleries in New York with Glenn Lowry, MoMA's current director.

DJ: *And you have a curator that works with you and sees to your collection.*

DR: Yes, indeed. It is Bertha Saunders, who is here with us today. Bertha worked with my brother John for many years before she was with me. It has been a wonderful privilege having someone as knowledgeable as Bertha available to me.

DJ: *Bertha, would you like to comment on working with Mr. Rockefeller as his curator for these many years?*

BS: I have had the privilege of being the curator of two very different but equally important collections—one belonging to David Rockefeller and the other to his late brother, John. Most curators in general, and especially those working in museums, deal only in their area of expertise. In my case, I have had the unique opportunity of being a participant in the development of two very select and varied collections. Over the years there has been a sequence of endless discoveries enabling my knowledge to grow along with the collections.

DJ: *And Mr. Rockefeller, you house your paintings in your homes. This brings to mind another important part of housing collections in your homes—the lighting systems.*

BS: The system that Mr. Rockefeller now has was one I read about in a magazine article by David Tunick, owner of a print gallery. The article was about how wonderful the fiber optic lighting system is. I became interested in it because Mr. Rockefeller has a very large painting that measures about six feet in height, and we could never light it properly. I believe that was the start of Mr. Rockefeller's interest in fiber optic lighting.

DR: It was clear that the old system of reflectors was inadequate; since I learned about the new system, I have installed it almost everywhere I have paintings.

DJ: *How has this affected your enjoyment of the paintings?*

DR: It has certainly enhanced the enjoyment, because I think it is better to look at a painting that is well lit and that does not have a reflector above it. So there is no question that I think it is a far superior way of lighting paintings.

SL: The important thing about our lighting system is that all of the heat and ultraviolet rays are taken out of the lighting and output fittings that are directed onto the art. Because of this, the relative humidity in the art environment is not affected by the lighting, so it is safe for the works of art. All of our output lenses are made from photographic quality ground glass, which allows for the viewer to see the artwork in more focused detail. We have even had some insurance companies approach us because they understand that the lighting system actually helps protect the value of the works, whereas reflector lamps and other conventional lighting systems

expose the art to high heat that can dry out the paint. Traditional light systems are also very damaging to watercolors and drawings, due to over-lighting with the bulb within reflectors or conventional fittings. This fiber optic system preserves the valuable artwork.

The light that is focused on the work is crisp and clear, more so than with general bulbs and other types of lighting.

DR: So for all those reasons, this was a superior way of showing what are considered to be beautiful pictures.

BS: Images emerge from the paintings that you would not be able to see with an ordinary reflector. We have a painting upstairs where there is a little boy playing in a sandbox, who I never saw until we had fiber optic lighting.

DJ: *You mentioned your other family members that collect art. And your children, do they collect?*

DR: Yes. My children have not collected as much, partly because paintings have gotten to be so expensive. My sister, Abby Rockefeller Mauzé, had beautiful paintings, as did my brothers John D. Rockefeller, III, Nelson Aldrich Rockefeller, and Laurance Spelman Rockefeller.

DJ: *What is the focus, would you say, of your collecting? Or are there many collections?*

DR: Primarily paintings, but I also enjoy porcelain services and individual objects.

DJ: *What would you tell people who are interested and want to collect but do not know how to go about it?*

DR: Well, I think the first thing is to get good advice from knowledgeable people. If you are going to buy an expensive painting, it is essential to know that what you are buying is, in fact, authentic, and that it is in good condition. I would always ask experts to advise me, and I usually have someone connected with MoMA do so.

DJ: *Are there any particular stories that come to mind that you can think of throughout your years of collecting?*

DR: Well, I think probably the most interesting story is the acquisition of the Gertrude Stein collection by a small group, including my brother Nelson and me. Some time after Stein's death, Alfred Barr, the former director of MoMA, learned that this important collection of early works by Picasso, Miró, Juan Gris, and others was available. We formed a syndicate to purchase the entire collection with the understanding that we would leave certain of the paintings to MoMA in our wills, if not before, in recognition of Barr's role in securing the collection. I chose a couple of superb Picassos and Mirós and have enjoyed them ever since. But, in accordance with the agreement, the works will ultimately be part of MoMA's permanent collection.

DJ: *What else do you think would be important for new collectors to know?*

DR: Most important for me is to buy a particular artwork because you enjoy it. I feel that it is regrettable to acquire works just because they are famous, or because people want to raise their prestige by having them in their homes. I feel very strongly that one should buy beautiful art because one wants to live with it.

DJ: *Bertha, would you comment on that advice to people who would like to collect?*

BS: To the novice collector, I would say do not be afraid to make mistakes, and remember that acquiring art is a learning process. Visiting museums, galleries, and auction houses for presale viewings can also be instructive. Ultimately, it is most important to like something and to be taken by it. Make it an adventure. Even with little funds, love of the art and pursuit of knowledge will bring a kind of gratification that only other collectors can understand.

Stairway with painting by Claude Monet.

DR: Yes, I think there have been a few cases where we bought things that we have come to feel were not as good as we thought when we bought them. And we usually turn those in for something else.

BS: I can only reiterate what Mr. Rockefeller said previously. I would add that intuition comes into play. I also think that including works of art by lesser-known artists makes a collection more diverse. Over the years, I have learned that having an art collection is not only a big responsibility, but that it requires a lot of care and maintenance.

DR: Yes, I certainly think the most important thing is buying things that you really like. For many years my wife and I bought together; we never bought things that we did not both like. And I think that is a good principle.

DJ: So you agreed on a painting before you bought it?

DR: Yes. There might have been one or two times when one of us saw something on our own and just bought. But any painting of significance we would always look at together, and in addition to being sure that it was authentic and of good quality, we would buy it because we both enjoyed it.

DJ: *It sounds like you have had a lifelong adventure with your passion for the world of art.*

DR: That is indeed true. As you can see, it is what my family philosophy has been—taking pleasure in having the pictures in the first place and also sharing them with others.

Living room with a painting by Pierre-Auguste Renoir (1841–1919).

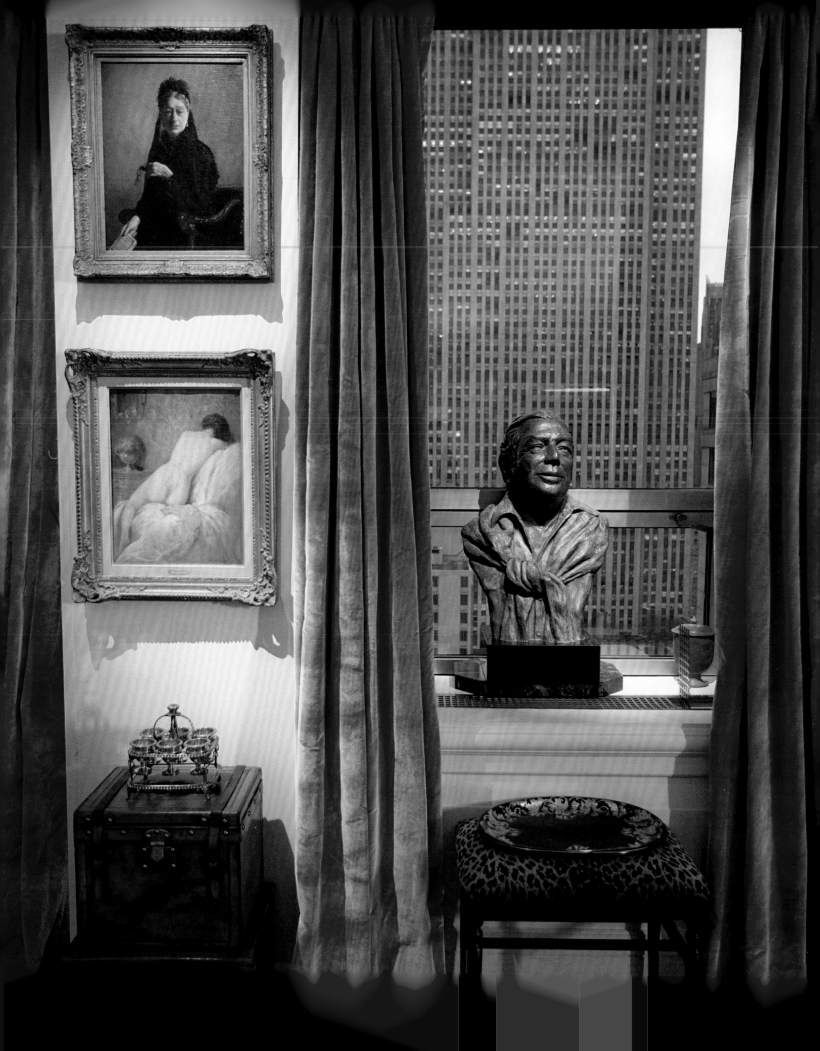

ALICIA WESTMORELAND VOLK AND NORMAN VOLK

Russian Icons, French and Scottish Impressionism, and Dog Portraits

DJ: *I would like to know how you started collecting.*

NV: Well, we each started at different points. We have been collecting together now for about eleven years. My family always appreciated art, but we did not have much of it. However, I grew up in and around New York City, so it was easy to see wonderful art. I found that over time, I tended to react more viscerally to art and did not try to intellectualize the meaning. I responded to color and texture of paint application.

Years ago the first thing I started collecting were icons. I had some relatives in Germany who had some icons which they gave to me. I appreciated them more for the dramatic color, rather than for any religious theme, and I thought the egg tempera technique was interesting. I was also intrigued by the one-dimensional

aspect of them—that there was no perception of depth in the images and everything appeared on the surface.

There used to be frequent icon auctions at the major auction houses. So on my small budget, whatever I could afford, I would always drop in and see if there was something that was of interest and if so, I would bid on it. If I was lucky, I got it.

I had one tremendous resource—an old gentleman in London. He was a clothing manufacturer who had a flat on the outskirts of London which was hung wall to wall, and floor to ceiling, with icons. Of course nothing was officially for sale, but a lot of the things in my collection came from that source. Also, there were antique shops that sold icons in Paris and in London then, so I slowly built the collection. The one thing about icons is that they demand a fair amount of restoration, be-

Left: Charles Henri Willems (19th century), *Old Woman*; Albert Joseph Penot (19th century), *Reclining Nude*.
In front of window: Jean Doyle (b. 1930), *Bronze bust of Norman Volk*.

Above: Alicia Westmoreland Volk and Norman Volk with *Joy of Summer* by Robert C. Moore (b. 1957).

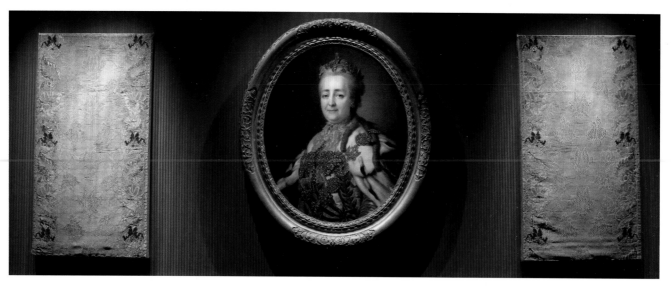

Alexander Roslin (1718–1793), *Catherine the Great*, flanked by Russian tapestries.

Opposite page
Wall of Russian Icons.

cause they are on wood panels. As you may know, today you cannot buy icons in Russia and take them out of the country if they are over a hundred years old. So the best opportunity for collecting icons was, and is, to find them in Europe.

I eventually took the icons down and had them in storage for a number of years until we found this apartment. Alicia suggested bringing them out of storage and making them the theme of a room. She had found a portrait of Catherine the Great by Alexander Roslin, a Russian court painter, and so we just built the room around it and the icons.

AWV: The story of the acquisition of the Alexander Roslin painting of Catherine II was one of pure admiration and passion—Catherine was an extraordinary woman in her day. To see such a superb portrait after looking for years and years at other portraits of Catherine II, was such a special moment. I could literally feel my heart pound when I first saw the painting. For me it was a very emotional experience and it is an honor to be the custodian of this painting.

DJ: *Are you still making acquisitions?*

NV: We still remain active and look to see what is available. I have given a number of works away to my children, so the collection was bigger than what we have now, but we still keep our eyes open.

On the journey of collecting you may see a hundred works and like ten, because I think every artist, as all of us, has their really good days, their average days, and their down days. You just have to be able to determine if a work does something to you. I can tell in the first instant whether I like it or not.

Alicia and I think that as a collector, one needs to evolve. We think one just needs to keep looking and exploring new ideas and new notions. In recent years, we are focusing more on the Flora Danica china we have collected, and Alicia loves antique textiles. Recently we have been focusing on those things.

DJ: *What qualities do you look for in works you acquire?*

NV: As far as paintings go, I am drawn to Post-Impressionism, to which I react very strongly. Over the years I have felt a pull toward the Scottish Colourists, the four artists that came from Scotland: Francis Cadell, John Duncan Fergusson, Leslie Hunter, and Samuel Peploe. They spent much time painting in France and Italy and developed a very strong technique. They had a very positive outlook toward things rather than the dour Scottish approach to painting.

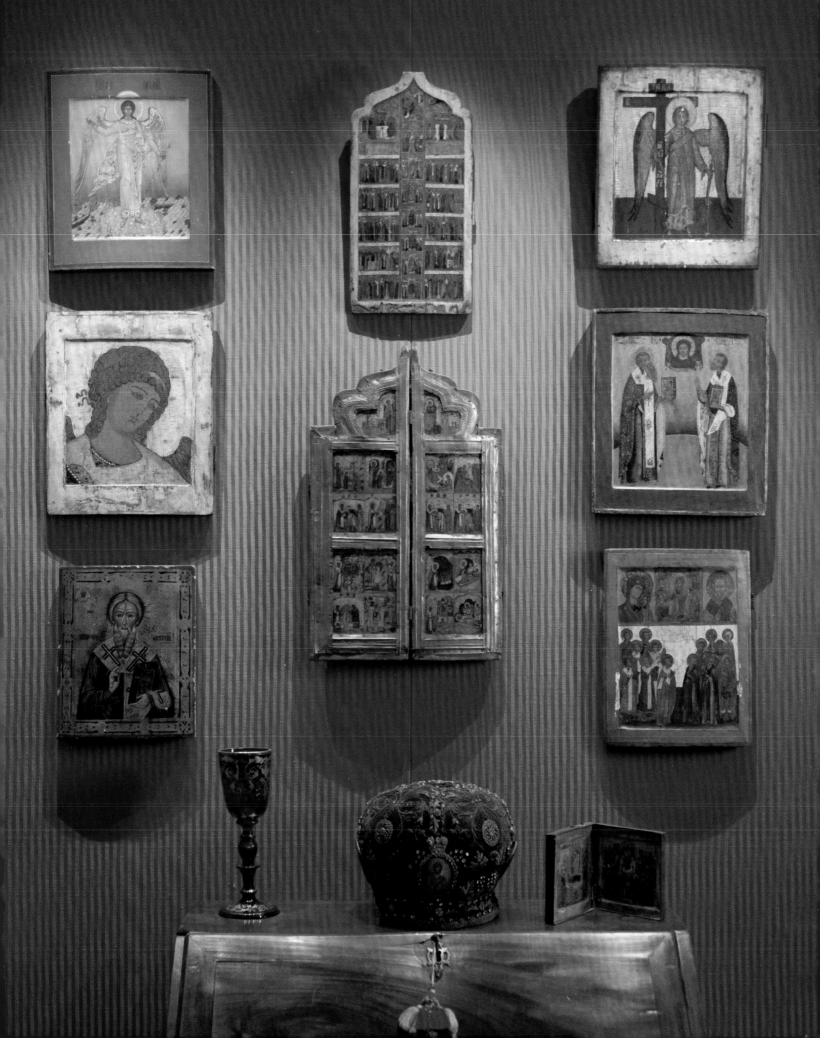

I felt that relative to other Post-Impressionists, they were undervalued. I knew people in London who collected Scottish Colourists and I focused on this area because I could not afford the full-blown Impressionists or better-known Post-Impressionists. If you cannot go all the way, you try to figure out something that gets you as close as you can, and that is what Cadell, Ferguson, Hunter, and Peploe did for me. I only wish I had been a bit more decisive in the 1970s, because they were a really good value then. But value alone is not the reason I collect. We love all of our art.

It would almost kill me to sell a painting. If I am going to own art, I want something that I feel comfortable living with. I want colors and themes. You will see a lot of flowers, which I think are just very restful. I think that art plays a tremendous influence in the way it fits into your home, and how it complements whatever else you have around—it is an important aspect of comfort.

We also collect paintings of dogs, but the dogs have to have tremendous character, or the painting really has to be a fine study of the texture, fur, and expression. Those are the things we look for in a dog painting—the quality of the look of the dog, and then having a dog that has a bit of personality. We do not like hunting or bird scenes of that sort; we like the portraits.

Everyone can find a painting that gives them some joy and comfort, no matter what your price range is, but it is just such a personal thing. I certainly cannot imagine anybody else choosing or buying a painting for me.

DJ: *Your tastes and ideas of what you want to collect seem to have melded—what is your common outlook and what has been shaped by the other?*

AWV: I feel part of collecting is being disciplined. I think that with each and every object or painting you need to have a connection or attachment. I would not

have problems with looking at other objects and/or paintings, but Norman gets to where he just cannot deaccession any of the works.

NV: Well, that is the way it is. I introduced Alicia to Henri Fantin-Latour, who, in my opinion, was the greatest flower painter ever. If you walk into a room and there is a Fantin-Latour, it just jumps off the wall at you—it is unbelievable—his work is in a certain stratosphere.

When you see a painting by Fantin-Latour you can just stand in front of it and explore the technique of every single flower. You wonder, how did he do that? Why have others tried and never quite gotten it? One might never take a second look at Fantin-Latour as a figure painter, but the flower subjects are another story and are quite extraordinary.

AWV: Fantin-Latour's wife, Victoria Dubourg, was an unbelievable artist in her own right. And she worked with him on a lot of his canvases; we have two of her paintings.

DJ: *Do you generally agree on what you purchase?*

AWV: We do. As you can see, our interests are floral still lifes and landscapes. I have always followed Henry Clay Frick's philosophy about the beauty of the arts, and surrounding yourself with beauty.

Your home is your inner sanctum—it shields you from enduring the strife and the struggle of life. When you come home to your inner sanctum—your home—away from it all, to be surrounded by beauty, is truly something special.

DJ: *Do you each have favorite paintings?*

AWV: For me, the portrait of Catherine the Great is the one. When I first saw the painting at A La Vieille Russie, I had a powerful reaction. I have long had an interest in Catherine the Great, who was an extraordinary and accomplished woman for her time (she died in 1796). I look to her and her legacy with great admiration.

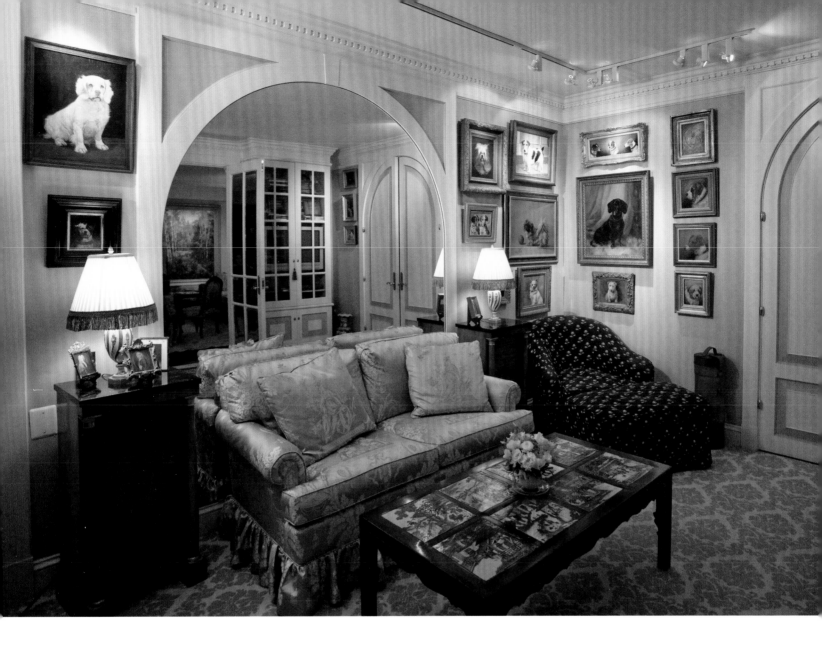

Above
Living room with dog portraits.

Right
From left: Anne Estelle Rice (1879–1959), *Moonlight in the Harbor*, 1910–11;
Frederick Mulhaupt (1871–1938), *Guinea Wharf, Gloucester, Mass.;*
Samuel J. Peploe (1871–1935), *Wooded Landscape, Cassis.*

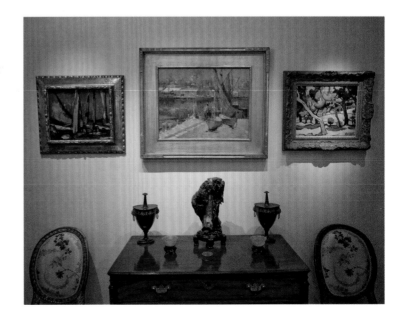

DJ: *Norman, do you have a favorite?*

NV: Among the thirty or forty paintings we have there is something unique about all of them and I enjoy them for different reasons. For example, I love the painting *Old Woman* by Charles Henri Willems. You can see the fantastic technique in her eyes, hands, and face as well as her imperious demeanor and look of wisdom, which bring the painting to life. The dealer that I bought it from mentioned that I was one of a few people to take a look at it, as most people do not like paintings of old people—I bought it on the spot.

DJ: *Are there any other thoughts you have on what you would tell someone who wants to begin to collect?*

AWV: Well, I think that people should collect what they love, that they should not allow themselves to be restricted by making the decision based on convention or price, unless they are building a collection for a specific reason at a certain level. I am talking about that person who loves art and wants to collect and loves the beauty of art.

I think it should be very personal and it is fine if the artist is unknown. If you are traveling in a certain part of the world and you find something that brings you peace—you will have such a beautiful memory when you bring that object home and that will be with you forever—that is really the ultimate. I think it is the very personal experience with that work of art or that artisan's work that is important.

NV: I too think that is the way it should be: listen to your instincts. Do not let yourself be told by curators, dealers, or anyone else that you must buy something. You have to be curious and challenge yourself to try to learn new things. There is just no shortcut for doing your own homework and research. There is no easy way to go about it. Eighty or ninety percent of the time, you look but come up with nothing. You have to go through that because it helps sharpen your eye. It allows you to make a comparison and determine what works for you and what you can afford. Most importantly, I think that if you see a potential acquisition you have to viscerally react to it. It has to say something to you.

But whatever your entry point is, you have to start. Then the rest of it is just a journey, that's all.

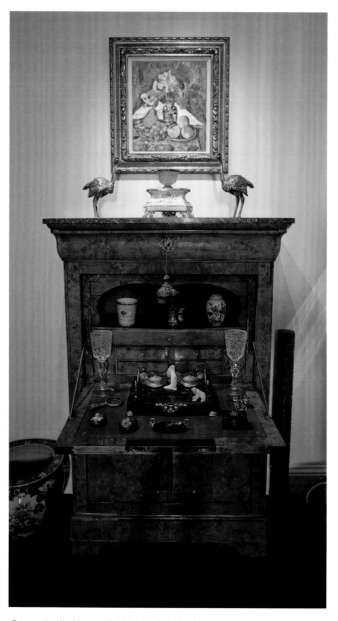

George Leslie Hunter (1877-1931), *Still Life with Fruit and Flowers.*

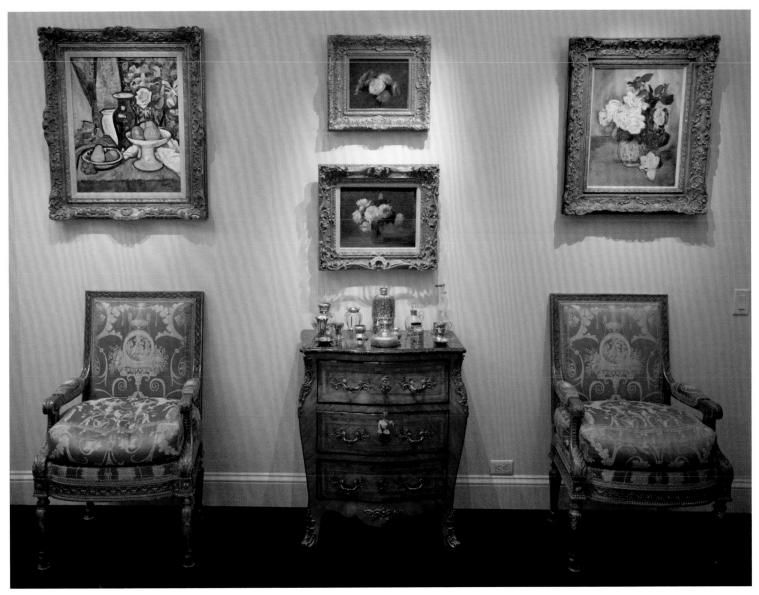

From left: George Leslie Hunter, *Fruit in a White Bowl*; Victoria Fantin-Latour Dubourg (1840–1926), *Roses*, 1907 (top), *Roses in a Vase* (below); George Leslie Hunter, *Still Life with Flowers in Vase*.

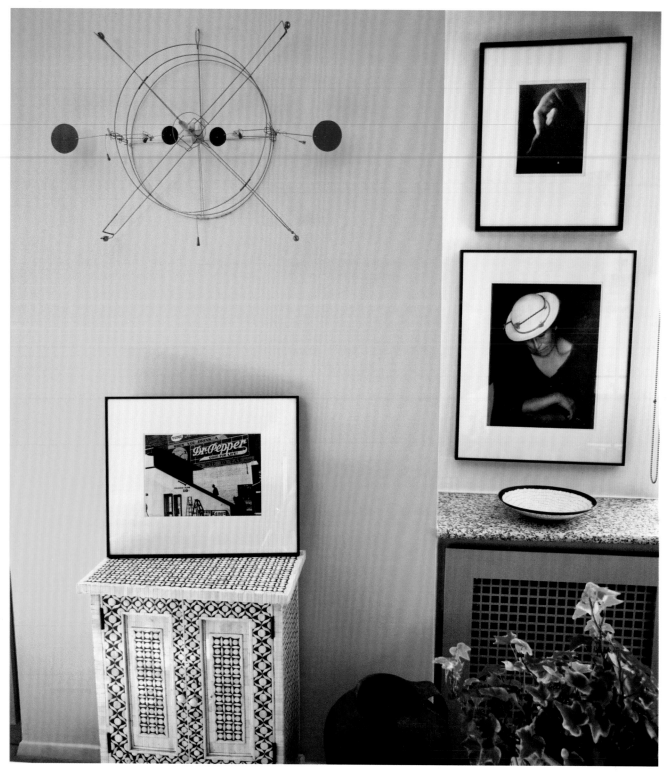

On wall at right, from top: Edward Steichen (1879–1973), *Nude*, printed 1981; Flor Garduno, *Virgen*, 1990.

On wall at left: Tim Prentice (b. 1930), *Whirligig*.

Photo on cabinet: Marion Post Wolcott (1910–1990), *Negro Entering Movie Theater by Upstairs, Outside "Colored" Stairway, Belzoni, Mississippi*, 1939, printed 1983.

Jessica Josell Wechsler and Steven Wechsler

Photography and Kinetic Art

DJ: *Jessica, how did you and your husband Steven begin collecting?*

JJW: Steven and I never set out to collect. He was an art history major before becoming a film and video editor, and I have always had an interest in art. We go to galleries, museums, and art shows because that is what we enjoy.

In the process, we discovered that we respond emotionally to the same works; so we will be trotting down an aisle at some show or another and come to a screeching halt because we have both fixated on the same piece. That is when we know that an acquisition is imminent. In the beginning, we acquired a work for one hundred dollars, then three hundred dollars, and then five hundred dollars, and then more.

As we have gotten older, we have saved our money and found excuses, such as birthdays or anniversaries, for purchases. Over time, we have probably bought about fifty black-and-white photographs, and have had an awful lot of fun doing it.

Our one rule is that we always have to find a place to hang a new purchase. In our home here in New York City, and also upstate, we have no wall space left. We are very selective about purchases, and very inventive about where things are hung, or more recently, leaned.

We also discovered kinetic sculpture and have a number of wonderful pieces in the apartment as well. We never set out to collect anything. We find something we respond to, purchase it, and then have the pleasure of living with it. Neither one of us has

ever bought something with the intent of selling it. For both of us, once we like it, we like it forever.

DJ: *That is a great philosophy. So you continue to collect, but very specifically?*

JJW: We do not go looking for something specific. We tend to like very bold graphics, which is reflected in the photos, the art, and the kinetic sculptures we have purchased. Various shows have exposed us to different dealers and artists and our tastes have evolved over the years.

It has been a very interesting learning experience. We have discovered that the works we have purchased have enjoyed increased popularity as the years passed, which is a nice validation of our sensibilities.

DJ: *Do you have a time period in mind when you collect photography?*

JJW: No. We have an eclectic mix of contemporary and vintage photographs.

DJ: *Along the way, have you studied the work you are collecting?*

SW: What came as a surprise was the number of books on the various photographers we have collected. It is a joy to curl up with these volumes and delve into the lives and work of these artists.

DJ: *And do you have any advice for beginning collectors?*

JJW: Buy what you like, stay within your budget, and have fun! We still love the first photographs we bought. There is something absolutely wonderful about being surrounded by art that gives you pleasure. We make it a point to re-hang—to move our photos around on a fairly regular basis. It is always a surprise to see them with a fresh eye, and in a new light.

DJ: *Do you have any ideas of where you will go, in terms of the future direction of the collection?*

SW: We have no idea at all. If we find something when visiting shows or traveling that resonates with us, we consider it. We have not yet purchased digital prints, but recently some color images have piqued our interest.

DJ: *So you are having a wonderful, fun adventure. And this is a large part of your life?*

JJW: Being exposed to photographers or artists who are new to us, and looking at the world through their eyes, is always an adventure. If you are curious and can afford what you like, that's even better.

DJ: *Some people who collect together acquire works of art separately, while others decide that they have to agree before they will buy. How do you both go about it?*

JJW: We have decided that we both have to have a strong visceral response to a piece of art before we add it to what has become our collection.

I will tell you a terrible story. When Steven and I got married twenty-nine years ago, there was no room in his apartment for me—every inch of closet space was occupied. So, one day while he was off doing something, I decided to organize the closets. Among other things I jettisoned were boxes of old daguerreotypes. Not knowing what they were, I put the boxes down by the incinerator, and they were carted off—all his daguerreotypes disappeared in an instant. That was not the smartest thing I ever did. Thankfully, he loved me more than he loved his collection.

Above

Michael Kenna (b. 1953), *Biwa Lake Tree, Honshu, Japan*, 2001.

Right

From top: Ruth Bernhard (1905–2006), *Two Leaves,* 1952; Lilo Raymond (b. 1922), *Untitled (Tulips)*, 1989; Ceramic trapeze artist by Joy Brown (b.1951).

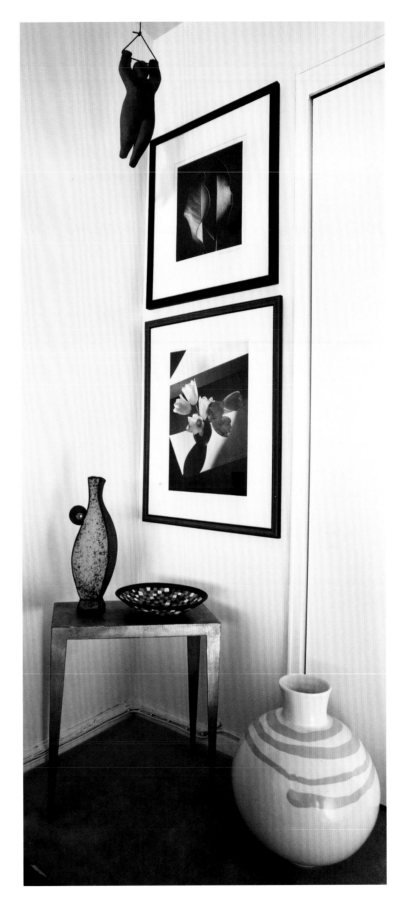

On wall at top: O. Winston Link (1914–2001),
Birmingham Special at Rural Retreat, Virginia, 1957; below,
from left: Doug Robbins, *George Washington Bridge*;
Edward Steichen (1879–1973), *Three Pears and an Apple.*

From top: Ruth Bernhard, *Perpective II*, 1967; *Classic Torso*, 1952; at right: Brigitte Carnochan, *Clematis*, 2004.

Portfolio of ten images by Karl Blossfeldt (1865–1932), *Urformen der Kunst I*.

Hanging from ceiling: Tim Prentice (b. 1930), *Double Zinger*.

On wall, from left: Cecil Touchon (b. 1926), *Collage*; Francisco Castro Leñero (b. 1954), *Untitled*; Cecil Touchon, *Collage*.

Coffee table by Howard Werner (b. 1954); Sculpture, *Untitled*, by James Hunter (b. 1965).

Charles Bell (1935–1995), *Oh Boy II*, 1992.

DONNA AND NEIL WEISMAN

Photorealism and Italian Glass

DJ: *Will you both share your ideas on art collecting? Neil, what or who was your inspiration for collecting art?*

NW: From the time I was about fourteen or fifteen years old, I attended auctions, and always appreciated beautiful things. So I did not have any particular inspiration.

DJ: *What did you collect in the beginning?*

NW: I first collected cast iron doorstops when they used to sell for very little, and I always liked art, too. I was originally drawn to Impressionism and graduated from that because it came to be like wallpaper to me. I moved on to art with an edge.

DJ: *Did your family collect art?*

NW: No, not at all. I had no background in it whatsoever.

It is like listening to an opera, if you had never been exposed to it. People who grew up with it really can appreciate opera, but if you hear it for the first time, it is hard to digest and takes a while to appreciate.

DJ: *What particular kinds of art have you focused on collecting?*

NW: In recent years, we have been drawn to the modern masters, which is the thing we most covet. And we end up going to almost every preview at all the major auction houses. We always play the game of choosing one painting we would like to take home—not for investment, but to have on the wall for the rest of your life—Donna and I always do that. Donna has a graduate degree in fine arts and has a great eye. She

would want one, and I would want another one. It was not that we could afford all of them, because we could not.

DJ: *Has the focus of your collection changed?*

NW: I have always had numerous collections. I think we counted it at one time; we had forty-two different collections—not all expensive things. I would always find things that would be of interest as collectibles and collect them, then get bored and move on to another collection. I have collected various things, including model lighthouses and birdhouses at one time, and I usually keep one piece of each collection as a reminder.

DJ: *What paintings, sculpture, or glass would you prize the most?*

NW: In glass, it would be the mosaics from 1910 through the 1920s. And in art, we have a couple of Picassos that we really love. You know, Picasso had a great passion; he both loved and hated women. We always liked his work when he hated women; they are always more interesting. We like the angst. We also have a self portrait of him drawn two years before he died. He is looking at his own death dressed as a harlequin.

DJ: *Where do you acquire your artwork?*

DW: Everywhere. The glass we bought from all over the world, including Japan, Switzerland, Germany, and Italy. But there is more Venetian glass in the United States than there is in Italy, I believe. So you can still find it here, and it is still an area that is not totally exploited.

DJ: *Do you have an advisor or curator to manage your collection?*

NW: No. We have always bought what we liked. Sometimes that is good, and sometimes it is not. But if we like it, that is enough. The art in our house is really for us.

DJ: *So do you and Donna always have to agree on a piece?*

NW: Yes, we definitely have to agree on a piece of art, and we do have a lot of similar tastes.

DJ: *Where do you display your collections?*

NW: Just where we live. When we moved from a house to an apartment in New York City we sold fifty-five paintings, because we did not have enough room to display them, and we do not like the idea of keeping art in storage. Unfortunately, some of the glass is in storage. I think we have about seven hundred pieces in storage.

DJ: *Do you loan art to museum shows?*

NW: We have loaned art, reluctantly, and we just got a piece back that had been gone for two years. We have loaned a few pieces of glass, but we are also very reluctant to do that.

DJ: *When do you sell works from your collection?*

NW: I have always said that if you hang something on the wall long enough, you will know whether it is good or not. If things start to become more like wallpaper, we dispose of them. In glass, I have not really sold very much, only when there were duplicates.

DJ: *Do you do this through auction or dealers?*

NW: Mostly dealers, though some of my friends who have coveted certain pieces have bought from us.

DJ: *What periods of art have you collected?*

NW: I would say I was always drawn to the 1920s, '30s and '40s. I like some of the furniture from that period as well as the art and the glass.

Above
Franz Gertsch (b. 1930), *Christina IV*, 1983.

Right
Robert Bechtle (b. 1932), *Vincente Avenue Intersection*, 1989.

Below
Audrey Flack (b. 1931), *Time to Save*, 1979.

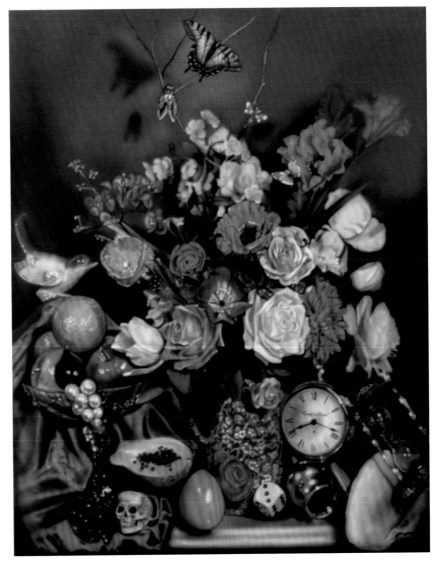

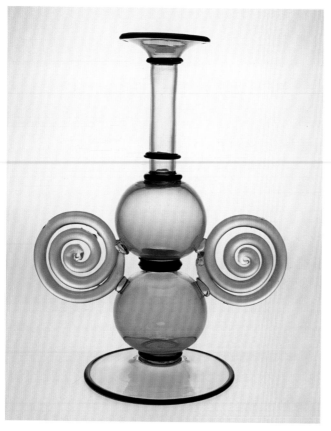

Umberto Bellotto, C.V.M. Pauly & Co., *Transparenti*, c. 1927.

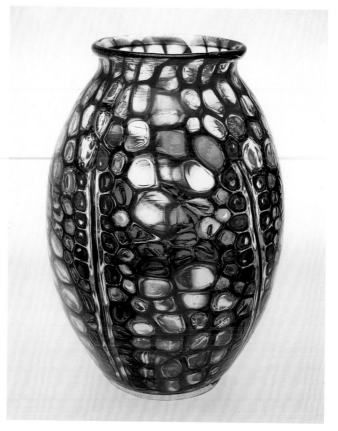

Ercole Barovier, Vetreria Artistica Barovier, *Vetro Mosaico*, 1924–25.

DJ: *What other periods drew your attention? I know you collected Photorealism.*

NW: That was our initial major collection. There were eleven original artists, and we owned the best that there was in that area. Most of the Photorealists were alive at the time we were collecting their work, so we were able to meet them. They do paintings one at a time, working from a photograph, which actually requires great skill and technique.

In modern masters, you can spend four or five hundred million dollars and not have much to show for it. We covet things, but we buy a piece once in a blue moon. But now, with the art market being so high, I would not want to be a buyer. It would have to be something that really took my breath away. Like when I saw a piece of glass that was very expensive and I asked if it could be held for me overnight, so that I could think about it. I could not sleep that night and felt I had to buy the piece.

I do not know what drives me to do it, but I had to own that piece.

DJ: *What do you see happening with your art collections in the future?*

NW: Well, one of my collections is Martha's Vineyard memorabilia, so that would naturally go to the Historical Society. I have always bought those things with the idea of donating them. I had some Wampanoag Indian pottery, which I have already donated to the tribe.

DJ: *Do you have advice that you would give others about collecting?*

NW: We would say to educate yourself as best you can and try to buy what you really like. And the education part can be a very painful process; it was with us with Venetian glass. I have made many mistakes and I still make them every once in a while.

DJ: *How do you do your research?*

NW: Well in glass, I have read every book that has been written on Venetian glass. I have a whole basement full of books. When I find a piece I like, I ask myself why I like this particular piece. It is usually technique or something else that will draw me to this piece, or this artist, or whatever. And I decide what it is I am particularly drawn to in the work.

DJ: *You must also steep yourself in the history of the art objects?*

NW: Yes, from books and from dealers, particularly with Venetian glass. The Italians absorbed ideas from everywhere, copied them, and made them better.

Donna has a very good eye for nice objects and art. I collect most of the glass, but Donna started the collection originally. I go to every show I can. Just for the idea that I might find a piece, or the piece.

DJ: *No matter what the show is about?*

NW: No matter what the show is about, I go to everything. I cannot help myself. I am just looking for things.

DJ: *You said your interest was in the 1920s and 1930s, which conjures up Art Deco.*

NW: Yes, we like Art Deco a lot. We have a couple of pieces. And some of the glass is Deco. We like that period. I love seeing collections, and nothing is more interesting than a whole collection of objects. We know a couple that collects Majolica and they must have three or four hundred pieces. When you look at them all, it is fascinating.

DJ: *Tell me about your Photorealism collection.*

NW: We have a lot of notable paintings. In our entry foyer there is a 10- x 13-foot painting of the face of a woman, by Franz Gertsch, a relatively unknown

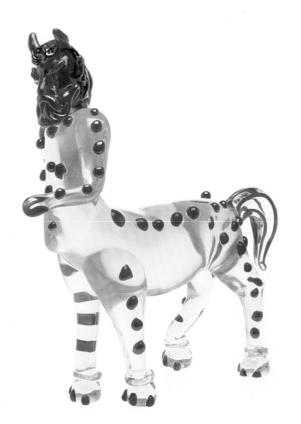

La Fucina degli Angeli, *Centauri* (from Pablo Picasso), 1954.

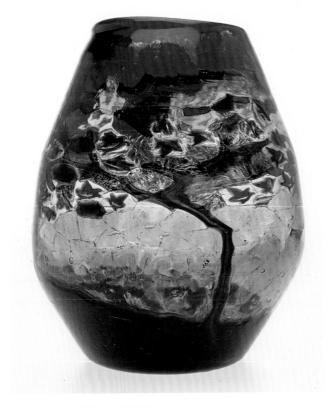

Artisti Barovier, *A Murrine*, 1918–19.

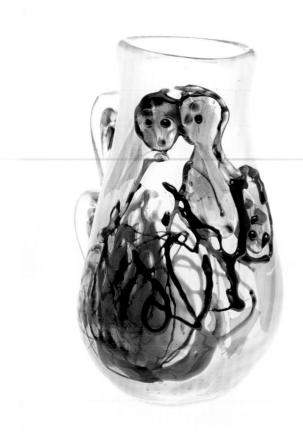

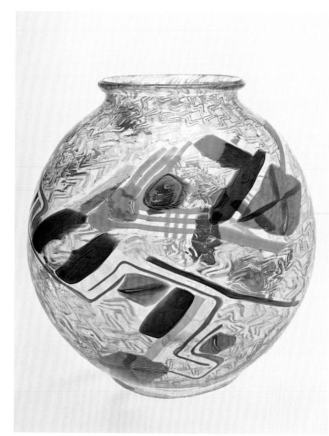

Photorealist. Donna and I knew every piece of work he did, either by picture or photo, or in person, and ours is one of the best. We actually had two, but we sold one to the Gertsch museum in Switzerland.

We also have work by Richard McLean, a California artist who only paints horses, in both acrylic and in watercolor. We have a couple of paintings by Ben Schonzeit, which look very realistic. The important Photorealists, Ralph Goings, Charlie Bell, and Robert Bechtle are among our favorites.

DJ: *Donna, do you and Neil have different roles in your collecting?*

DW: We approach it differently. I always describe Neil as a collector, and I am a selector. I like one, and I have to feel it is the best one. But Neil is a true collector, he wants everything, and that is a difference. When we lived in New Jersey, our house was minimalist, but in his office, objects were everywhere and were three-deep around the perimeter of every room, which explains how we have remained married for thirty-nine years. Our rule of thumb has always been that if neither of us hated it—really hated it—then that was okay to buy, but if it was a significant investment of money, we would have to both agree on it. We collect and live with these pieces. I think you have to have a sense of style, a sense of proportion. And so when you see something, you just know it intuitively. No one is going to teach you to have an eye.

Top
I.V.R. Mazzega (from Marc Chagall), *Sposi*, 1960.

Bottom
Nicolo Barovier, *Vetro Mosaico*, 1924–25.

Opposite page
Clockwise, from top left: Nicolo Barovier for Salviati, *A Murrine*, c. 1914; Nicolo Barovier, Vetreria Artistica Barovier, *Vetro Mosaico*, c. 1925; Nicolo Barovier for Salviati, *A Murrine*, c. 1924; Studio Ars Labor Industrie Riunite, Artist unknown, *Incisi*, 1930–33.

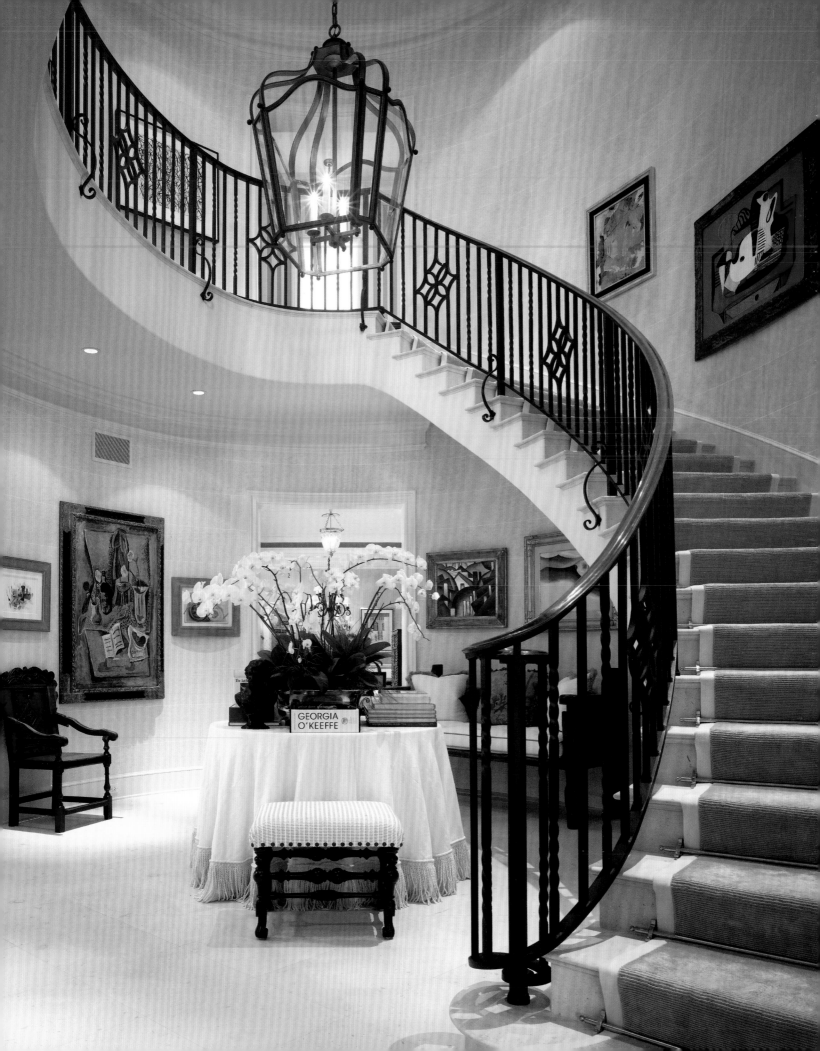

TOPICS IN COLLECTING

Frederic Edwin Church (1826–1900), *Cotopaxi*, 1862. Detroit Institute of Arts; Founders Society Purchase, Robert H. Tannahill Foundation Fund, Gibbs-Williams Fund, Dexter M. Ferry, Jr. Fund, Merrill Fund, Beatrice W. Rogers Fund, and Richard A. Manoogian Fund.

Buying at Auction

Peter B. Rathbone

Advisor and Consultant
American Paintings and Sculpture, Sotheby's
New York, New York

Pursuing works of art at public auction can be one of the most exhilarating experiences imaginable, or one of the most frustrating, depending on your final bid when the auctioneer's gavel falls. Were you the successful buyer or were you the underbidder? Were you thrilled by your coveted acquisition or disappointed at how tantalizingly close you came to adding something special to your collection? There is no question that the extraordinary growth of the art market over the past several years has generated enormous enthusiasm and excitement, not to mention previously unheard of price levels, in all fields of collecting. Auction houses around the world have been at the forefront of this expanding market, as the publicity generated by successful results has increased the number of participants in these public sales, helping to achieve new record levels in every collecting category. This booming international art market is a relatively recent phenomenon.

My own background in art stems largely from having been raised in a family whose life revolved around the art world of my father, Perry Rathbone. He was a charismatic and dynamic museum director for more than thirty years, first at the Saint Louis Art Museum, and subsequently for seventeen years at the Museum of Fine Arts, Boston. His enthusiasm for his chosen profession was infectious, and my sisters and I were captivated by his experiences with fellow museum directors, curators, collectors, artists, and dealers. Although I had always aspired to play right field for the Yankees, I opted for majoring in art history at college, realizing that the chances of patrolling the turf where Babe Ruth had once roamed were slim to none.

Having no specific plan as to what sort of career to pursue with my undergraduate degree in art history, I enrolled in the relatively new Sotheby's training course in London, hoping to buy some time and possibly gain insight into where my academic study might lead. I was extremely fortunate that an entry-level position became available at Sotheby's in New York in an area in which I had expressed interest, so I arrived there in September 1972 as the newly hired cataloguer trainee in the American Paintings Department.

The art market and the role of the auction house was very different in those early years of my employment. In 1964, Sotheby's had acquired Parke-Bernet, New York's venerable auction gallery, in an effort to expand its operations beyond its base in London. Numerous changes were initiated under the new management; generalists gave way to specialists and separate expert departments were formed, including a department for American painting that handled traditional works from the eighteenth century through the mid-twentieth century—a department that would have been wholly unthinkable in London. Separate departments were also formed for contemporary art, Americana, American furniture, decorative arts, and folk art—which were all novel areas to the British. The concept of reserves (the confidential protective minimum agreed upon between the seller and the auction house, below which a work would not be sold) was introduced. The auction world was about to undergo considerable changes.

From my vantage point as a newcomer to the American Paintings Department, the world of art auctions was still a novelty, despite what I had gleaned from my course

Peter B. Rathbone with Dara Mitchell, Director, American Paintings Department, and auctioneer William W. Stahl, Jr., Vice Chairman, North and South America, American Furniture and Folk Art, with *Robert Louis Stevenson and His Wife*, 1885, by John Singer Sargent (1856–1925).

at Sotheby's. During my year in London, I learned that American paintings (from the few examples I saw there) were considered derivative and inferior to their British and European counterparts, and therefore, suffered in stature and value. Although there were a small number of dedicated collectors in the American field: Dan and Rita Fraad, Ray and Margaret Horowitz, Meyer and Vivian Potamkin, and Arthur Altschul to name a few, there was still a relatively narrow collecting base and a limited marketplace. In the same vein, there were a handful of dedicated dealers and galleries who were instrumental in furthering interest in American art and introducing it to the limited collecting audience.

Selling works of art at auction was viewed as something akin to a wholesale outlet, where the dealers dominated the salesroom and generally purchased about 75 percent of the works being sold. There was no guarantee of authenticity at that time and the dealers would vet the works. Once acquired, they would conserve, reframe,

and do whatever was necessary to prepare the works for sale to their clients. Generally speaking the prices asked were considerably higher than what had recently been paid at auction for the very same painting, but of course the works had been transformed since their appearance on the auction block. In those more innocent and leisurely times in the auction world, presale estimates did not even appear in the catalogues. A prospective buyer had to call the department to get an idea of what the gallery and the seller had arrived at as a suggested price range. This was also helpful to the auction gallery in assessing what sort of interest there might be in a given item being offered in its forthcoming sale. It is notable that as the auction market has evolved, in the American field at least, the early 1970s ratio of dealer to collector buying at auction has been reversed, with 75 percent of the buyers currently collectors (or dealers acting as their agents) and 25 percent dealers buying for inventory.

Dara Mitchell, Peter B. Rathbone, and William W. Stahl, Jr., with *Hotel Window*, 1955, by Edward Hopper (1882–1967).

One has only to observe the dramatic rise in prices over my thirty-six-year career at Sotheby's to put in perspective how dramatically the collecting interest and the market for American paintings has grown (not to mention every other collecting field as well, some of which did not even exist in the early 1970s). I recall arriving at the office my first day and seeing Thomas Anshutz's *Steel Workers, Noontime* hanging on the wall of the department. It was a work with which I was familiar from Edgar Richardson's seminal treatise on American paintings—the text I had used for a college survey course on the subject, which was one of the few being offered at that time. I was somewhat surprised and also thrilled to see a painting that I had encountered in my studies being offered in my first sale. In fact, it was the star lot from the collection of Dr. and Mrs. Irving Burton of Detroit. It fetched $250,000, a new record for an American painting at auction, and was bought by John D. Rockefeller III, with The Metropolitan Museum of Art as the underbidder. It was an exciting beginning, but there was so much more in store.

Although there have been many extraordinary public sales over the years, one of the most important auctions took place in October of 1979 when Frederic Church's long-lost (it is hard to imagine losing a painting that measures 6 x 10 feet) masterpiece *The Icebergs* was offered for sale at auction. It was the first American painting to exceed the $1 million mark when John Marion hammered it down at $2.5 million. The buyer's premium of 10 percent, which had only been adopted by Sotheby's in New York that year, brought the total price to $2.75 million, which was not only a record price for an American painting, but the third highest price ever achieved at auction for any work of art, exceeded only twice, by paintings by the celebrated Old Masters Velàsquez and Titian. An impromptu celebration ensued in the main salesroom at Sotheby's on Madison Avenue as the 10 percent seller's commission combined

with the 10 percent buyer's premium earned the gallery half a million dollars—the highest single commission in Sotheby's history at that time. As an unheard-of sale price for an American painting, it stood the art world on its ear and made front-page news in the *New York Times*. Since then more than four hundred American paintings and sculpture have exceeded the million-dollar mark, and a vastly greater number when you add the numerous contemporary works by American artists, which are sold in a separate department specializing in post-World War II art. In striking contrast to the record price of $250,000 for the Thomas Anshutz masterpiece sold in 1972, the record at public auction for an American painting (excluding contemporary art) now stands at $27,502,500 for George Bellows' *Polo Crowd* sold at Sotheby's by the Museum of Modern Art in December 1999.

The boom in the auction market really hit its stride in 1983, when Alfred Taubman, the real estate magnate from Detroit, acquired Sotheby's. He brought considerable energy as an entrepreneur and infused his new venture with a strategy of promotion and marketing previously unknown in the auction world. Scholarly and lavish auction catalogues were produced, and grand parties were thrown in conjunction with auction sale preview exhibitions. This excitement brought many more collectors through Sotheby's doors, and a whole generation of buyers became comfortable buying works of art at auction and in fact even enjoying the competitive nature of the bidding process. Scholarship in all fields and numerous exhibitions all over the world have brought greater attention to art and the enjoyment one gets from collecting. The market has prospered beyond many an observer's wildest dreams, with demand strong for the very best works and the supply more limited than it once was.

Many factors come into play when contemplating a purchase at auction, and participation is not for the faint of heart. As the auction market has grown in expertise and sophistication, so has the auction buyer. First and foremost, an astute collector should be well versed in the area in which they would like to collect. Of utmost consideration is the quality of the work itself, whether by an important artist or one of lesser stature. Knowing the physical condition of the work is also paramount, especially given the considerable sums of money spent on works of art today. The price paid for any acquisition will also be determined by the rarity of the work, its size and medium, as well as its provenance and or historical importance. Is it the artist's best subject, from the best period? The collector should not just seek the advice of the auction house specialists, but also that of outside experts or consultants for assistance in developing a bidding strategy. In order to participate at auctions successfully, it is a good idea to attend numerous sales before taking the plunge. A collector will then be better prepared for the pace of an auction and the subtleties of bidding. These are important and essential factors to consider before venturing into the exciting and compelling world of pursuing works of art at auction.

I have been privileged to play a part in the art auction scene as a member of the American Paintings and Sculpture Department at Sotheby's for my entire thirty-six-year career, with thirty-two years as a director of the department. I have witnessed its unprecedented growth during that period, and it has been an ideal venue to learn about American art. The vast number of works which one encounters is constant and unending, and there is always the hope and expectation that the next undiscovered treasure is just around the corner.

Art Education

Lisa Koenigsberg, Ph.D.

Initiatives in Art and Culture
New York, New York

I grew up surrounded by art, and from my earliest years, art was at the core of my life. The Myth and Symbol School of history, prevalent during my high school years, shaped my view that every object conveys messages about the era in which it was made and about its maker, and its aesthetic characteristics may shed light on a national sensibility or a world movement. It also became clear to me that with the study of past civilizations, cultural objects and works of art can be examined for their beauty, as well as for what they impart about the culture and society from which they come. Today's McDonald's sign will be tomorrow's archaeological shard or artifact, to be studied for what it reveals about history, class, and taste.

My experience as director of Programs in the Arts and adjunct professor of arts at New York University's School of Continuing and Professional Studies, and my consulting with museums, galleries, and other cultural institutions led me to found Initiatives in Art and Culture (IAC). IAC is an organization committed to educating diverse audiences in the fine, decorative, and visual arts and architecture. IAC's primary activities are conferences, publications, and exhibitions. Particular areas of emphasis include American painting, the history of frames, the Arts and Crafts movement (internationally and in the United States), the art of metalworking in America, the influence of Asian cultures on American fine and decorative art, and the history and future of fashion and of materials. Additional areas of inquiry include sustainability, and the catalogue raisonné as an interpretive genre. IAC has always embraced collaboration with other institutions throughout the country and abroad, and we have worked in tandem to explore such subjects as a regional style or the reconceptualization of the role of the museum.

Our long-range focus on a number of specific areas permits ongoing exchange among members of communities of interest who bring their unique points of view to bear at gatherings that further knowledge. For example, since 1996 the annual American art conference has brought together scholars, conservators, collectors, and students to focus on a theme that cuts across the discipline, shedding new light on artists and eras of American visual culture and offering a forum for lively discussion and exchange.

Diversity of interest and experience among learners enhances the educational endeavor. Such exchanges are supplemented by reading publications in related fields, visits to public and private collections, and gallery visits. These are part of the lifelong, ongoing commitment to learning that any passionate interest requires.

IAC is committed to learning forums that bring together communities of interest across a wide range of fields and disciplines and that draw on the broadest possible range of approaches. Our diverse constituency includes collectors, scholars, conservators, authors, and connoisseurs. Providing a forum for a multiplicity of perspectives is central to the organization's mission. We believe that the people with whom one engages are integral to any learning experience. All our activities attest to and are manifestations of the fact that each person learns differently and that learning is a lifelong process.

Opening of *Modernism: A Century of Art & Design.*

Navigating Art Fairs

Sanford L. Smith

Sanford L. Smith & Associates
New York, New York

In 1979, I introduced the Fall Antiques Show—the first American antiques show in the world—with ninety dealers housed in the Park Avenue Armory in New York City. The intention was to re-define the manner in which antiques and art shows were run. I had exhibited in shows run by other managers when I was a dealer myself, and was not satisfied with the attitude I found with management. My philosophy is that the dealers are my clients; they pay me to take care of them and to give them the best show possible.

I continue to subscribe to this approach with the five shows I produce and the two others I manage every year. My staff has been trained to serve the exhibitors in every way. The mandate is to quickly fix any problems that arise, serve as a buffer for them with the various trades that work on the show, and to represent them properly to a discerning collecting public. When dealers participate in a show, there is a lot at stake—difficulties can arise and it is our responsibility to maintain calm.

Six of my annual shows still take place in the Park Avenue Armory at 67th Street in Manhattan. The drill floor of this historic building can be transformed for America's finest fairs in the course of about forty-eight hours. Once a year, my company runs three shows back-to-back, reconfiguring about seventy to ninety booths to new measurements, and adding new wall coverings and lighting designs. To accomplish this incredible change-over, five different unions have to cooperate: carpenters, electricians, teamsters, painters, and expo workers.

Galleries must apply to participate in our shows. We vet a prospective gallery's reputation and the way that they conduct business through the recommendations of other exhibitors; most of the time we require three of these recommendations. The applicant then submits copies of catalogues they have published, or articles about their gallery. We try to ensure that galleries demonstrate a certain level of quality and conduct themselves professionally. The art itself is obviously a subjective matter. The monetary value of art is determined by the marketplace: supply and demand, what is fashionable, and how well an artist's dealer has marketed the work.

Promotion is the secret to some artists' success and, when lacking, the reason why other truly wonderful artists never achieve proper recognition. Very few artists have been able to promote themselves well; they need the help of a gallery that will spend money, give them the opportunities for shows, and insure that they get attention. Everyone needs somebody working to help sell his or her work.

By the same token, one of the major services we provide our exhibitors is promoting them through our shows. We maintain a mailing list of fifty thousand people who have attended specific shows. My website links to the websites of all the exhibitors in our shows. The *New York Times* is another principal way of reaching the very upscale national market we need for our shows. I also advertise on the radio, choosing stations based on the

demographics I want to reach. Radio is immediate—and we advertise in publications that target specific markets where we can reach the people with a direct interest in the kind of show being organized.

For the first two or three years we were in business I used public relations firms, and I found there was not a public relations person who was competent to do this work for the amount of money they demanded. So everything was brought in-house, and has been done that way for the past twenty-five years. Developing relationships with the right people in the press is important, but you do not need a public relations firm for that. It is actually just a matter of getting the right information to the right person.

These days there are so many art shows around that it can be difficult to differentiate between them. About ten years ago, I started branding my shows with my name so that people know they are attending an event with history and credibility in the business. Another important aspect of our form of branding is that each of our shows is different. I do not duplicate a show, and each one is targeted to a specific audience. I do not need twenty thousand people attending; I need three to five thousand people who are genuinely interested in the material.

What does one look for when attending an art or antique show? If you are a novice collector who has seldom or never attended a quality art or antique show, the first thing to do is to look and ask questions. Dealers come to shows hoping to gain collectors, and the way they do that is by educating individuals. If a dealer takes a glance at you in your jeans and sweater and gives you a look that says they have no time for you—bypass them. There are thousands of others who will treat you

properly. Dealers need to treat everyone they encounter as potential collectors, whether they buy something or not. Smart dealers do this. Another thing to consider is that negotiation is accepted and respected. Remember, though, that negotiation means making a respectable offer. A 10 to 15 percent discounted price is acceptable to both dealers and collectors.

When you see works of art that interest you, it is best to research the artist and the object. With the Internet, it is easy to research the artist, the period, and the price structure. The more knowledge you possess and the more informed you become, the better collector you will be. If you are an experienced collector confident in your own knowledge of the material, you have more independence and can look and judge for yourself. Nevertheless, it can always be useful to ask questions. If you are looking at an antique piece of furniture, you still need to know if there have been any repairs, restorations, or replacements. At the Winter Antiques Show about thirty years ago, a well-known and knowledgeable dealer sold an American eighteenth-century highboy for one of the highest prices ever paid at that time,

based on information that the piece was untouched—that it had never been repaired, refinished, and had no replaced parts. The couple who purchased it insured it, and their insurance company sent an appraiser to value the piece. After an exhaustive examination of the piece, the appraiser concluded that there had been a small repair to the rear foot that was less than an inch deep and was at least a hundred years old. The collectors returned the piece to the dealer and canceled the sale.

The moral of this story is to make sure you get a bill of sale on whatever you buy and make sure that bill of sale says exactly what is being purchased. If it says you are getting a work that is free of repairs, replacements, and restoration, then you have recourse and can go back to the dealer and either cancel or renegotiate the terms of the sale if the condition was misrepresented.

Collecting is one of the great joys in life, and true collecting does not require great sums of money. It can be interesting and rewarding at any level. To be a collector, however, you have to have a passion for what you do. I wish you all that great passion.

Framing Works of Art

Eli Wilner

Eli Wilner & Company
New York, New York

The fascination with frames began with Egyptian funerary paintings and increased during the Italian Renaissance; private collectors began to assume the decision-making process in the 1500s, and wealthy individuals as well as royalty continued the process, which now includes collectors and institutions through to the present day.

Framing has become a common practice, whether it is simply placing a surround on a family photograph or reframing a masterpiece. The desire to reframe a painting or drawing has several motivations: it can be an assertion of a collector's aesthetic vision, or the desire to historically recontextualize a work of art or match it stylistically to a specific room. The universal inspiration for framing, however, is a creative and collaborative act on the part of the owner or guardian of a work of art. With over eight thousand reframing projects since 1977, our work has facilitated this joyous interaction.

The importance placed on framing is best evidenced by the major auction houses, Christie's and Sotheby's, who borrow frames to enhance the monetary potential of their paintings before a major sale. For example, we recently framed the $95 million-dollar Pablo Picasso painting, *Dora Maar with Cat*, before it went on view. It is difficult to place an exact figure on the enhanced dollar value that our frame added to the painting, but the transformation of the frame from the slight narrow border to a wide, dark, powerful frame certainly maximized the dramatic impact of the painting.

As the supply of great American and European period frames diminishes in the face of greater demand,

Carved and gilded ornament from a replica of a c. 1851 American frame by Eli Wilner & Company.

William Merritt Chase (1849–1916), *Blue Kimono*, 1898, oil on canvas, 57 x 44 ½ in. The Parrish Art Museum, Southampton, New York.

Robert Henri (1865–1929), *Portrait of Mary Ann Cafferty*, 1928, oil on canvas, 24 x 18 in. Private collection.

Childe Hassam (1859–1935), *The Church at Old Lyme*, 1906, oil on canvas, 30 ⅛ x 25 ¼ in. The Parrish Art Museum, Southampton, New York.

Restoring frames at Eli Wilner & Company.

the prices of frames have escalated dramatically. In the 1980s frames were still being discarded at a time when historical accuracy was not considered the best approach for framing, whereas today that has changed and now a period frame can easily command more than $100,000. My gallery started producing nearly identical replica frames several years ago as a way to stave off the inevitable dearth of original frames. Our studio produces these replica frames by hand, because the mass production of moldings has never been able to match the subtleties of carving and gilding. This venture has proven to be very popular with collectors and institutions as, naturally, the price structure is less than the period frame while the quality and period appearance are retained.

Collectors are a varied group and their tastes range accordingly. What never seems to change is their fascination with the creative process of choosing just the right frame to highlight a treasured painting. Once satisfactorily reframed, the painting becomes like a new acquisition. This process is centuries old and will continue; for me and for collectors, the joy of seeing the transformation of a work of art is one of the wonders of collecting.

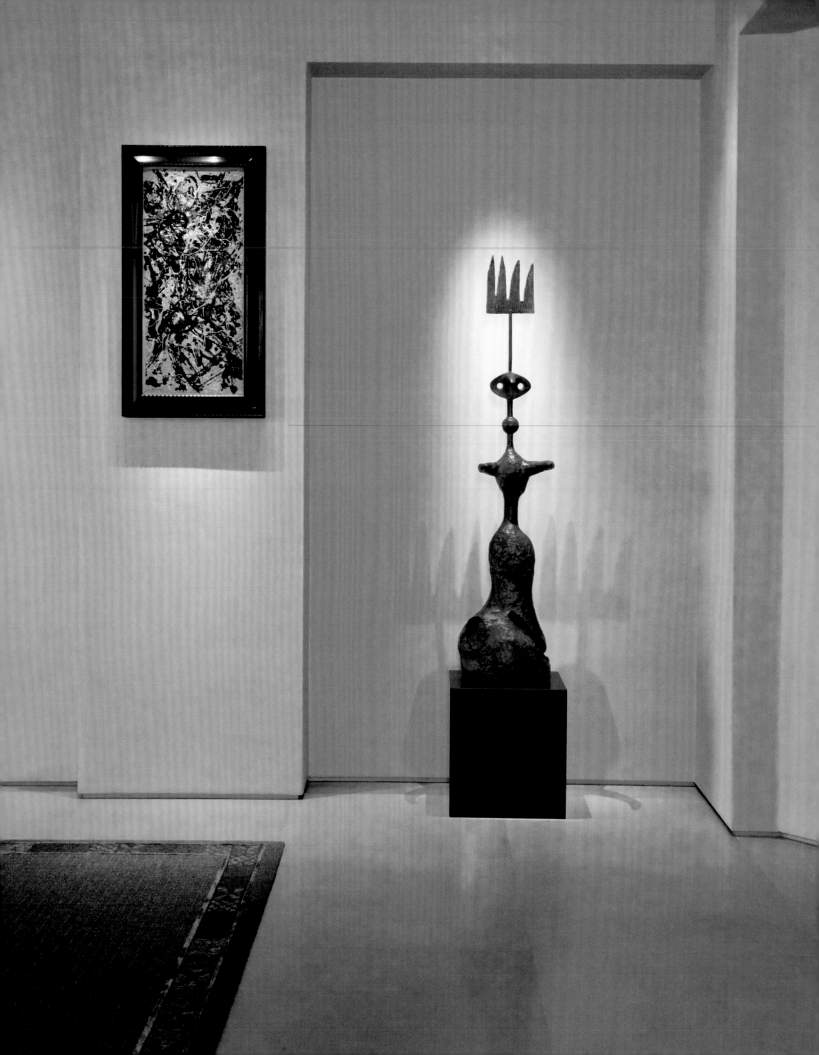

Lighting Art Collections

Sandra Liotus and Sir David Crampton-Barden

Sandra Liotus Lighting Design
Newport, Rhode Island

Even the serious collector of art often settles on lighting solutions that do not protect or show their irreplaceable art and objects to their best advantage. Lighting should be regarded as a necessary element of viewing art, but it should not contribute to the deterioration of its condition; many paintings and works on paper have been destroyed or irretrievably damaged by improper lighting. The science of environmentally correct lighting for art is a relatively new one. It should be a concern of every collector, who should be able to pass their art onto the next generation in as good a condition as they received it. Collectors are only temporary custodians of the art collections that they own and enjoy in the home or museum setting.

The main goals for lighting works of art should be to provide correct lighting for display while ensuring that no damage occurs from the illumination which allows them to be seen. Harmful, damaging effects of both ultraviolet and infrared radiation must be eliminated. This can be prevented by controlling the level of projected light in keeping with the standard conservation limits applicable to each specific work.

Collectors naturally want to minimize future maintenance and electrical consumption by careful selection of a lighting system. Collectors also want to ensure that the lighting remains discreet within the environment. A customized lighting design can be achieved by an expert working with a client and their professional design team and chosen contractors.

Though light basically enables one to see works of art, it is actually a far more complex subject than it would at first appear. The spectrum of light is measured in nanometers or millionths of a meter and covers wavelengths from the shortwave ultraviolet to infrared. The shortwave ultraviolet and long-wave infrared cannot be seen by the human eye, but they are nonetheless present all the time. The ultraviolet rays of the sun are highly destructive to materials and will rapidly fade color and can cause the disintegration of organic materials. Consider the once lush colorful drapery in a house that has been exposed to the sun through a few summers and how the colors have been bleached from it.

Infrared can be felt as heat, and as with any source of heat, it will dry and prematurely age any organic material. Typical conventional lighting systems create this type of heat. It should not be forgotten that the Windsor Castle fire in England, which led to the destruction of an ancient building, priceless and irreplaceable artwork, and historic furniture, was found to have been caused by the proximity of a halogen lamp to drapery.

As lighting specialists, we have carried out ongoing research and have attempted to develop constantly improving techniques for the lighting of art. With combined backgrounds of lighting design, fine art, engineering, industrial design, and manufacturing, we have set out our goal to create a lighting system specifically for the illumination of art—one that allows

Opposite page: On wall, Jackson Pollock (1912–1956), *Vertical Painting*, 1949; Sculpture by Joan Miró (1893–1983), *Projet pour un monument pour la ville de Barcelone (lune, soleil et une étoile)*, 1967.

for perfect viewing with no detriment to the condition of the art. These key principles are essential to the serious collector and investor because maintenance of condition preserves both the appearance and the value of the art. We have been in the forefront of fiber optic lighting, which we believe is the best way to light works of art and to meet professional illumination demands in interior and exterior spaces.

Important features of fiber optic lighting are the removal of unwanted and detrimental infrared and ultraviolet frequencies, as well as the ability to faithfully reproduce the color of various objects, as measured by the CRI (color rendition index) of the lighting. This index measures the purity and balance of the entire visible spectrum, which permits color to be seen precisely as the artist intended, enabling the viewer to see every detail of the brushwork or pencil work.

Top-quality glass fiber optic lighting is the safest lighting system available. In the many residences that have benefited from this technology, the lighting has been almost invisibly retrofitted while no damage has been caused to the décor and fabric of the property. Where the art lighting is installed as a part of a new construction or reconstruction of an interior it can be planned into the project and becomes far simpler than using conventional lighting technology.

The essence of our glass fiber optic lighting system is the remotely positioned light source, the glass fiber optic harness, and the individual output fittings, which are all custom designed and built specifically for each project so that they provide the optimum results. The light source is a fully integral component that has been miniaturized so that it can be easily concealed in an accessible but hidden location. Once installed, the light source will be controlled by the residence lighting system so that it will perform in the same manner as any other lighting on the property.

With our glass fiber optic lighting system there are many benefits that no conventional lighting systems can provide. There is absolutely no heat or ultraviolet rays at the output. Once installed, the fittings never require any future maintenance as they are projecting only transmitted visible spectrum light. Each fitting

can be adjusted as many times as necessary to allow for frequent changes to the display of the artwork.

The fittings can be chosen according to individual taste. Many clients like to see their paintings lit so that the light is tailored around the frames or canvas. This technique works exceptionally well in very formal or traditional spaces where having a spill of light onto walls or furnishings would be out of keeping with the style of the interior. In more modern, lighter rooms the lighting is very often washed onto the paintings where it will add to the ambient lighting within the room in addition to lighting the artwork. This method of lighting also lends itself to areas where three-dimensional sculpture may be displayed. There are also special techniques which are used when lighting watercolors, drawings, and other works on paper, in order not to exceed the necessary lower light levels.

Left of doorway: Mark Rothko (1903–1970), *Untitled*, 1968.
On wall at right: Richard Diebenkorn (1922–1993), *Ocean Park 14 ½*, 1968.

Below
On wall, from left: Jean-Michel Basquiat (1960–1988), *Untitled (Famous Negro Athlete)*, 1972;
Ellsworth Kelly (b. 1923), *Black Curve V*, 1973.

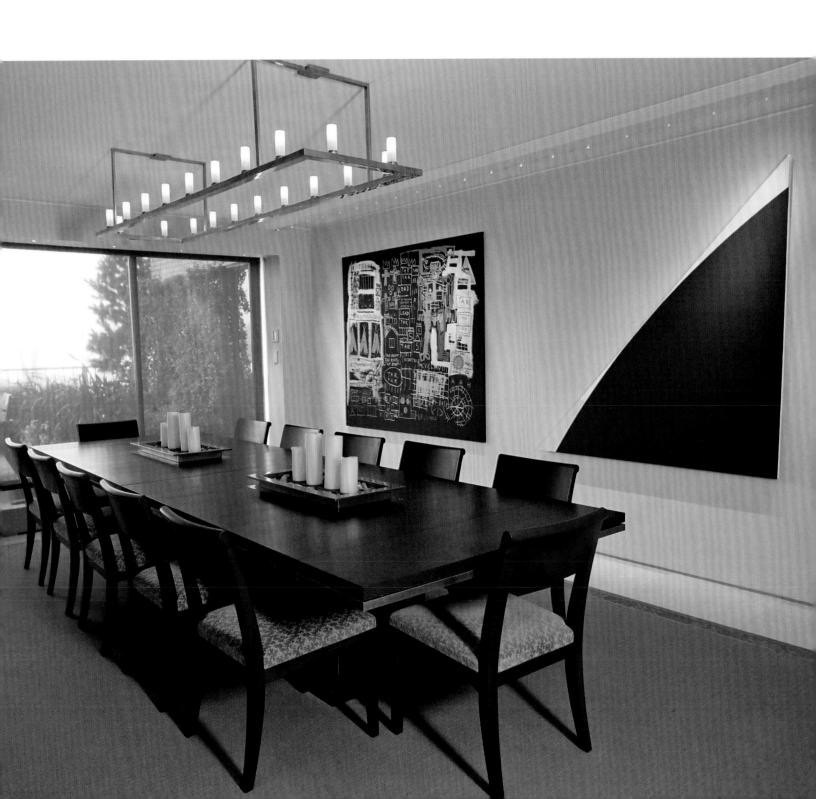

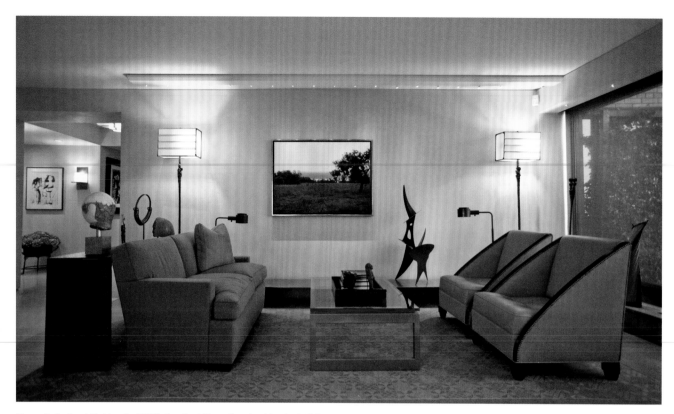

On wall: Gerhard Richter (b. 1932), *Laacher Wiese (Laacher Meadow)*, 1987.

It is best if the lighting is considered as part of architectural or design scheme from the inception of a project, however, we have often had to improvise when a plan is already underway. The lighting expert should be a part of the team involved in creating a space; this can include an architect, interior designer, and contractor.

It has been our mission as lighting experts to develop the best lighting systems possible so that clients can both enhance and protect their collections with light, seeing their art with the correct color, temperature, and clarity while removing the detrimental aspects of conventional lighting systems. Ultimately all of these positive developments in lighting allow the collector the opportunity to enjoy their most treasured possessions in their homes by means of museum-quality lighting that maintains both the value and condition of their artwork.

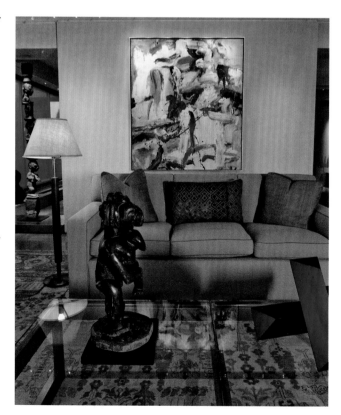

On wall: Willem de Kooning (1904-1997), *Untitled XV*, 1976.

Aesthetic and Practical Concerns in Displaying Fine Art

Suzanne Smeaton

Gallery Director, Eli Wilner & Company
New York, New York

The care and display of fine art spans aesthetic and practical concerns that are at the forefront for any good framer. Clearly the picture frame will have a profound effect on the art it encloses. As nineteenth-century painter Charles Willson Peale remarked, "A good picture deserves a good frame and a bad picture may sometimes preserve its place longer by having a handsome frame."*

In recent years, collectors and curators have become increasingly aware of the importance of the frame. The practice of historically appropriate framing—having a frame style and design that is contemporary with the artwork—has become a desirable practice. It is essential to work with a framer who understands period styles and designs so that the perfect marriage between a work and its frame can be made.

In framing terms, fitting refers to the practice of placing the artwork into the frame. If the artwork is an oil painting, the primary practical concern is that the inner side of the frame rabbet, or groove, should not come into contact with, and possibly abrade, the painting surface. The rabbet should be lined with a soft felt. In some cases, the painting is executed on wood or fiberboard panel that is warped and it can endanger the panel if pushed flat into the frame rabbet, increasing the chance of cracking or splitting the panel. In such a case, the frame rabbet must be carefully constructed to conform to the curve of the panel in order to support it evenly without undue pressure.

Artwork on paper—watercolors, drawings, pastels, or photography—present specific challenges. Many papers have been made with wood pulp and are acidic, which can burn the paper and create discoloration and damage. The proper course is to use 100 percent rag papers that are acid-free and have no wood pulp. This is true for both the top mats as well as the backing paper used to secure the art in the frame. Works on paper are also glazed—covered with a material such as glass or Plexiglas to protect the surface. This glazing should never come into direct contact with the artwork. This means that if a mat is not used, a spacer must be inserted between the art and the glazing.

Glazing is a broad term that includes many different types of available glass and acrylics. The best products include filters that eliminate or greatly reduce the amount of harmful ultraviolet and infrared light that touches the artwork; left unfiltered, ultraviolet rays can fade pigments and damage the art.

Many available glazing products offer a variety of features such as non-reflectivity and ultraviolet filtering. One specialty glass embodies all the desired attributes: it is non-reflective, UV filtering, and shatter-resistant. If the artwork is especially large and requires Plexiglas rather than glass, there are other materials available that serve the best interest of the artwork. It is critical that all the options are explored with a knowledgeable framer who can assist you in making the very best choices.

*Letter of March 7, 1805, to Alfred William Grayson (Peale-Sellers Papers, American Philosophical Society, Philadelphia).

Living room with *Millet's Garden* by John Singer Sargent on the back wall, and John Sloan's *Grey and Brass* over the mantle.

The careful display of the artwork is just as important as proper framing to the longevity and safety of the object. Practical considerations require that hardware affixed to the back of the frame should be firmly attached and that the wire used is sufficient to bear the weight of the framed artwork. In many cases the artwork is hung from two points, utilizing drings and wire loops that guarantee strength and the stability of the artwork so it remains evenly hung on the wall.

Aesthetic concerns also factor into the presentation of artworks: combinations and juxtapositions of artworks can underscore and amplify stylistic connections and a dialogue between works. Different themes can be developed. For example, modernist explorations of abstraction, seaside landscapes in watercolor, or urban scenes, all in a variety of media, can be grouped or arranged in a room to a powerful and pleasing affect. Such groupings can set the mood for a space or provoke fascinating connections. Those collecting over many years will find that one new acquisition can change the relationship within groupings and will warrant a possible reinstallation of all the artwork to show them all to the best effect. This can prove to be an exciting and compelling aspect of displaying and enjoying a private collection.

Fine art lighting is a major concern for the collector, and is one of the more challenging aspects of displaying fine art. There are a variety of lighting options

available, though most present the primary drawbacks of conventional lighting: the heat, infrared, and harmful ultraviolet rays that such light emits. Fiber optic lighting promises to revolutionize the lighting of fine art because it has none of these drawbacks and it allows for extensive adjustments so that the art is perfectly illuminated. When fiber optic lighting is not an option, there are alternatives. When assessing the different lighting methods, it is wise to consider the nature of the collection. Many methods leave little room for moving artwork or making additions as a collection grows and evolves.

There are lighting systems that employ spotlights, other lamps that wash a wall in light, or lighting that is configured to match the size and shape of the artwork. There are also a variety of picture lights available on the market today. A drawback to picture lights is that they must be plugged into an outlet. Ideally a special recessed wall outlet can be situated behind the artwork. If a socket is not situated behind the art, then the cord trails down the wall behind it to the outlet. Some picture lights employ conventional light bulbs, others use halogen bulbs of varying wattage to which special filters can be attached. In addition to the actual size and number of bulbs inside, some picture lights can be equipped with special arms in different shapes and

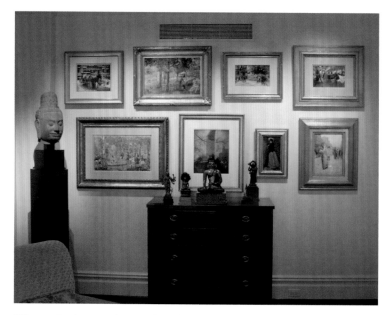

This grouping features photography and works on paper, with Asian sculpture in the foreground. Artists include Maurice Prendergast, Childe Hassam, Everett Shinn, Alfred Maurer, Edward Steichen, and Alfred Stieglitz.

lengths to best accommodate the size and shape of the artwork. Most picture lights are available in a range of four or five finishes, such as polished or matte gold. Whatever kind of picture lights are used, it is critical to select lights that can be filtered to eliminate harmful ultraviolet rays.

Finally, the safe packing and transportation of your artwork is critical to its well-being. Whether an artwork goes out on loan to an exhibition or is stored for a time, proper methods and materials should be employed. Changes in temperature and humidity as well as movement warrant careful attention. When an artwork is packed, the delicate and vulnerable gilded and painted surfaces should be protected with specialty wrap that will not cling to the surface, and the artwork should also be further protected from moisture with additional plastic wrapping. Finally, a well-made crate is frequently warranted—one that will allow the exterior to absorb handling and also allow the framed artwork to rest snugly inside, protected from any jarring movement that may occur during transport.

Thoughtful attention to the aesthetic and practical considerations that address both the beauty and safety of fine art will reward the collector with years of pleasure and enjoyment.

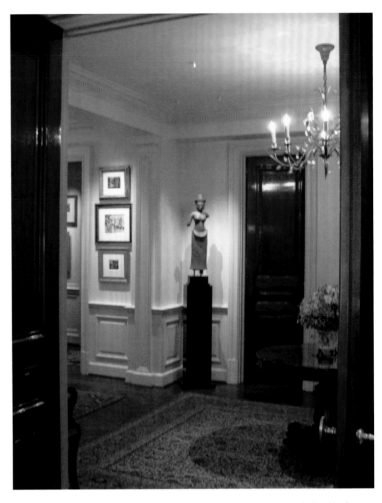

In a hall, Asian sculpture is juxtaposed with American modernist works by Charles Demuth and Oscar Bluemner.

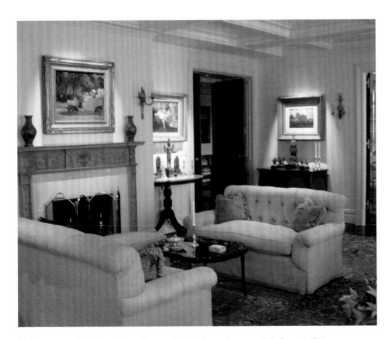

Living room with John Sloan, *Gray and Brass* (over the mantle), Everett Shinn, *Rehearsal*, and Winslow Homer, *Plowing-The Last Furrow* (at right).

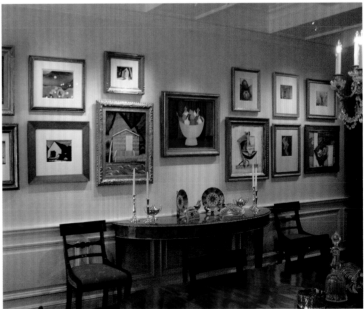

This thematic grouping successfully combines American modernist works of different media, including photography, works on paper, and oil on canvas and glass. Among the artists represented are Arthur Dove, Paul Strand, Rebecca Strand James, Helen Torr, Max Weber, and Charles Sheeler.

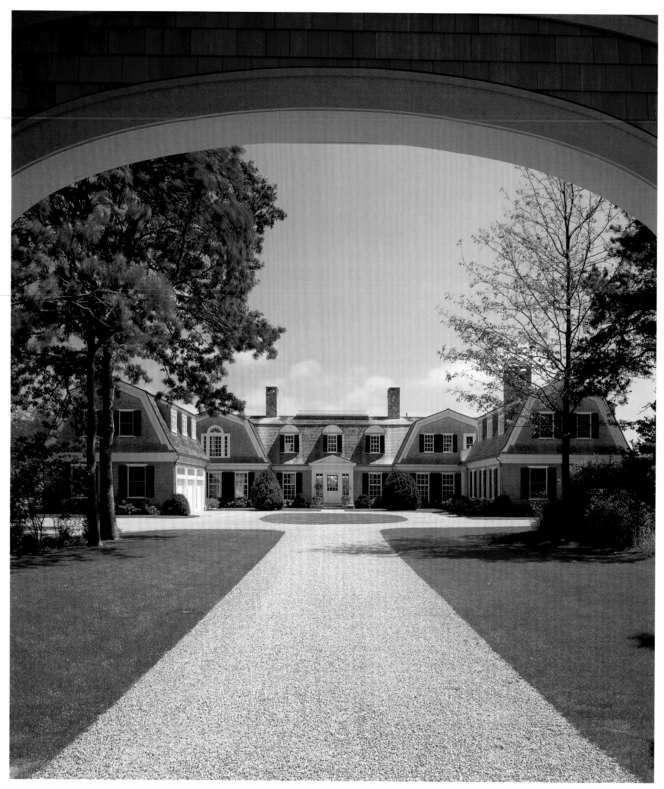

Traditional exterior, Witchwood.

Art and Architecture

Patrick Ahearn

Ahearn Schopfer Architects
Boston and Martha's Vineyard, Massachusetts

Many of the homes I have designed have been conceived with art in mind—not only paintings, but sculpture as well as animated water features as an art form. In many cases, indoor and outdoor spaces have been created to highlight a client's collection of large-scale three-dimensional art. Design plans often establish fluid indoor and outdoor spaces through transitional portals to outdoor rooms or courtyards, which change the spatial relationships in terms of scale and hierarchy, and place emphasis on the art that is located within each of the spaces. This concept provides the opportunity to change the art over time and also to create spaces that are essentially architectural sculpture in their own right.

In terms of circulation, the residences I have developed use the concept of a major spine or street. Secondary streets or galleries provide access to many of the other interior spaces; this approach allows for circulation through a residence without having to walk through a series of rooms. Placing art in the secondary spaces reinforces the fluid concept and also provides the opportunity to integrate art within the overall architectural scheme.

These major and minor galleries can be designed with art niches, or recessed voids, along the circulation route. The negative spaces can house paintings, three-dimensional art, and/or sculpture. Appropriate lighting in these major and minor galleries is also an essential component; halogen or LED lighting, in up light, down light, or back light, creates mood as well as focus on the artwork located within these spaces.

When initially developing the design concept for a new residence, it is important to create opportunities to feature the art both within and around the house. The integration of art and architecture enriches the experience of that environment.

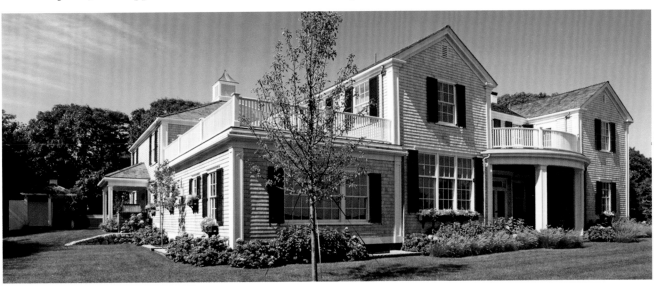

Historic Edgartown Harbor exterior.

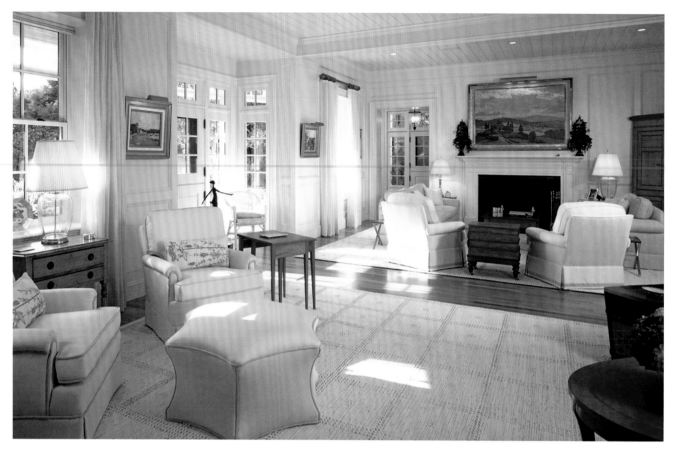

Historic Edgartown Harbor interior.

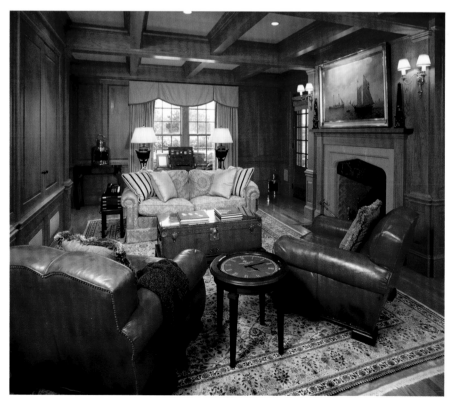

Traditional Herring Creek Farm interior.

Interior Design and the Collector

The Scharf Family Collection of
American Abstract Modernism 1910–1935
Palm Beach, Florida

Lee Bierly, A.S.I.D. & Christopher Drake, A.S.I.D.
Bierly-Drake Associates, Inc., Boston

Successful interior decorating can be attributed to the sensitive layering of elements, finishes, materials, and objects. This coalescing of various elements can address and solve spatial and utilitarian issues, and is also a tool in creating a thoughtful, attractive, and possibly provocative environment in which clients reside and can also integrate their art. Decorating must never exhibit pretension, and the success of a room, like that of the larger house of which it is a part, must always appear logical and natural.

The decorative and architectural elements that comprise a successful room must be combined with careful thought. Many clients bring years of memorabilia including family photographs, cherished keepsakes, and other assorted objects with them, and others have fine art and antiques, prints, and sculpture. These collections often drive the creative direction of the space that they will inhabit and provide a springboard for the design scheme.

How do we as interior designers make room for these elements, these collections, and how do we integrate them into the architecture of the space? This is the point where the designer as the visionary must be at his creative best. Of foremost importance is that the designer must have an understanding of the collection. It therefore goes without saying that the designer must understand what

Lee Bierly (standing), Chris Drake, and Speedo.

the client's intentions are regarding the display of that collection. It is also essential that the plan blend or layer the rooms in such a manner as to present the collection at its best, whether it is traditional or contemporary. It is better to edit the room to allow for growth than to overcrowd, leaving little or no breathing space. In such a situation, walls should be clear of embellishment and all finish materials should be simple and uncomplicated; as in a gallery, the walls should allow for flexibility.

Some clients may even want an extreme approach to showcasing their collection, so the designer must listen to wants and needs of the client. If the collection is one of paramount importance, the decorative elements of the room must complement it. Some important design logistics to remember are that plenty of wall space should be left available for art (present and future) and each piece should be measured in order to properly fit within the allotted space. The collection should be laid out before hanging it and this should be done with consideration for scale and chronology; pieces may be grouped together in order to provide a chronology or narrative. Consideration should also be given to sources of natural light, which can be detrimental to photography, watercolors, and prints. The art should be arranged so that it can be properly lit, and the difference in daytime and nighttime lighting should be taken into account. There are

In the foyer, two small abstract images greet guests and share space with an antique hall porter chair and a Japanese chest. The vivid wall color is inspired by the accent colors in the lush Florida gardens. On the east side of the foyer, double doors open into Mrs. Scharf's study, where subtle ivory tones serve as a backdrop for a collection of her favorite paintings.

many lighting systems available to highlight art. Lighting a collection is an important and personal choice that can significantly impact the resulting presentation.

Some modern collections may warrant a gallery-type arrangement, while most contemporary or traditional collections can be integrated into the residential setting. In this instance, there are many ways to highlight the collection, while also comfortably assimilating it within the decorative scheme. An easy way to feature a collection is with the selection of the wall color: color choices can be either a subtle or dramatic way to showcase a collection; there are no absolute rules that dictate that walls must be white.

With regard to placement of works, special consideration should be given to the particular importance or relevance of the subject matter. Works should relate to their surroundings; still lifes are often well-suited to dining rooms, portraits to parlors, and landscapes to bedrooms. While this may be an over-simplification, it serves as a reminder that a family portrait does not belong prominently looming over a dinner guest. Keep in mind the amount of available space and ease of viewing distance when selecting where to hang individual pieces. Special consideration should also be given to the scale of a room and also the available wall space and sight lines.

The ultimate goal for an interior designer should be to give clients the best environment they can have for reflection, relaxation, and inspiration. This is often a collaborative effort that can be satisfying for designer and collector. From the outside, a house may appear one among many, which can belie the intimacy that lies within. A house is transformed with the introduction of the clients' most prized possessions and is completed by a design scheme that forms the perfect backdrop for its residents and their art collection—and that should be the ultimate objective of the interior designer.

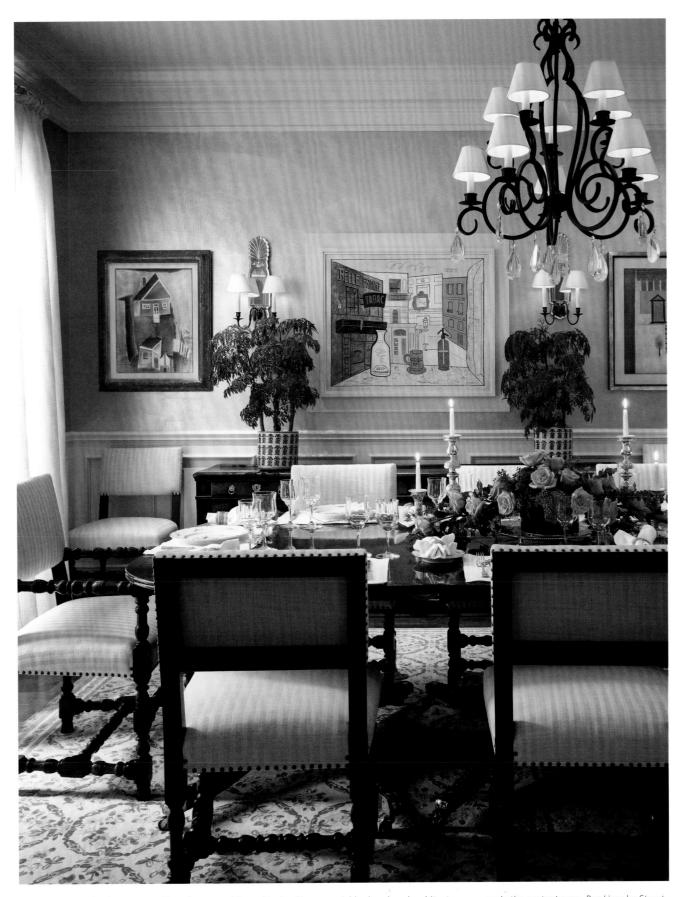

The paintings in the dining room all revolve around the subjects of house, neighborhood, and architecture, as seen in the center image, *Rue Lippe* by Stuart Davis (1892–1964), and the left image, *House with Steps* by Max Weber (1881–1961). The neutral palette of the textiles, along with the subtle silver-leaf walls, offer a sophisticated and unpretentious backdrop to the collection.

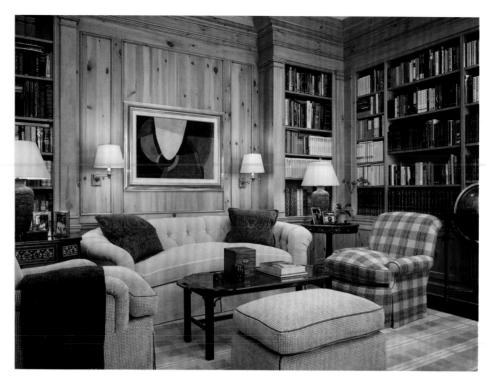

Left

Parabola by Arthur Dove (1880–1946) is a significant work that requires a prominent location. It is one of Mr. Scharf's favorites and was placed in his library among warm colors and textures.

Below

An important arrangement of paintings can be seen on the left wall of the living room. These five paintings (one is not in view) by Abraham Walkowitz (1878–1965) are fine examples of modernism by this Russian–born American artist. The large work over the fireplace is *Abstraction* by Marsden Hartley (1877–1943). Its dramatic coloration draws the viewer into the room and serves as its focal point. The color scheme is derived from the existing Savonnerie carpet, which works with the art to achieve a sense of balance in the room.

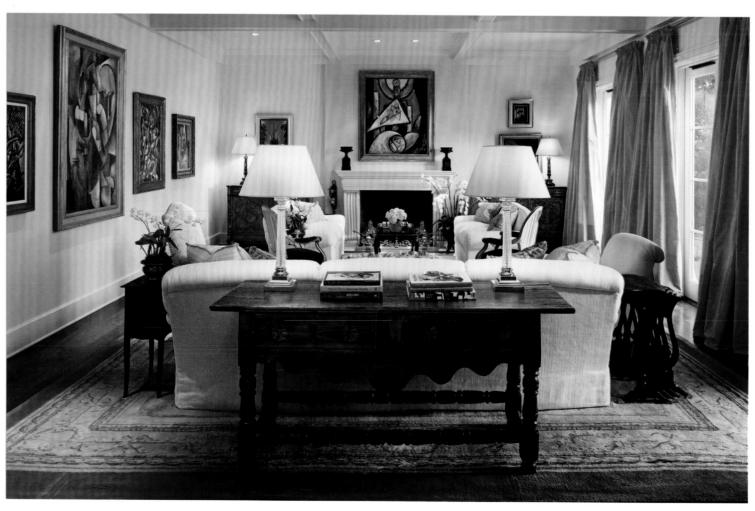

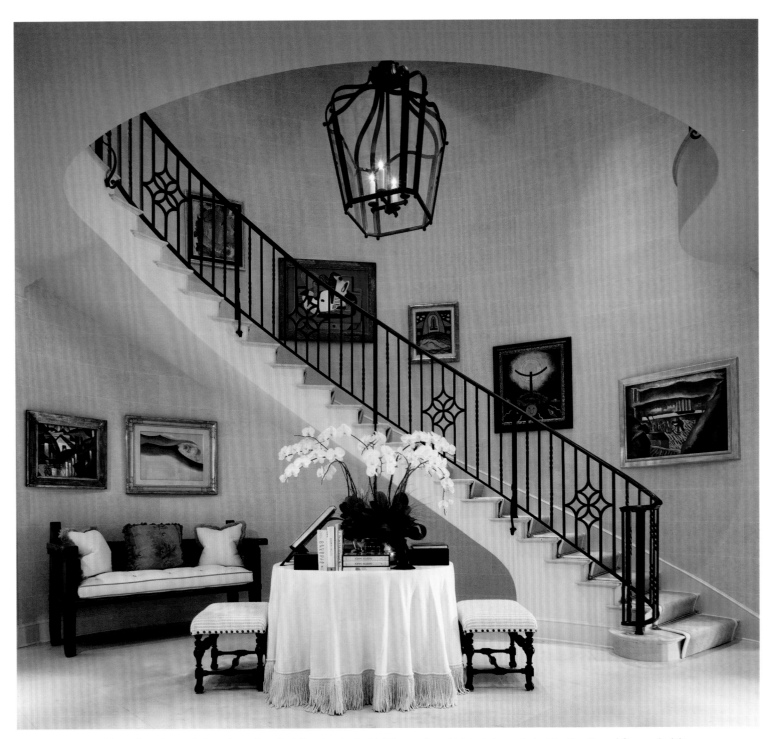

An assemblage of graphic works lines the main stairs. Vibrant and colorful, this grouping, which includes works by Man Ray, Konrad Cramer, Arshile Gorky, and Edwin Dickinson, draws the viewer toward the upper gallery. The two paintings beneath the stairs are more intimate in tone with subtle coloration. On the left, the image is *Nature Symbolized* by Arthur Dove (1880–1946), and on the right is *The Wave* by Georgia O'Keeffe (1887–1986).

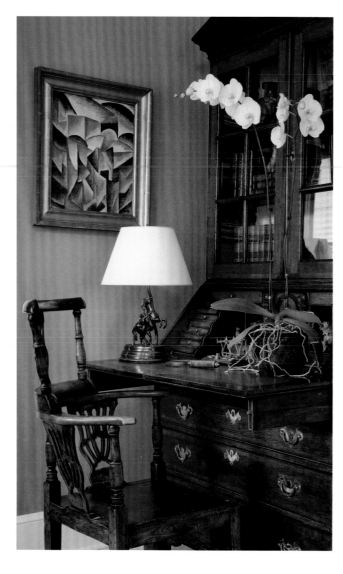

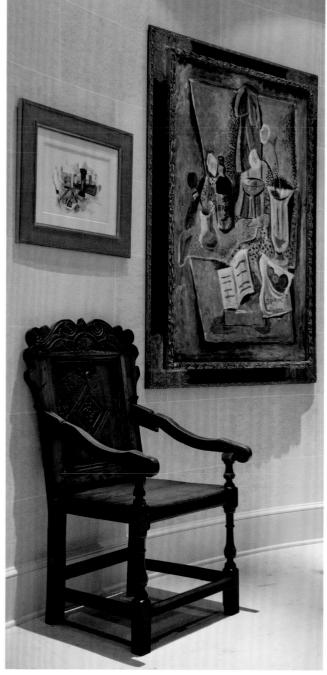

Above

Abstraction by Konrad Cramer (1888–1963) is an example of American modernism. It is a small work that requires an intimate location. The setting is filled with colors, textures, and patterns that complement the painting rather than detract from it.

Right

Abstraction by Stuart Davis (1892–1964) is a large canvas in a vertical format that is set into an elaborately carved frame. The framed image is in turn situated against a neutral background in a vast space that draws the viewer in. The painting can also be seen from a distance and is complemented by an antique Portuguese armchair.

Conservation

Simon Parkes

Simon Parkes Art Conservation
New York, New York

After an apprenticeship in London with an old-school painting restorer, and after working in various capacities within the restoration field, I set up my own small business in London, before moving to America in the spring of 1978. When I came to America, I worked at the auction house at Doyle's with conservators Gustav Berger and Paul Moro, and then established my own studio in New York in 1981, Simon Parkes Art Conservation.

Our clients include auction houses, numerous dealers, and private clients both here and abroad. It is a large and busy operation. It is always important to me that each painting be correctly restored and that the relationships that develop during my work are honest and sincere. This business is very complicated, and the clients, particularly those in the trade, are often fickle and require patience and understanding, which is not something one can learn in school or on the job.

The paintings I work on are varied and reflect a five-hundred-year spread from Old Masters to contemporary art. The two important characteristics that are the foundation on which our company is formed are first, that I have to be correct about the age, condition, quality, and general presentation of almost any oil painting from any period. The second is that I do not consider painting restoration to be brain surgery. Our prices are fair and are based on the hours worked, rather than the value of the piece or how much I feel I can get away with. While there are other very good restorers in New York, I am proud of the reputation we have established.

Many of the restorers at my studio are practicing artists, like myself. I have also bought and sold paintings throughout my career. This is frowned upon in some conservative circles, yet apart from anything else, it helps me understand the perspective of painting owners; the emotional connection many people have with their paintings certainly needs to be understood, and as a collector myself, I can more easily speak the same language.

Simon Parkes, *Sailboat*.

Our studio has worked on paintings by almost every-one—of varying degrees of quality—but the number and range of artists whose works we have conserved is extensive. For example, these include works by Jean-Baptiste-Camille Corot, Milton Avery, Jasper Cropsey, and Marsden Hartley, and many other artists whose works are so familiar to me that I feel uniquely qualified to shepherd their works through the art world for a time.

Conservation is hard work; sometimes people are disappointed and sometimes we are disappointed, but as long as we know we acted properly on behalf of the painting and its owner, it is a very worthwhile and rewarding profession. It is important to point out that conservation is not something that can be learned quickly. A collector should have a relationship with a restorer who is respected, not just in their town or state, but nationally or internationally. It may cost a bit to keep the relationship on a secure footing, but it is vital to the acquisition process. The condition of a painting needs to be fully disclosed at a sophisticated level—and before the painting is acquired, not after. Therefore, any purchase at auction or from a dealer or collector should be accompanied by a condition report by a restorer known by the collector, or to someone known and recommended to the collector.

Another point for collectors and buyers to be aware of is that a condition issue is not something that necessarily can be solved by a restorer. A restorer can make a painting look better in many ways (some appropriate and some not), but the condition, despite restoration, remains the same.

A technically correct restorer who has only little experience cannot properly judge what is acceptable in each period, or how much is too much work. There is often a good deal of money at stake, which is not a factor that can be ignored. It is important to remember that it takes years of experience to be able to make good judgments about the proper course to follow with regard to the condition and maintenance of a painting.

Parkes restoring a painting.

Transport and Storage of Fine Art

Marlene Worhach

Director of Marketing & Business Development
Artex Fine Art Services
Landover, Maryland

The field of specialized art transport is one that has developed in the United States only in the past thirty years. Prior to that, general freight companies or companies that specialized in the transport of antiques were the only choices that were available to museums, galleries, and art collectors. In the late 1970s, specialized art transport companies began to form in response to museums mount-

Architectural drawing review.

ing larger and more ambitious exhibitions in and the expansion of the commercial gallery world. Many of these companies were founded by artists who were looking for ways to support themselves and enjoyed handling artwork.

The majority of these specialized companies sprang up in major cities such as New York, Boston, Los Angeles, San Francisco, and Washington, D.C. As these companies grew and began to perfect their standards for handling artwork, more information about techniques and materials was developed. This information largely came from museum conservators who were examining the materials and practices being used. Museums began to publish research papers devoted to the best practices for the packing and shipping of artwork, and developed professional standards for all to follow.

The services that these companies now provide include local and long-distance transportation, crating and packing, storage, installation, and in some cases international import and export. Depending on the focus of the particular company, these services may be tailored more to the private individual or gallery, or to the most stringent requirements of the museum community.

As museum science has determined the best practices for the transport of artwork and museum objects of all types, a growing consensus has developed.

For example, investigations by museum scientists have shown that trucks equipped with air-ride suspension provide the single best protection from shock and vibration, although the use of air-ride suspension does not eliminate the need for proper packing and crating.

Climate control is also important and has become a museum requirement for all shipments. It has been shown that rapid changes in temperature and humidity can have devastating effects on certain types of artwork. Modern climate control equipment on trucks has become very sophisticated, and the temperature inside the truck can be very carefully regulated. The control of humidity, however, is not as straightforward. One byproduct of air conditioning is the removal of moisture from the air, which lowers humidity. This is very valuable in the hot summer months, but these same units do not add humidity in the winter months when the air is

Crate Interior — Marble bust (reverse view).

Rigging a monumental sculpture.

very dry. In those times the proper packing of sensitive objects is even more important. Crates must be insulated and well sealed, and protected as much as possible from rapid changes in temperature. If necessary there are techniques that can be used to moderate humidity changes within a crate, and this is typically done by introducing silica gel packets into the crates. Silica gel is a material that absorbs or releases moisture in response to changes in the environment. Once properly conditioned to the desired humidity, this material will help to moderate changes in humidity to which a crate might be exposed.

While the use of specialized trucks is certainly the optimum way in which to transport highly fragile objects, it is also important to recognize that it is not always necessary. When shipping short distances, or when the objects being transported are not highly fragile, it is possible to use a wide variety of trucks and packing techniques. Understanding the dangers that a particular object or objects might be exposed to during transit is the first step in determining appropriate packing and transportation.

Climate issues are also important for storage of artwork. When museums use private companies for the storage of their collections, the climate must be maintained at about 50 percent relative humidity and 70 degrees Fahrenheit, with little variation. Large fluctuations in either can cause stress to objects by forcing them to expand and contract on a microscopic level. Rapid change in humidity can create detrimental and irreversible damage to certain works of art. Air quality must be maintained by proper filtration systems, which can range from standard commercial filtration to systems that remove fine dust particles and hazardous gases. Monitoring the conditions in storage must be done on a regular basis and records should be available for inspection if required.

Facility security and fire protection are additional matters of great importance in storage. Security systems must have such features as motion detection, electronic contacts on all doors, and vibration sensors, as well as water detection and possibly closed circuit surveillance systems monitoring. The warehouse must have a sprinkler system and ideally be equipped with smoke and heat detection equipment as well. Over the last ten years most museums have come to accept that a standard wet-pipe sprinkler system is the most reliable and effective means of controlling fire, and that is slowly becoming the industry standard. Gaseous systems can prevent a fire without the use of water and are used in certain highly sensitive collection areas. These systems require a significant investment in both fire suppression equipment and detection systems, as well as in the construction of an air-tight room.

Although these means provide the optimum protection for works of art in storage or transit, they are not always used by commercial galleries or auction houses, primarily due to the fact that they are considered too costly. That is not to say that what museums might require is always necessary for the private collector who wishes to transport artwork as economically as possible while still insuring its safety. In many cases, the choice depends on the type of artwork that is being handled, its fragility, where it is going to be shipped to and from, and where it is ultimately going to be installed. For example, shipping across town a contemporary photograph that has been properly framed under Plexiglas is a different matter from that of an oversized sculpture that has to be moved across the country. Understanding the nature of the shipment is the first step that must be taken in order to properly assess what means should be chosen.

Rigging an oversized painting.

Insuring Art

Dorit Straus

Vice President, Specialty Fine Art Manager
Chubb Group Insurance, New York, New York

If you ask most people what the most common cause of loss of art is, they will probably say theft. The media is full of stories about art heists, and the public is entertained by films such as *The Thomas Crown Affair* and *Entrapment*. Though theft definitely occurs, in reality there are far more losses from water damage than from theft, particularly in urban environments such as apartment living in New York City. It is not uncommon to see losses from leaking air conditioners, washing machines that overflow to the apartment below, or leaking roofs after a torrential rainstorm. I will never forget how terrible a painting by Mark Rothko looked after it was drenched with water that leaked from a penthouse roof into the apartment downstairs. Because color is so important to the works of Rothko, that painting will never fully recover from the water damage it sustained.

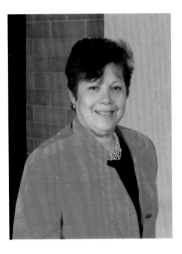

Most collectors want to protect their art, which they both cherish and which represents a significant investment. Unlike other investments, however, protecting art collections requires special considerations. Purchasing a fine art insurance policy transfers the financial loss resulting from damage, theft, and title disputes to another party, namely the insurance company. But in order for an insured collector to be made whole, the insurance policy that is chosen has to reflect the true nature of the collection. So when choosing their insurance policy, a collector needs to find an insurance professional who understands their needs and can translate those needs into an appropriate policy.

The insurance industry comprises insurance agents and brokers who represent the insurance companies that take the risk. The brokers provide information to the insurance company's underwriter so that they can determine the terms, conditions, and premiums that constitute the acceptance of the risk. Part of the assessment of the risk is to determine where the art is located. The type of security measurements that are in place will also help determine whether the collection is vulnerable to theft, fire, water damage, and other typical perils. Obviously, the more protection one has such as fire alarms, smoke and heat detectors, burglar alarms, motion detectors, and security personnel, the more these risks will be reduced. If the security or the fire protection is not sufficient, recommendations will be made to improve the conditions.

The insurance industry is not a monolith, but is composed of many companies, each with its own set of rules. There are some insurance companies who specialize in fine art insurance, and they can provide expertise, knowledge, loss control, and mitigation of risk specific to fine art. There are also brokers who represent museums, galleries, and corporate and private collections. A combination of an insurance agent or broker and an insurance company with expertise in fine art insurance is a good way to ensure that the policy in place fits the needs of the collector. In these turbulent financial times, it is important to evaluate the financial stability and strength of the insurance company in order

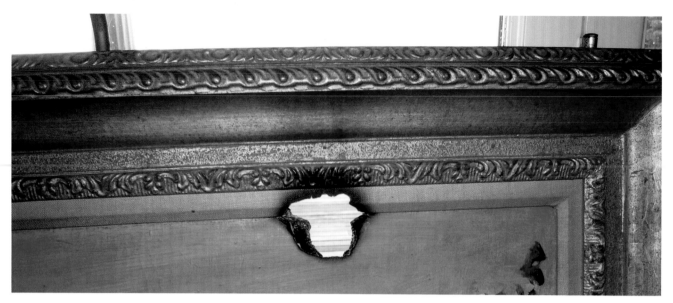

Damage caused by picture light, which dropped onto the painting and burned canvas, liner, and frame.

to be assured that they have the financial resources to pay claims in the event of a loss.

Proper and current valuation is critical in determining the limits for the policy. Underwriters recommend that collectors keep pace with the current valuation, particularly when the art market is so volatile. For example, in recent years contemporary artworks have been rapidly increasing in value. Works of contemporary art should therefore be appraised at least once a year. For works whose market is not as volatile, an appraisal should be completed every three to five years.

Many people wonder why one should bother to purchase a fine art policy at all. Collectors who have never had a loss can only appreciate the need for insurance if they know more about the possibilities for damage or loss. Artwork is always at risk, whether it is on display, in storage, or in transit. Risks differ depending on the situation. Damage to a work is rarely reversible, and will not only decrease its value but can also affect its integrity and originality. The most common types of damage to a work of art are abrasions or surface damage, including rips or punctures; staining, i.e., when a foreign material adheres to the canvas; and climate-related damages such as foxing, warping, and cracking, resulting from natural disasters or improper climatic conditions.

Fine arts insurance policies cover most losses, however some are excluded. A typical exclusion on a fine art policy is the exclusion for "inherent vice," which is a problem with the work's original materials that is known from the outset to cause deterioration, and so is an inevitable occurrence. Someone once explained the meaning of "inherent vice" by comparing it to a mothball—whose very nature is to deteriorate over time. Insurance is intended to indemnify for the unanticipated losses, not those that are certain to happen; such losses are not insured, because they are considered part of the natural process.

Insuring that the home is a safe haven for artwork is of the utmost importance. Maintaining a current inventory of your collection in a comprehensive collection management system is crucial; accurate records can simplify the insurance claims process.

Display conditions can dramatically affect the condition of a work. One should not hang art in direct sunlight, over a working fireplace, or store fine art objects or collectibles in basements and attics, which are typically not temperature controlled. Some objects require specific temperature and humidity levels, typically a constant temperature of approximately 75 degrees Fahrenheit and 55 percent relative humidity. All art (especially paper, textiles, and photographs) should be framed with museum-quality archival materials. Collectors should hire knowledgeable professionals skilled in proper framing, hanging, and display techniques.

Any domestic staff should be informed as to how art objects should be properly handled. Background checks should be performed on all household employees. The collector should identify items that should never be touched by household employees without prior instructions from the collector or conservators. Fragile objects should never be picked up with one hand or by its most vulnerable point, such as the handles or neck. One should not dust an object with a rag or any other material that could snag on sharp or ragged edges; instead, one should use a synthetic or feather duster. Mass-marketed cleaning products and art do not necessarily mix—never use any sort of cleaning solution on a work of art unless a conservator has approved it. If an artwork suffers damage or breakage, staff should know the proper protocol. The staff must be trained to collect and save all of the pieces. A piece of masking tape pressed to the floor to gather even the smallest fragments can be the difference between a successful restoration and a disappointing one.

If a collector lives in an area that is prone to natural disasters such as hurricanes and earthquakes, there are special steps that can be taken to ensure the collection is properly protected. Before a hurricane hits, the collector should create a list of all works in the collection and include notes about any existing damage, as well as the condition of the frames and bases, and check that all wall-hanging devices are secure. After the hurricane,

immediate action must be taken to deal with any damage that the artwork has suffered, as early treatment is the best way to help reduce additional damage. If works are wet, gently blotting off excess moisture with towels or blotting paper, carefully removing wet backings, mats, and frames, and moving wet artwork to an air-conditioned area as soon as possible can help to mitigate problems. Keeping the works in a lighted area where the air is kept moving with fans can reduce mold and mildew growth. These conservation processes should be carried out in coordination with a competent conservator.

In an area prone to earthquakes, collectors should secure heavy furnishings, appliances, and bookcases to the wall using steel "L" brackets. These objects could cause harm if they fall and might also block escape routes. In order to stabilize smaller two- and three-dimensional objects, collectors should use proper display and hanging devices, such as specially designed earthquake hooks. Child safety door latches can prevent objects from flying out of cupboards. One should never hang heavy or glass objects in bedrooms. It is essential to know the location of gas, electrical, and water main shutoff valves. As always, maintain a current inventory list and store it at a separate location. Should damage occur, the collector should immediately contact his or her insurance broker, who will initiate the claims process by contacting the underwriter, claims adjuster, conservators, and appraisers, as may be needed.

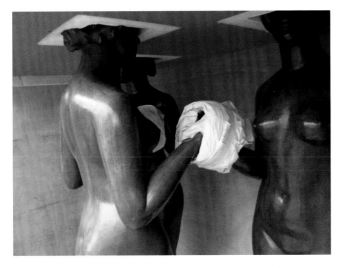

Damage found when sculpture was unpacked at a client's residence.

If a collector is planning to lend significant works of art to a museum or transport a work to another location, they should notify the broker so that the underwriter can be informed. There are many considerations with regard to the transport of fine art, and underwriters can make suggestions about packing and shipping so that the possibility of loss or damage can be minimized.

Proper packing and shipping techniques are the best way to ensure the safety of valuable artwork during transport. Specialists in fine art packing and transporting will take care of the art when it is most vulnerable. Poor packing, shipping, and handling can lead to serious damages.

Proper security measures are also important during transit, as was evidenced by the theft of a Goya painting from a truck en route to a New York City museum.

The nature of what is being shipped and the distance over which it is being transported determines the method of packing used. Soft packing is typically used for shorter distances. Crates should always be used for longer transits. A crate is not just a plywood box; rather, it is typically a carefully constructed wooden container with a cushioned interior. When transporting art, collectors should first make an inventory list of each item and its condition prior to shipping. The same applies to receiving art. Upon arrival and unloading, note the condition of each object. If damage has occurred, one should make a note on the waybill, take photographs, unwrap the artwork immediately, and save the wrappings.

Loaning a work of art to a museum is a wonderful opportunity for both the collectors and the museum. The insurer should never discourage collectors from lending their works; however there are some issues that should be considered before agreeing to a loan. First, to ensure that the borrowing museum or museums are properly accredited, one can consult the American Association of Museums and the International Council of Museums. The borrowing museum is responsible for all aspects of the loan and associated costs, and should always provide wall-to-wall insurance. The collector should ask their agent or broker to review the museum's insurance policy and evaluate the financial strength of the insurance carrier. A current, independent appraisal to establish the proper value of the work at the time of the loan will help avoid problems in the event of damage to or loss of the art. Logistics including packing, shipping, and display conditions, including proper security measures and precautions at all the locations where the work will be on view, should be considered. In addition, the collector should consider whether they wish to be credited with the loan or remain anonymous.

When lending a work to a museum, provenance gaps and title issues may be exposed. Consulting with a provenance or title researcher can help mitigate these potential risks and any resulting negative publicity. Stolen art has the potential for making its way into the most renowned galleries and auction houses, and eventually into the private collections of even the best-intentioned collectors. Title to a stolen work of art cannot be transferred, even to a buyer in good faith. The implications of purchasing stolen art can be quite serious, as the purchaser may be forced to relinquish the work, pay millions in damages, and make restitution to the proper owners or their descendants. Such an event can result in severe monetary loss and personal stress. An insurer may offer coverage services that are designed to help reduce the risk of art title disputes.

Insurance is meant to protect the collector in the event of a loss. As outlined above, all possible steps should be taken to prevent such losses. Collectors should heed recommendations provided by their insurance companies, keeping in mind that these suggestions are not meant to harass the collector or protect the insurance company; they are intended to protect the collector's irreplaceable fine and decorative art objects and collectibles. Collectors should not hesitate to contact their insurance providers with any policy or collection management-related questions, as these providers have experience in insuring collections and can recommended vetted art professionals.

Art and the Law

David J. Jensen, Esquire

David J. Jensen & Associates
Brookline, Massachusetts

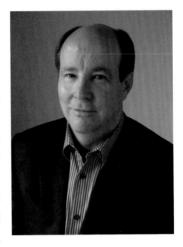

To the beginning collector, gaining awareness of art law may not seem necessary; however, failure to pay heed to relevant statutory and case law can have dramatic consequences. Among other matters, collectors can find themselves drawn into time-consuming and expensive litigation over title to works of art. There are many concerns that collectors, dealers and artists alike need to address, including consignment agreements, copyrights, expert opinions, international laws, resale rights, and intellectual property rights, among other matters. Notable cases in the civil and criminal courts over the last decade have brought greater scrutiny to what has been a lightly regulated industry. Price fixing allegations against major institutions and auction houses have resulted in criminal convictions of prominent industry leaders. The law has both protections and pitfalls all involved in the passion and pursuit of collecting.

The unsolved theft of important and valuable paintings valued at several hundred million dollars from the Isabella Stewart Gardner Museum in Boston garnered much press, but there are legions of less publicized, unsolved thefts of less valuable works of art that call into question the nature of title to stolen or looted art and artifacts. In 2009, Marc Dreier, a collector of paintings and sculpture by noted contemporary artists such as Mark Rothko, Robert Indiana, Roy Lichtenstein, and Andy Warhol, and a prominent New York attorney, was arrested in connection with an alleged financial scam that reportedly netted him nearly $400 million. While he sat in jail awaiting bail, a number of paintings quietly were removed from his office walls. Title to those paintings, along with others that remained on his home and office walls, may remain in dispute as the courts unravel the extent of the fraud for years to come. Meanwhile, Dreier is now in prison serving a twenty-year sentence for fraud.

The realities of the marketplace have created a vast array of statutory and case law that directly addresses the business and pursuit of art collecting. Other regulations derived from laws governing commercial transactions impact the art business. The Uniform Commercial Code (UCC) is no longer a consideration only for those engaged in commerce, such as art dealers, but also can be relevant to collectors. Failure to comply with the provisions set out in the UCC may have dramatic and unexpected results; for example, title to a work of art can pass to a buyer despite payment not being made, and despite a written disclaimer stating that title does not pass until payment in full is made. Moreover, private sellers may find themselves unwittingly violating the Statute of Frauds, which can make a contract "voidable" by one of the parties, or may otherwise unknowingly pass title which is voidable. A working knowledge of the relevant sections of the UCC would be of great benefit to any serious collector.

The importance of doing business with knowledgeable and reputable art professionals has

Morris Atkinson Blackburn (1902–1979), *Abstract*, 1950. Cecilia and Richard Canning Collection.

never been more important. Just as being a seller of a work of art raises certain legal issues, purchases from dealers or auction houses bring with them issues such as the applicability of express and implied warranties, whether of authenticity or title. The three simple elements that are the foundation of any a legal contract—offer, acceptance, and consideration—need to be considered. An offer may seem clear, but there must be enough detail for there to be a meeting of the minds between a buyer and a seller. An acceptance with conditions might legally be a rejection of the offer and the making of a counteroffer. And for any contract to be binding, consideration must be given. While money is the most common form, consideration is anything of value which induces someone to enter into a contract; that includes performing an act, or refraining from doing so, in reliance on the representations of the other party to

the proposed contract. Once a contract is formed, other legal considerations follow: the passing of clear title to a work of art, free from liens or claims of title by others, is essential; fraud and misrepresentation of facts relating to the artwork can lead to damages or rescission of the transaction. Although collectors, as sellers, are bound by many of the same principles as dealers, there are allowances for collectors on account of an expectation of lesser expertise. The collector, however, generally remains bound by requirements of good faith and fair dealing, and defining the meaning of those terms is now more important than ever.

As values of works of art have soared, consideration of art as an investment has become more commonplace, and legal issues have been increasingly relevant. Many major financial institutions have created art advisory services for their top clients,

providing financing and access to industry professionals. Other businesses have sprung up in response to the current financial turmoil. Several private companies now offer loans secured by works of art, often taking possession of the individual paintings or sculpture as collateral for a loan. These businesses will take title if the property is not redeemed within a specific period of time, much as a pawnshop operates. The *New York Times* reported in the fall of 2008 that famed photographer Annie Leibovitz used the rights to her lifetime of photographic work as collateral for loans exceeding $15 million; the artist Julian Schnabel apparently did the same. A failure to strictly adhere to the repayment provisions of such loans may result in a loss of those rights, just as dealers and collectors would face a loss of their prized works of art. By the summer of 2009, Leibovitz and Art Capital Group were in litigation over allegations of default in the performance of the loan agreement. In some states, the only regulations for such transactions are those governing pawnshops. Collectors need to be aware of the legal implications of any transactions in which they engage.

Many collectors become so active in collecting that considerations of art as an investment can take on new meaning with regard to tax laws. For almost as long as there has been an art market, there have been individuals or investor groups engaged in speculative investment; it is not only those parties who need to be concerned about the law as it applies to art as an investment. Some collectors will keep every work of art they have ever acquired and do not consider selling at any time, instead leaving their collections to museums or to heirs. Others will trade actively, selling works for the purpose of upgrading their collection, or to take advantage of the gains to be made in a hot market. In either case, collectors incur expenses related to maintaining a collection:

insurance, framing, restoration among them. Under what circumstances may such expenses be relevant, and perhaps deductible, for income or estate tax purposes? The answer will depend on whether a taxpayer is treated as a dealer, investor, or collector, under the Internal Revenue tax code. A collector should seek the guidance of an experienced attorney in order to avoid running afoul of tax regulations.

As with investment-related tax issues, estate planning concerns grow with the size and value of a collection. The constantly shifting provisions of the tax code make expert advice from estate planning professionals essential. Whether the issue is charitable transfers before or upon death, partial transfers such as fractional interest transfers, or testamentary transfers, the IRS has complex regulations, the proper use of which can maximize tax benefits. Collectors owe it to themselves to be familiar with the legal issues surrounding their collecting activity. With proper guidance, a collector can use the law to his or her benefit.

Hugh Breckenridge (1870–1937), *Composition in Color*, 1915. Cecilia and Richard Canning Collection.

The Collector's Role within a Museum

Annette Blaugrund, Ph.D.

Former Director, National Academy of Design Museum
New York, New York

As donor, lender, advisor, visitor, mentor, and potential board member, a collector can provide invaluable assistance to museums. Donors contribute works of art or provide financial support for exhibitions, capital expansion and improvements, endowments, and general operations. In my experience as director of the National Academy Museum, an organization that collected only the work of its Academicians, it was the artists, rather than the collectors, who were the donors of paintings and sculpture to the institution's permanent collection. Unfortunately, while collectors who donate art to museums receive a tax deduction for the true market value of a work, artists can deduct only the cost of materials. Fortunately collectors who are interested in specific exhibitions that coincide with their interests can, and do, provide funding for shows at the National Academy. In the field of American art, it is well known that Frank and Katherine Martucci are passionate about the work of George Inness. In addition to supporting the Inness catalogue raisonné, they also helped fund a number of Inness exhibitions, including the Academy's *George Inness and the Visionary Landscape* in 2003. Other collector patrons, such as Paula and Peter Lunder, provided funding for the cataloguing and preservation of the National Academy's historic archives.

Lenders are equally important to the realization of exhibitions. Many collectors can be generous and gracious about lending works from their collection, though most want to make sure that the show they are lending to has value and substance, and moreover, that a catalogue in which their work will be illustrated will accompany the effort. Occasionally, the Academy would exhibit works from a single private collection, as it did with the Henry Martin collection of exceptional Hudson River School landscapes, organized by the New Britain Museum of American Art.

Because of that exhibition I became acquainted with the Martins, and Hank eventually joined the Advisory Board of the National Academy Museum.

Many collectors are knowledgeable in the areas in which they collect, and, as advisors, often provide important outside information and points of view to directors and curators. They often have the time and dedication to research an artist, a painting or a period. Curators, on the other hand, often supply collectors with information from curatorial files and discoveries, while some collectors also provide business and legal advice to museums.

Visitors are the lifeline of a museum's existence, and collectors are visitors who usually view exhibitions multiple times and bring friends. In addition, collectors often support and participate in educational programs.

Mentoring is one of the most satisfying roles a collector can play; many collectors have a willingness to help others by speaking to aspiring collectors in museum forums or individually. This is an important contribution that collectors can make.

Board members are often drawn from the ranks of interested collectors, and there is no greater involvement for a collector than to become a trustee of a museum. The collector can have considerable influence on current affairs and long-range planning for an organization. In addition to experiencing the pleasure of acquiring works of art, the collector now has impact on a public institution by sharing his or her expertise. This can prove to be a wonderful benefit to both the institution and the individual.

Institutional Collecting at the Detroit Institute of Arts

James Tottis

Former Associate Curator of American Art
Detroit Institute of Arts

The difference in philosophies in building a private collection versus a pubic one is a topic that is rarely addressed, but it arose in a conversation I had several years ago. The discussion related to strategies in assembling a serious group of works of art, and the inquirer assumed that there was a blanket approach to building a collection that did not differentiate between private and institutional collecting. There are in fact certain underlying advantages to the development of an institutional collection, such as the privilege of having generations to form it. Moreover, there is also the responsibility to tell the story of the development of a particular area of art history and a mandate to acquire the finest objects that it can to celebrate the achievements of that era. Such distinctions make building a museum collection a far different endeavor than the pursuit of a private collection. That is also the reason that curators, the institutional staff responsible for proposing acquisitions, must possess a broad range of knowledge in art history, connoisseurship, the market and its trends, and aesthetics, and must also have the social abilities to enlist the necessary support to successfully grow a collection. The 124-year history of the American collection of the Detroit Institute of Arts, one of this nation's great institutions, provides a case study for the formation of a public art collection. The Detroit Institute of Arts possesses one of the leading encyclopedic collections of American art, spanning three centuries, from the early Colonial period through modernism. The collection developed as the result of the patronage of many individuals who had a desire to share the artistic heritage of the United States with their community. In addition, a symbiotic relationship involving curators, patrons, dealers, and directors provided the formula to create this collection. Three curators were largely responsible for assembling this anthology of American art; they were Clyde Burroughs, Edgar P. Richardson, and Nancy Rivard Shaw. Each held curatorial positions with the institution for extended periods and each exhibited great aesthetic and art historical acumen. The acquisitions that form the core of the collection were made possible through the philanthropic support of lovers of American art such as Dexter M. Ferry Jr., Eugenia Gibbs, Richard A. Manoogian, Julia Peck, Beatrice Rogers, and Robert Hudson Tannahill, to name a few.

Detroit's interest in American paintings was evident from early in the museum's history, when Francis D. Millet's *Reading the Story of Oenone* (c. 1883) was purchased

Isaac Vose and Son, (1767–1823), Neo-classical Center Table with Specimen Marble Top, 1818–22.

Detroit Institute of Arts, Contemporary Gallery, New American Wing, 1927.

two years prior to the founding of the Detroit Museum of Art in 1885 (renamed the Detroit Institute of Arts in 1919). Thus, American painting became the cornerstone of the institution's collection. During the museum's first few decades, American paintings were acquired primarily through gifts and bequests by contemporary artists. This was the greatest source of acquisitions to the collection, although the works were not always of the highest quality.

With the beginning of the twentieth century, the quality of acquisitions changed dramatically with the appointment of curator Clyde Burroughs, under whose tenure the foundation of the collection was laid. Burroughs organized annual exhibitions of works by American painters and arranged numerous solo and group exhibitions from which many late nineteenth- and early twentieth-century works were acquired. These included some of the museum's signature paintings, such as John Sloan's *McSorley's Bar* (1912) and George Bellows' *A Day in June* (1913), which are both icons of the Ashcan School, as well as Frank Benson's *My Daughter Elisabeth* (1914) and Mary Cassatt's *In the Garden* (1903), exceptional examples of American Impressionist painting.

At this time, Detroit industrialist Charles Lang Freer, this country's leading patron of James Abbott McNeill Whistler, helped to shape the fledgling American collection by donating works such as John Twachtman's *The Pool* (c. 1906), and underwriting the purchase of one painting by an American artist each year.

The strength of the Detroit collection goes beyond a list of well-known images; the depth in the collection that Burroughs created over a forty-five-year career allows for close examination of variations within a given style or the nuances of an individual artist's oeuvre. The coverage given to a singular artistic movement can be seen, for example, in the museum's paintings by The Eight, a group of independent artists led by Robert Henri. Works by seven of the group—Henri, John Sloan, George Luks, Ernest Lawson, William Glackens, Arthur B. Davies, and Maurice Prendergast—are in the collection; only Everett Shinn remains unrepresented. Detroiter Julia Peck, an aspiring artist who studied in New York where she met and socialized with fellow painters, introduced Burroughs to members of this group. The careers of William Merritt Chase and Gari Melchers are also among those well documented through works collected by Burroughs.

The paintings of the late nineteenth and early twentieth century are only one aspect of Burroughs's interests. With the establishment of the American Wing in 1927, he laid out a historical progression for the collections through the sequence of galleries. Combining furniture, decorative arts, and sculpture with historic paintings by Frederic Church, John Singleton Copley, Thomas Sully, George Inness, and others acquired during his tenure, Burroughs helped create a comprehensive experience for the visitor.

It was during Burroughs's tenure that Dexter M. Ferry Jr. became a major benefactor of the American collection. An heir to the Ferry Seed Company fortune, he followed his father, Dexter M. Ferry Sr., and was an active and influential member of the museum's board of trustees for twenty-eight years. Burroughs found a kindred spirit for mid-nineteenth-century art in Ferry, who did not collect for himself, but provided funds through gifts and established an endowment in 1922 for the purchase of American paintings. The purchase of works by Copley, Thomas Cole, Thomas Eakins, Maurice Prendergast, and William Sydney Mount, among others, helped bring Burroughs's plans for an historic overview of American art to fruition.

American Classical Gallery at the Detroit Institute of Arts, 2007.

During the Detroit Institute's first fifty years, the museum did not collect any American furniture and had little in the area of decorative arts, with the exception of art pottery, the majority of which was Detroit-based Pewabic Pottery. During the early decades of the twentieth century, a group of Detroiters pursued work of the Arts and Crafts movement and a number of notable examples of art pottery, including some of its most important Pewabic pieces, were added to the collection.

After years of neglect, Burroughs developed the core of the eighteenth-century American furniture collection, first through a large bequest and then through a creative arrangement with the legendary New York furniture dealer Israel Sack. In 1922, the Institute's architect, Paul Cret, learned that an important mid-eighteenth-century Philadelphia house, Whitby Hall, was about to be moved from its original location and that the owner planned to sell elements of the historic home to assist with financing the endeavor. Cret suggested to Burroughs that the museum purchase architectural elements from two rooms and the stair hall for installation as a suite of period rooms in the proposed American Wing, thus creating a core for the American Colonial galleries. Thrilled with the idea, Burroughs acquired the rooms with funds from Edsel Ford. Shortly before the museum opened, the furniture dealer learned of the installation and suggested the loan of several important pieces of eighteenth- and early nineteenth-century furniture to augment the period rooms, with the intention that patrons purchase them for the collection. As a result of this collaboration, several pieces from the loan joined the museum's collection.

In the mid-1920s, Robert H. Tannahill, a great friend to the American furniture and decorative arts collections, began supporting Burroughs' efforts through a series

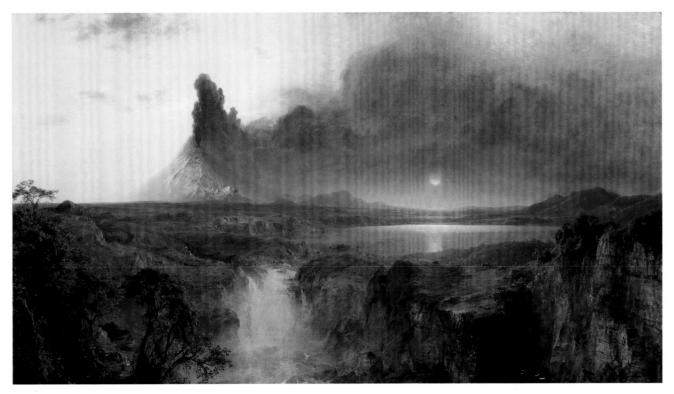

Frederic Edwin Church (1826–1900), *Cotopaxi*, 1862. Founders Society Purchase, Robert H. Tannahill Foundation Fund, Gibbs-Williams Fund, Dexter M. Ferry, Jr. Fund, Merrill Fund, Beatrice W. Rogers Fund, and Richard A. Manoogian Fund.

Detroit Institute of Arts, Paul Cret building, Woodward Avenue, c. 1935.

of gifts. Tannahill donated paintings, furniture, glass, silver, pewter, and ceramics from his personal collection and also established the Robert Hudson Tannahill Foundation Fund, which continues to provide for the growth of the collection and has enabled the purchase of some of the museum's most notable paintings.

Edgar P. Richardson came to the Detroit Institute in 1930 and assisted Burroughs in developing the mid-nineteenth-century American collection. Richardson belonged to a group of scholars who began to codify eighteenth- and nineteenth-century American art history, focusing on painting from the Colonial and Federal periods, mid-century genre painters, and Hudson River landscapes. During Richardson's tenure, a number of the acquisitions made reflected these interests. Other noted works also entered the collection, including one of the museum's most recognizable paintings, Whistler's *Nocturne in Black and Gold: The Falling Rocket* (c. 1874), which was the cause of Whistler's famous libel suit against art critic John Ruskin.

Richardson's interests also included amassing and preserving material to aid in the study of American art. In 1945, he, along with collector-patron Lawrence Fleischmann, showed great prescience in founding the Archives of American Art, which eventually became part of the Smithsonian Institution—and serves as a major research resource for the study of American art to this day. Richardson organized numerous exhibitions and

publications with an emphasis on the mid-nineteenth century. In 1956, he published *Painting in America: The Story of 450 Years*, the first general history of American painting published in half a century, which became the standard text for several decades. Richardson went on to become the director and left his imprint on many other significant areas of the museum.

In the years following Richardson's departure in 1962, Charles Elam, Graham Hood, and Larry Curry served as curators of American art. Hood was responsible for reinstalling the expanded American Wing in 1969 in preparation of its naming for Tannahill, which was later renamed for Richard Manoogian. Hood is also responsible for working with a group of local collectors to form the Associates of the American Wing.

The early 1970s also saw two pivotal figures become involved with the American collection, curator Nancy Rivard Shaw and patron Richard Manoogian, who worked to refine and augment the collections with a series of important acquisitions and programs. Shaw was responsible for numerous transformative acquisitions that strengthened the breadth of the American collections. These included such notable works as Benjamin West's *Death on a Pale Horse* (1796); Jasper Cropsey's *Indian Summer* (1866); one of Mary Cassatt's rare depictions of a male subject, *Alexander J. Cassatt* (c. 1880); and John Singer Sargent's double portrait, *Mosquito Nets* (1908).

The singularly most important addition to the collection during this time was Frederic Church's monumental *Cotopaxi* (1862), which was acquired with funds from among others, the Ferry fund, Tannahill Foundation, and Richard Manoogian fund, three of the museum's most significant benefactors of American art.

Interest in the frames that American painters placed on their works grew among curators, collectors, and scholars during the mid-1980s. With the financial support of Manoogian, Shaw was able to pursue a program of acquiring period frames for paintings that lacked appropriate treatment. Some museum works, such as Whistler's *Arrangement in Grey: Portrait of the Painter*, are in frames designed by the artist, while other paintings have specially commissioned frames, as in the case of Dewing's *The Recitation*, with its gilded surround designed by Stanford White. The extensive work with frames accomplished over the last twenty years allows for entire galleries in the American Wing to be hung with paintings in original or period frames, thus providing visitors with the opportunity to view works in the manner in which the artists meant them to be seen.

Two groundbreaking exhibitions in the early 1980s addressed the long ignored subject of furniture and decorative arts from post-Civil War nineteenth-century America: *In Pursuit of Beauty*, at The Metropolitan Museum of Art in New York, and *The Quest for Unity*, at the Detroit Institute of Arts, organized by Shaw. These exhibitions renewed national interest in furniture and decorative arts from the incredible artistic production of post-Civil War America. The early 1980s also saw an increased enthusiasm for the Arts and Crafts movement, which was reflected in the growth of that area within the Institute's collection.

In the late 1970s, Shaw reevaluated the Detroit Institute's presentation of post-Civil War painting and sculpture through a series of gallery reinstallations. These were designed to more effectively tell the story of American art from the mid-seventeenth through the early twentieth centuries with examples of high style art and design from the collection. With the arrival of director Samuel Sachs II, who supported her activities,

Louis Comfort Tiffany (1848–1933), Tall Case Clock, 1882–83. Founders Society Purchase, Robert H. Tannahill Foundation Fund.

Hiram Powers (1805–1873), *Greek Slave*, after 1845. Founders Society Purchase, Dexter M. Ferry, Jr. Fund.

or did not meet the quality of the rest of the collection. Specific areas that were reviewed were painting, furniture, glass, pewter, and ceramics, excluding art pottery. Certain pieces were sold at a number of public sales and the resulting funds were used for the purchase of other works of art for the collection within those media. One area of the collection that was strengthened through this process was American glass from its mid-eighteenth-century beginnings through the early twentieth century. The department of American art also began to refocus on the long-ignored American neo-classical period in furniture and decorative arts and made important additions in those areas.

Paintings were also added to augment the collection of American nineteenth-century still-life painting, two of which were Severin Roesen's *Flowers* (c. 1865), and George Cochran Lambdin's *Roses on a Wall* (1877), considered a seminal work among the floral paintings that dominate the second half of his career. Over the past decade there have also been important additions to the sculpture collection, among them an exquisite bust

Shaw began buying against the market and assembling the core of Detroit's Aesthetic collection, which would complement one of the areas of strength within the American painting collection—that of Tonalism.

In 1985, Shaw asked me to join the staff of the department of American art. We shared many of the goals and concerns for the collection, as well as many of the acquisitions during our joint tenure. In addition to exhibitions and permanent collection catalogue production, early projects included refining and restoring the American Wing to the original architectural vision held by Burroughs and Cret, to correct the unfortunate modernization that had occurred over the years. The process of restoring the elaborate architectural details and decorative elements throughout the galleries began in the late 1980s and is still ongoing.

The American collections of the Detroit Institute of Arts have continued to be refined through a formal deaccessioning policy that was adopted in 1989. This afforded a meticulous reexamination of the collection that included identification of pieces that were redundant

Wilhelmina Post. Trefoil Vase, 1905–07. Founders Society Purchase, Edward E. Rothman Fund, Merrill Fund, Eleanor and Edsel Ford Exhibition and Acquisition Fund and Gibbs-Williams Fund.

by Hiram Powers, *Greek Slave* (after 1845), which have filled gaps and expanded its depth. Nineteenth-century American furniture has been enhanced with significant works, including fine examples by Frank Furness and by Louis Comfort Tiffany and Tiffany and Company. The area of Arts and Crafts pottery, long ignored at the DIA since the departure of Clyde Burroughs, was addressed with the help of both collectors and dealers, in particular by the acquisition of two magnificent and rare vases by Newcomb College Pottery and Adelaide Robineau.

Kenneth Myers joined the staff as curator of American art in 2005 and began working on the reinstallation of the American Wing. Embracing Burroughs's ideas of a logical progression of American art history through the galleries, the reinstallation and ongoing restoration led to the renaming of the American Wing in honor of Richard Manoogian. Through meticulous searches, Myers located works that have added subtle nuances to the museum's holdings of Alexander Wyant and Whistler. Additionally, he has been supportive of the continued

John Sloan (1871-1951), *McSorley's Bar*, 1912. Founders Society Purchase, General Membership Fund.

development of the furniture and decorative arts collections through the backing of acquisitions such as the Specimen Top Center Table, attributed Isaac Vose and Sons, and a very rare Philadelphia Piecrust Tea Table.

The work of enhancing the American collections over this 124-year period has been an evolving and collaborative process involving many individuals who have brought different strengths and interests to the endeavor. Burroughs laid the groundwork for the breadth of the collection, Richardson added depth, and Shaw began the process of rediscovery and refinement, which continues and will be carried on by subsequent curators in the department of American art. Their relationships with many of the leading dealers in the field who brought stellar works to the museum's attention, coupled with generous donors and collectors, have provided the necessary formula to build the American collections that permit the museum to tell the story of American art from the seventeenth through the early twentieth centuries.

As this overview of the evolution of the American collections at the Detroit Institute of Arts makes apparent, it is the enormous support and collaborative spirit among curators, museum directors, patrons, and dealers that is vital to create leading collections such as those at this institution. The continuation of that synergy will ensure the collection's refinement and development in the decades to come.

John Singleton Copley (1738-1815), *Watson and the Shark*, 1777. Founders Society Purchase, Dexter M. Ferry, Jr. Fund.

Samuel F.B. Morse (1791-1872), *Gallery of the Louvre*, 1831-33, oil on canvas, 73 ½ x 108 in. Terra Foundation for American Art, Daniel J. Terra Collection, 1992.51.

Evolution of a Single Benefactor Museum: The Terra Museum of American Art

Judith Terra
Washington, D.C.

My husband, Daniel Terra, and his late wife had collected art for a number of years; her love was British eighteenth- and nineteenth-century landscapes and they mostly had European paintings, including some Dutch works. Back in the late seventies, my husband was in the New York apartment of a major collector of American art, and he was so overwhelmed by the power of the paintings he saw that he developed a passion for American art. That is how he began collecting the works for which he is most known. One of his early acquisitions was the renowned *Jolly Flatboatmen* by George Caleb Bingham, which he bought for what was probably the highest price ever paid for an American work of art at the time, about $1 million.

Dan began to have strong feelings about the American cultural heritage that he uncovered through the art he was collecting. Later, when we were in Washington, D.C. and he was serving as cultural ambassador for the United States, it became apparent to both of us that most Americans were ignorant about their own cultural heritage. There is a tendency to see this as a very young country, but we have a rich artistic heritage and we felt it was important to expose people to American art.

In order to accomplish this, we created a small museum in Evanston, Illinois, in 1980. It was a beautiful and intimate space which had been an old

flower shop. At that time, there were about sixty or seventy works in the collection that were displayed, and it gradually expanded.

About a year later, Dan became enamored with the work of Maurice Prendergast, and we started collecting his work as fast as we could, especially the monotypes; there are over sixty in the collection. We sent a number of the monotypes on a national tour to eighteen different museums. The monotypes are quite fragile and we had to send a curator to make sure that the light levels were correct and that the works were properly cared for. Dan and I both believed that one of the exciting things about the privilege of owning great works of art is to be able to share them.

The museum in Evanston had a great response; even Paul Mellon would visit when he came through Chicago, because he loved what he called "the little museum in Evanston." It was, however, difficult for people to get there, since there was no mass transit to that area of the city. Dan also felt that we needed a better place to display those early works, and he wanted to share the art with a greater public. We were also running out of space!

As our passion evolved and the collection became much more extensive, we held a series of symposiums in connection with Northwestern University, which drew crowds of sometimes twenty-five hundred people on a Saturday. They came to listen to people

Above: Ambassador Daniel J. Terra (1911–1996) and Mrs. Judith Terra at the opening of the Musée d'Art Americain, Giverny, France, June 1, 1992.

George Caleb Bingham (1811–1879), *The Jolly Flatboatmen*, 1877–78, oil on canvas, 22 ⁵⁄₁₆ x 36 ³⁄₈ in. Terra Foundation for American Art, Daniel J. Terra Collection, 1992.15.

like John Wilmerding, as well as other art historians and critics that we would bring in to speak. We began to realize that people were hungry to know more about American art. As a former educator, I was passionate about education, and believed that it was important that all of our endeavors have an educational component.

We began thinking that in order to have an impact in the Chicago area, a facility needed to be downtown and centrally located. For that reason we made a decision to develop the Terra Museum on North Michigan Avenue. We also knew that there was no museum of American art anywhere in the Midwest. There is

the Whitney Museum of American Art in New York and the Pennsylvania Academy of the Fine Arts, in Philadelphia. So we acquired the buildings, and finally in 1987, the doors to the Terra Museum of American Art on North Michigan Avenue opened.

Because of my husband's position as Ambassador-at-Large for Cultural Affairs for the United States, we were traveling a lot, representing the President and the Secretary of State on cultural matters around the world. The more we traveled, the more we came to realize that Europeans knew even less about American art than Americans did. They might be familiar with some of the modern masters, artists who had had

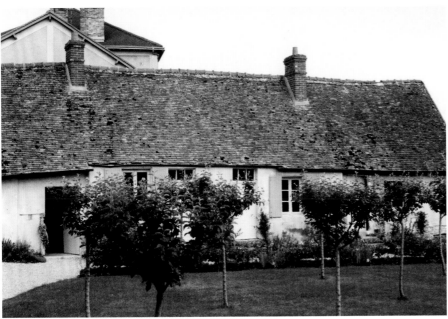

Above
Theodore Robinson (1852–1896),
The Wedding March, 1892, oil on canvas,
22 5/16 x 22 1/2 in. Terra Foundation for
American Art, Daniel J. Terra Collection,
1999.127.

Left
"Le Hameau." House rented by Boston artist
Lilla Cabot Perry, Giverny, France, now owned
by the Terra Foundation for American Art.

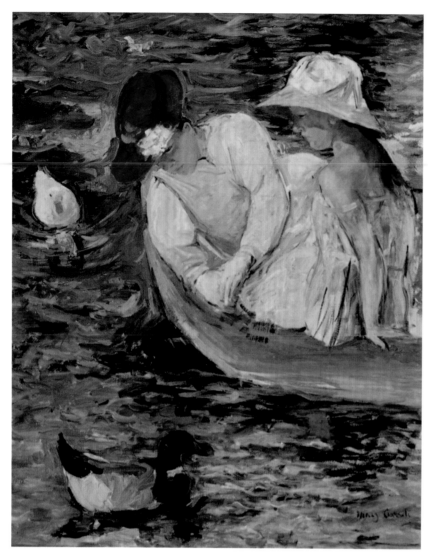

Mary Cassatt (1844–1926), *Summertime*, 1894, oil on canvas, 39 ⅝ x 32 in. Terra Foundation for American Art, Daniel J. Terra Collection, 1988.25.

ter part of the nineteenth century. It made a great deal of sense that if we were going to open a museum of American art, Giverny would be the perfect venue. It was a major art colony that had drawn many American artists to visit, some of whom settled and painted there.

In 1986, we bought our first piece of property, which is what is known as the Perry House—the residence of Lilla Cabot Perry, where she and her family lived for about thirteen summers. It was right next to Claude Monet's house. She was an artist herself who encouraged so many of the Americans to come to Giverny. We acquired that property, then we were able to finally acquire two contiguous pieces of land that were vacant except for one little contemporary house, which we were able to tear down. That gave us the land on which we built the Musée d'Art Américain Giverny, which is now the Musée des Impressionnismes. The Terra Foundation is now working to establish cooperative exhibitions and programs with other museums in America and in France.

a real international impact, like Robert Motherwell, Robert Rauschenberg, or Willem de Kooning, but had little knowledge beyond that. So we began to feel that the United States needed a venue abroad where American art could be displayed. Dan attempted to see if the government would be interested in establishing such a place, but that went nowhere and he decided that we should do it on our own.

We had traveled to Giverny in 1984 when the Monet House and Gardens were reopened. We visited there because the Impressionist period was one of Dan's favorite periods in American art and many of the American Impressionists went to Giverny in the lat-

One of the most interesting acquisitions happened in 1981, when Dan was able to purchase the great Samuel F. B. Morse *Gallery of the Louvre*. There is an amazing story behind that purchase, because when he was a young student at Penn State University, Dan was studying to become a chemical engineer and was very interested in learning about Morse and the telegraph. Morse did other things, too, because he was quite a scientist as well as an artist. Dan was reading about Morse in an encyclopedia, which had a reproduction of the painting *Gallery of the Louvre*, and he was fascinated by it. He decided that he would find that painting someday. After he had become involved with

collecting American art, he learned that Syracuse University owned this painting and it was in storage in the basement of the museum. Eventually he was able to acquire it for the Terra Museum, where it was considered one of the most important historical works of the collection.

By the time Dan passed away in June 1996, there were over twelve hundred works of art in the Terra collection. Though the North Michigan Avenue location closed after his death, many of these works are now on long-term loan to the Art Institute of Chicago, and the Terra Foundation continues to lend works to exhibitions throughout the world.

Recently I have been more active on a local level. I am still very interested in what is happening in Giverny and in America with respect to American art, but after Dan's death, I decided to stay in Washington where I work to promote the arts for the city.

I would tell people who want to embark on the journey of collecting to collect the things about which they feel passionate. I would also advise them to be sure and share their objects with the community, because it is one thing to have art for yourself, but it is so much more meaningful when you can share it with others and the community at large. I cannot describe the excitement that we experienced in being able to develop museums where we could display art and we could see people's reactions, particularly children, who were excited by the art that they saw.

In dealing with major issues between countries, on an economic level, or on a military level, the arts are the common denominator. This was part of the thrill when Dan was our Ambassador-at-Large for Cultural Affairs. There were ways that we could talk with leaders of countries about the arts and artistic exchange through exhibitions that opened a

dialogue and established lines of communication through a universal appreciation of culture.

I would like to continue with our journey and keep alive the passion for art. Particularly now that we are going through difficult economic times, it is going to be even more important that we pay attention to foundations and nonprofit organizations that are at work to keep the arts front and center in our lives.

Maurice Prendergast (1858–1924), *Franklin Park, Boston*, 1895–97, watercolor over black chalk on ivory wove watercolor paper, 17 1/2 x 13 1/8 in. Terra Foundation for American Art, Daniel J. Terra Collection, 1999.111.

Takashi Murakami (b. 1962), *Eye Ball Pink*, 2001.
Kelly and Scott Miller Collection.

PHOTOGRAPH AND REPRODUCTION CREDITS

The author and publisher gratefully acknowledge the collectors and institutions for the use of works of art and permission to reproduce them in this book. Additional credits are listed below. Every effort has been made to identify owners of copyrighted material. Any omissions will be rectified in future editions.

Photographs accompanying Interviews have been provided by Ralph Toporoff, New York, and photography accompanying Topics in Collecting is provided by the authors, with the exceptions and additional credits on the following pages:

iv, 90, 190, 221 (O'Keeffe): © 2010 Georgia O'Keeffe Museum / Artists Rights Society (ARS), New York

xi (photograph of Wendell Garrett): courtesy Sotheby's Inc., New York

xviii, 80, back jacket (Picasso): © 2010 Estate of Pablo Picasso / Artists Rights Society (ARS), New York

4 (Lawrence): © 2010 The Jacob and Gwendolyn Lawrence Foundation, Seattle / Artists Rights Society (ARS), New York

7 (Cadmus): © Jon F. Anderson, Estate of Paul Cadmus / Licensed by VAGA, New York, NY

7 (Bearden): © Romare Bearden Foundation / Licensed by VAGA, New York, NY

7 (Marsh): © 2010 Estate of Reginald Marsh / Art Students League, New York / Artists Rights Society (ARS), New York

7 (Depero): © 2010 Artists Rights Society (ARS), New York / SIAE, Rome

8, 13 (Archipenko): © 2010 Estate of Alexander Archipenko / Artists Rights Society (ARS), New York

9 (Frankl desk and bookcase): Photograph © 2010 Museum of Fine Arts, Boston

11, 15, 17 (Segal): © The George and Helen Segal Foundation / Licensed by VAGA, New York, NY

19 (Photograph of Scott Black with Degas, *Pagans and Degas' Father*): courtesy Ralph Toporoff and Museum of Fine Arts, Boston

18–25 (photographs of works in the Scott M. Black Collection): © 2010 Museum of Fine Arts, Boston, with the exception of 20 (Magritte): photograph by Benjamin Magro, © 2010 Portland Museum of Art, Maine, and 24 (Monet): photograph by Melville McLean, © 2010 Portland Museum of Art, Maine

20 (Magritte): © 2010 C. Herscovici, London / Artists Rights Society (ARS), New York

20, front jacket (Léger): © 2010 Artists Rights Society (ARS), New York / ADAGP, Paris

22 (Braque): 2010 Artists Rights Society (ARS), New York / ADAGP, Paris

23, 78 (Dufy): © 2010 Artists Rights Society (ARS), New York / ADAGP, Paris

26, 28–31: Paulette Brill, New York, NY

27: courtesy Robert Modaffe, Ramapo College, NJ

42 (de Chirico): © 2010 Artists Rights Society (ARS), New York / SIAE, Rome

45, 78, 206 (Miró): © 2010 Successió Miró / Artists Rights Society (ARS), New York / ADAGP, Paris

45 (Slonem): © Hunt Slonem / Licensed by VAGA, New York, NY

45 (Zadkine): © 2010 Artists Rights Society (ARS), New York / ADAGP, Paris

46 (Warhol): © 2010 The Andy Warhol Foundation for the Visual Arts, Inc. / Artists Rights Society (ARS), New York

46 (Chagall): © 2010 Artists Rights Society (ARS), New York / ADAGP, Paris

47 (Arp): © 2010 Artists Rights Society (ARS), New York / VG Bild-Kunst, Bonn

48 (Haring): © Keith Haring Foundation

48 (Kandinsky): © 2010 Artists Rights Society (ARS), New York / ADAGP, Paris

48 (Dubuffet): © 2010 Artists Rights Society (ARS), New York / ADAGP, Paris

48 (Kline): © 2010 The Franz Kline Estate / Artists Rights Society (ARS), New York

48 (Kisling): © 2010 Artists Rights Society (ARS), New York / ADAGP, Paris

69 (Kahn): © Wolf Kahn / Licensed by VAGA, New York, NY

74–81: courtesy William I. Koch Collection. All rights reserved.

76 (Dali): © 2010 Salvador Dali, Gala-Salvador Dali Foundation / Artists Rights Society (ARS), New York

76 (Maillol): © 2010 Artists Rights Society (ARS), New York / ADAGP, Paris

78 (Valtat): © 2010 Artists Rights Society (ARS), New York / ADAGP, Paris

90–99: Photographs © 2010 Colby College Museum of Art, Waterville, Maine; The Lunder Collection

Special thanks to the following individuals for their assistance in providing the photography:

Erin M. A. Schleigh and Jennifer Riley, Manager of Image Licensing Ventures, Digital Image Resources, Museum of Fine Arts, Boston

Erin Damon, Registration Assistant-Rights and Reproduction, Portland Museum of Art

Natasha Khandekar, Director and Curator of the William I. Koch Collection and Gisela Garneau, Executive Assistant, Oxbow Corporation, West Palm Beach, Florida

Patricia King, Assistant Director for Administration & Collections Management, Colby College Museum of Art, Waterville Maine

Silvia Inwood, Photo Services Department, Detroit Institute of Arts

Cathy Ricciardelli, Registrar, Terra Foundation for American Art, Chicago

All transparencies scanned by Paul Weinschank, Tarrytown, New York